Barossa Journeys

into a valley of tradition

NORIS IOANNOU

NEW
HOLLAND

Published in Australia in 2000 by
New Holland Publishers (Australia) Pty Ltd
Sydney • Auckland • London • Cape Town
14 Aquatic Drive Frenchs Forest NSW 2086 Australia
218 Lake Road Northcote Auckland New Zealand
24 Nutford Place London W1H 6DQ United Kingdom
80 McKenzie Street Cape Town 8001 South Africa

First published in 1997 by Paringa Press
Revised edition published in 2000 by
New Holland Publishers (Australia) Pty Ltd

National Library of Australia Cataloguing-in-Publication Data:

Ioannou, Noris, 1947-.
Barossa journeys: into a valley of tradition.

Bibliography.
Includes index.
ISBN 186436 612 5
1. Folklore - South Australia - Barossa Valley. 2. Germans
- South Australia - Barossa Valley - Material culture.
3. Barossa Valley (S. Aust.) - Civilization. 4. Barossa
Valley (S. Aust.) - Social life and customs. 5. Barossa
Valley (S. Aust.) - Description and travel. I. title.

306.0893 1094232

Designed by Patricia Howes
Typeset by Clinton Ellicott, MoBros, Adelaide
Printed by Griffin Press, Adelaide

Back cover illustrations clockwise from top.
Detail of table runner embroidered with traditional European 'paired bird' design
in red and black thread on linen, c. 1855.
Clock tower and twin parapet facade of Yalumba, Australia's oldest family-owned winery;
constructed 1908 and 1909 from Angaston blue marble.
Orlando's Heritage Picnic is held during the Barossa Vintage Festival at Jacob Creek
where traditional Barossan foods are served by locals wearing early dress.
The steeple of Langmeil Lutheran Church framed by its distinctive candle-pine lined path.

For my father

Acknowledgements

In this revised and updated second edition of *Barossa Journeys*, I am delighted to open with a note of thanks for New Holland Publishers' foresight and support in this venture.

This is also an opportunity to raise concerns regarding the integrity of the Barossa's unique cultural landscape, lately placed under considerably accelerated development pressures, including submitted plans to cut down ancient stands of gums, build gigantic wineries and to establish a major industrial factory! I repeat what I have stated in public talks and in the media, that the time has come for decisive action if the Barossa region is to be managed in a manner that balances the diversity of interests which wish to exploit it. There may even be a case to consider placing the region on the World Heritage List, although this may be unnecessary if commonsense prevails.

In producing this book, I am most grateful to the many people who were helpful to me during my research forays in the Barossa. In particular I wish to thank Pastor Henry Proeve, Bertha Hahn, David Herbig, Roger and Myrene Teusner, Nathalie Leader, Barry Rosenzweig, Mel Goers, Margaret and Cedric Zweck, Luke and Fay Rothe, Andrew Falland, Colin Gramp, and the Braunack family. There are others too numerous to list here but who are mentioned in the text: many have shared their reminiscences, relating their living memories of tales as passed down through the generations.

Aside from a set of seven historic views kindly supplied by the Barossa Archives and Historical Trust, photographs were sourced from family collections, or else taken by myself. I am also grateful for permission from G. Young to reproduce the illustration of the black kitchen.

Memory, oral lore or tradition which comprises much of the primary source for this book, together with artefactual, archival and primary documental evidence, has preserved a large part of the Barossa's cultural heritage and landscape—as have the lingering remains of living customs and various traditional practices, be they religious, viticultural, musical, cuisine, or of material folk culture. My approach has drawn from these to mix narrative and commentary, so that the following chapters map out this region's cultural heritage, its traditions, their origins and the way they have evolved into their present-day display—and not least, the manner of their total expression as the Barossa *mise en scene*. In particular, I hope that I have conveyed something of the texture of life, past and present, in this special region.

Noris Ioannou, Adelaide, South Australia

Contents

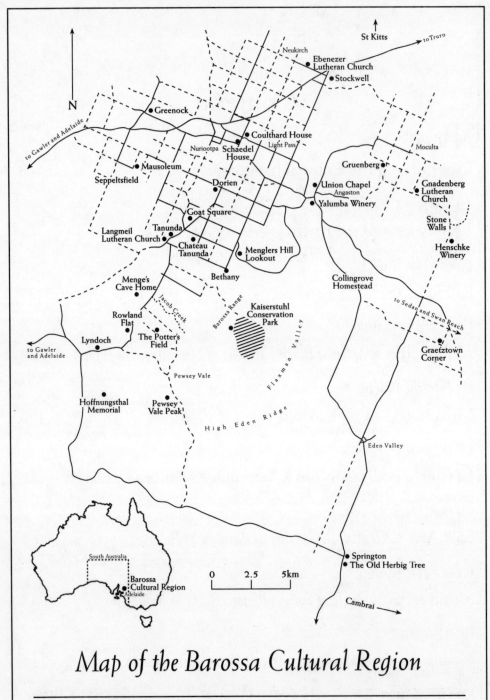

Map of the Barossa Cultural Region

Showing a selection of some of its many sites of heritage, lore and interest

Preface

Experiencing the Cultural Landscape

'... in order that we may understand the logic that lies behind the beautiful whole.'
W.G. Hoskins

My first trip to the Barossa Valley occurred in the winter of 1971 when I accompanied a newly-made friend on a visit to his family. Not only did our destination seem exotic, despite its proximity to Adelaide, but even my friend's Germanic name had a foreign ring to my ears. Setting out by car, our seventy-minute journey took us through the northern suburbs of Adelaide, followed by the monotonous bungalow housing of the satellite township of Elizabeth. Eventually we were driving through the Salisbury plains and wheatfields which surround the Victorian splendour of the country town of Gawler. Afterwards, the highway twists and turns as it enters the low hilly countryside to follow the contours of the southern reaches of the Barossa Valley.

As one approaches, the green-blue Barossa Ranges present a scenic backdrop to the amiable township of Lyndoch. It was then that a quaint, tumble-down settler's dwelling revealed the first hints of past European influence on the

landscape. However, it was not until some fifteen minutes later, after passing through stretches of undulating vineyards, and driving under the Orlando wine-advertising welcome archway leading into Tanunda, that I knew our journey had taken us to a place which was quite different.

Meeting the Barossa family was a new experience: the father was tall and dour; the mother ample and buxom and cosily domestic in the small kitchen of their 1920s bungalow where a wood-fired stove tantalised the air with an aromatic bounty. The afternoon tea of Bienenstich and other traditional German baked delights, was followed by a tour of their huge garden with its herbs, almond, fig, apricot and peach trees and grape vines, while down in the darkened coolness of the cellar its meatsafes were well stocked with pickled and preserved delights; the lilac and rose garden similarly reflected an Old World self-sufficiency. Then it was time for an excursion to view favourite places in the valley which, curiously, included a number of historic ceme-teries: it was a few years before I became fully aware of the Barossa folk custom of regularly visiting the latter.

This tour included a number of enchanting, out-of-the-way sites; I remember being especially impressed by the imposing Seppelt mausoleum, a neo-classical temple which tops a pine-shrouded knoll, itself surrounded by a unique landscape which blends Mediterranean date palms and pines with the ubiquitous gumtree. I was told, with some reverence, of the bodies of the Seppelt family of vignerons—including Joseph, the patriarch founder, and his son Benno—embalmed and interred within the mausoleum. At the other extreme of this ostentatious display we viewed the more humble, but just as fascinating, private cemetery of the Habermann family, a pocket hankerchief-sized burial ground of slate and marble tombstones surrounded by a lichen-covered stone wall. It is located just below Mengler Hill, yet high enough to command a breathtaking view across the valley floor.

Returning to Tanunda, the tour continued with a stroll through Goat Square and its surrounding quaint, high-peaked German cottages: this medieval scene contrasted to Seppeltsfield's neo-classical architecture. The final visit had been reserved for the old Langmeil cemetery where we stood before a modest, oak-carved, nineteenth-century slate gravestone sheltered by an imposing modernist granite centenary (1838–1938) arch. This was the memorial of

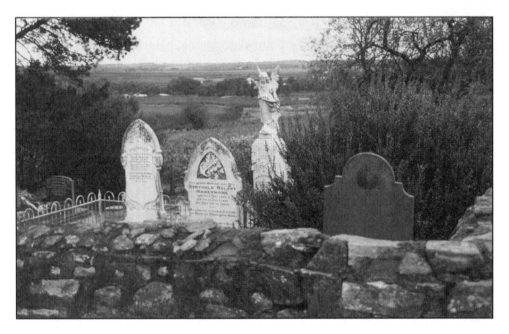

Pastor August Kavel, the revered leader of the refugee pioneer Lutherans who settled the valley.

It is only now, quite some years after my inaugural visit, that I realise the full import of these places and their weighty monuments, social markers of portentous events memorialising a people long past; Kavel's memorial, for example, symbolised the 'epicentre' of Barossa-Germanic culture. Yet to me, they are also points of enchantment in the Barossa landscape, anchoring a people to the land, testifying to the passage of long stretches of time, and pinpointing the seamless continuity of generations past with the living community.

One such marker includes the 150 year pioneer commemoration, memorial located at the look-out on Mengler Hill: its inscription and figurative bas-relief imagery impart a sense of momentous history. It stands above the

The Habermann and Mengler private family cemetery preserves some excellent examples of the stonemason's art in slate, sandstone and marble, all neatly bounded by its original stone wall. Following German tradition, most of the headstones are engraved in early Gothic text on both sides, while carved motifs symbolise various beliefs.

panorama of a valley of relatively modest dimensions – a narrow, vineyard-grid floor, the low Greenock Hills on the distant north-west horizon, with the townships of Tanunda and Nuriootpa punctuated by their church spires.

This was the first sampling of a place I was to visit on many occasions, for little did I know then that the Barossa region and its cultural heritage was to become my chief obsession. Over the following twenty-five years I made many more trips, travelling over its highways and by-ways as I explored and mapped its culture. Each visit revealed new places – even more cemeteries, wineries, churches, cottage ruins, and views. I gradually discovered that these and other sites were all suffused with their own intimate tales of the past, somehow linked through present lives.

On each excursion too, I was privileged to meet the 'Barossa folk', many of them descendants of the Lutheran pioneers, and some of British descent. Invariably, I found them all to be a calm, strong and kind folk, generous in sharing of reminiscences and stories of the valley.

Cultural Pioneers

Chief amongst the queries I wished to answer in my study of the place was the question: how did the Barossa come to be as it was? As we see it today, the contemporary cultural landscape and heritage of the Barossa region is the product of some 155 years of human endeavour and design applied to an ancient landform. Yet its origins may even be traced beyond this span of time, to its emergence following a catalytic series of historic events in the Old World, including wars, economic disruption and the inevitable social upheavals, which sparked the migration and arrival of Europeans in the hinterland of South Australia.

This is the locality of our interest, a place which first came to be called New Silesia and later, the Barossa Valley.

Strangers in a strange land, its cultural pioneers arrived on these distant shores and set to clearing the virgin forests, cultivating the earth, and constructing dwellings, villages and towns. In this manner they recreated a semblance of Old World village life according to European and, to a lesser degree, British values and traditions. The making of the Barossa's cultural landscape and heritage as we currently perceive it commenced in earnest, and continues to metamorphose to this day.

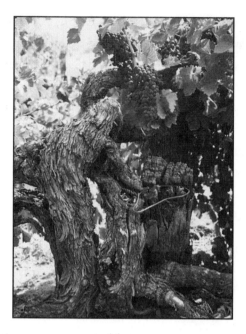

The grape vine is a key visual, historical and commercial element in the Barossa's cultural landscape. Modern viticultural practices have evolved from a blend of 150 years of British and German approaches with contemporary innovation to create the many premium wines of this region. The Barossa's vineyards of aged shiraz grape vines are especially valued.

At its core, we readily recognise its patchwork of vineyards, fields and farms, and its villages and towns with their steepled churches, tidy dwellings and coppiced carob or palm tree-lined roads. Beyond this immediate visual appeal exists another aspect of its cultural heritage, one replete with memory and rich in the stories of its making. Indeed, the Barossa region is a treasure trove of sites where place and story are inextricably fused by time. A perusal of its inspiring locales includes my personal favourites: the cliff-cave home and farm 'island' of the eccentric and legendary mineralogist and explorer Johannes Menge, set at the dramatic conjunction of two creeks, and now wildly over-grown with pine and olive trees; the old farm and vineyard where a venerable pepper tree drapes its fronds over the stone foundations of a potter's long-gone cottage, while worn potshards of his secretive craft lie scattered in a lone adjoining field; and the esteemed Hill of Grace vineyard which stretches across the foreground of a rural view punctuated by a stone-steepled church, the aged, gnarled shiraz grapevines still yielding precious drops of red liquid. These and many other cultural sites are dotted about the region, intermingling with the vineyards to create a seamless tapestry across the lie of the land.

Yet most travellers to the Barossa region simply manage to skim its surface, only a few venturing to partake further of its cultural bounty.

A Sensorial Journey

How does one undertake to discover Barossa's special sites, access its history and stories, and the richness of its traditions? Somehow, we must unravel the complex weave of history and culture which make up the sense of place that is so quintessentially 'Barossan'. We may readily identify the region's religious and domestic architecture; its townscapes; its industrial landscape; its cuisine; its viticulture and wines; its traditional decorative arts and crafts; its extraordinary tales; and its music and festivals. In short, unravelling the Barossa's folklife past and present.

A vernacular fusion of old and new world: a folk-carved date stone embellishes the entrance-way to these stables made from local materials of limestone, redgum and handmade sandstock bricks; old rusted iron ploughs weigh down the corrugated sheets.

On the basis of my study and experience of the place, I would suggest the following three approaches. First, the traveller could be intellectually fore-armed, so to speak, by becoming cognisant of the region's history on a broader level, and then, by accessing the stories linked to each place. Many of the stories recounted in this book have a locus or site which, in most instances, may be approached, seen, and even touched, and where the remains and markings of past human activities and endeavours have the potential to evoke their tales and enliven the senses.

This brings us to the second stage of discovery: through the act of searching out and visiting sites, viewing scenes, by strolling through villages and

townscapes, and entering churches and other buildings, and generally, by interacting with the landscape on a physical basis.

Finally, a sensorial journey can deepen our experience. This may be achieved through the engagement of our senses – by tasting local wines and dining on traditional foods, by listening to the region's music, and by joining in with the community during its celebrations and festivals.

Memory and Fragments: Cultural Icons

A word about the origin of the region's history and its stories. The narratives presented in this book, as any other history, were constructed from diverse archival and material fragments. I combined my personal, first-hand experiences in the field with gleanings from early newspaper accounts, researching church and other public documents, recordings of family oral lore, interviews with local inhabitants, and even transcriptions from gravestones. Especially important are the interpretations which emerged from my study of potshards, furniture, embroideries and other textiles, construction details of cottages, and other architectural structures. Indeed, any physical traces of materials preserved, identified and recovered from the Barossa region and its landscape have something to say of its past.

In particular, over five generations of Barossa craftsmen have left a unique cultural legacy, much of it as objects or places altered and fashioned by the human hand as directed by their society's cultural framework. The visitor is, in a number of instances, able to actually come into physical contact and interact with this tangible heritage. You may caress a dresser crafted by a local nineteenth-century Barossa cabinetmaker and smoothed by the hands of its previous owners, noting its consummate dovetail joins and elaborate moustache-crested tops; handle an embroidered cloth admiring the threads and quality of its maker's stitches, often spelling out catechisms extolling Lutheran virtues; explore a cottage constructed by its long-gone inhabitants; walk through its rooms and experience its domestic scale, the mind's eye conjuring up the flickering fires of family hearths; amble along a country track taking in the lie of the land, the postcard views of vineyards, church spires and dwellings; or wander through a cemetery of slate and marble gravestones; puzzle over inscriptions writ in Gothic text or ponder their symbolic, carved

motifs; then enter and sit on the worn pews of a church, listening to the rich notes of its ancient organ – music which has been heard by generations of worshippers.

Another window into the Barossa's history and making was provided through the eyes of its past artists. Any cultural landscape is the result of an interaction between what we perceive directly as physical experience and what is available through the perception and imagination of others. Artists, historians and writers who have themselves 'been there' and directly experienced the Barossa's visual panorama, its sights, sounds and tastes first hand, have also provided a record of their responses, filtered as they are through their personalities and the perspectives of their times. These experiences are made available to us through surviving paintings, sketches, books, and photographs, a selection of which is reproduced in this book. These 'frozen' moments or views of the past, of particular places and people, have each contributed towards this composite picture of the Barossa.

This is my personal experience of the Barossa, as a cultural landscape created from and steeped in a richness of traditions. The heritage, customs and practices of a particular people handed down from generation to generation, yet modified by the Australian setting – for traditions are rarely immutable. It is this creative process of modification into vernacular forms which, paradoxically, permits their survival.

Aside from a portrait of the Barossa's cultural landscape, readers will note that the idea of the 'vernacular', the *way* traditions have shaped its unique regional character, is a prominent theme which emerges in this book. The gradual blending of homeland Prussian and British cultural traditions and practices with the influences of the Australian setting over time have produced local Barossan forms – that is, 'Barossa vernacular'. Examples of these may be found in the peculiar 'Barossa Deutsch' speech, the region's unique folk art, its wines, and its distinctive architecture.

Mapping the Barossa Cultural Region

The Barossa region takes in those surrounding environs which have been settled by German Lutherans in the past, and which, therefore, have extended the influences of the traditional cultural practices of these people beyond the

valley itself. This defines a 'Barossa cultural region'. Hence, the high plateau country to the east of the escarpment of the Barossa Valley as formed by the Barossa Ranges (which gave the valley its name), and which takes in Flaxman Valley, Eden Valley, Keyneton, Springton; and the low country immediately to the east where the plateau drops steeply to the the beginning of the dry Murray Flats, taking in the villages of Sedan and Cambrai. To the west of the Barossa Valley we may include the mixed British–German township of Freeling; the farming centres of St Kitts and Dutton in the low hills to the north; while the southern boundary of the Barossa cultural region can be circumscribed as extending beyond Lyndoch towards Williamstown.

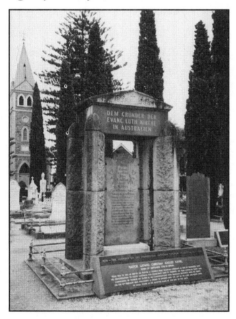

Langmeil Church gravestone and 1938, centenary granite memorial to Pastor August Kavel, proclaiming him as founder of the Evangelical Lutheran Church in Australia. This site symbolically marks the epicentre of Barossa-Lutheran history and culture.

Readers whose appetites are whetted by the cultural sampling this book offers, and who wish to find out more about the Barossa region and its heritage, will discover, at the end of the book, a select bibliography which will direct them into various specialty areas.

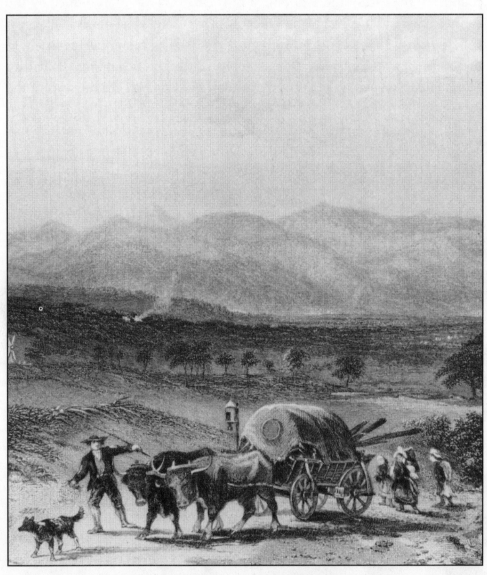

A German family on route to the Barossa
Valley in about 1845, is pictured entering
its southern approach through the
Lyndoch Valley. In the background
are the Barossa Ranges, somewhat
exaggerated in height in this lithograph
by S. Prout.

The Making of the Barossa

Creating New Silesia

'... persecuted Christians seeking refuge amongst the wilds ...'
George Fife Angas

Take a stroll down the main street of Tanunda, observe its gnarled trunks and darkly-dense canopies of coppiced carob trees, the tidy gardens of roses and lilacs, take in the smell of freshly baked bread, and note the four Lutheran churches with their consummate stonework and distinctive spires. Now wander into the rural setting of Bethany where vineyards stretch back from quaint cottages of high-pitched gabled roofs, and the solitude of the pioneer cemetery with its serried headstones carved in German Gothic script – all set against the backdrop of the wooded slopes and the twin peaks of Kaiserstuhl.

Find your way to the southern entrance of the valley, just beyond Lyndoch to the ring of low-peaked hills that form the Hoffnungsthal lagoon, a place where the scant remains of a pioneers' village evoke the echoes of long-past human dramas within the pastoral solitude.

Or else journey to the northern plains of the Barossa, to Light Pass where

the twin spires of its two neighbouring churches add a vertical line to flat vine-yards. Stroll through their windswept cemeteries, note the inscribed names on the gravestone of Karl Launer the village's long-dead master cabinetmaker, and that of Julius Rechner, teacher then pastor of the break-away church. Then wander across the road and inspect the 1850s school house with its large lithograph of Martin Luther casting a stern eye over the tiny desks still littered with primers in German text. Alongside is a tiny cottage where the area's first local school teacher Johann Luhrs lived, a quaint clutter of Victorian furnishings and embroidered Germanic catechisms.

These are but a small handful of the many places and features of the Barossa region which identify it as a unique place, one which has no equal in Australia, or for that matter, anywhere else in the world. The combination of a particular terrain, the pattern of vineyards and wineries, and the scatter of villages and townships indicated by church spires which signal the faith and European origins of its founders, constitutes the cultural landscape of the Barossa. It is the sum total of all of these natural and man-made elements, historic and con-temporary, which give the setting its distinctive identity.

Just as we often describe wines as having an intense regional character, so too we may attribute this intensity to other areas: to a region's particular community, its decorative arts, architecture, cuisine, and so on. And while we derive an understanding of the Barossa's make-up by mapping these and its other traits, we remain aware that its regional personality is immeasurably more than the sum of its parts.

The Dreamtime Landscape

On first impression the 155 or so years of history since the settlement of the region by Europeans would seem trivial compared to the long centuries of the recorded history of the Old World. Yet the cultural landscape of the Barossa Valley is inextricably linked in seamless continuity to its faraway origins on the other side of the world, and to events which unfolded over a period of many years.

Prior to delving into these beginnings, there is another epoch, before the coming of the Europeans, which existed for thousands of years. This was the Dreamtime, as its original inhabitants, the Aborigines, called it.

Their impact was less intrusive than that of the European's: the Aborigines had an intimate relationship with their natural environment which included regular setting of fires to burn and reduce undergrowth shrubs, hence encouraging fresh growth which attracted kangaroos and the other animals they hunted. Colonel William Light, South Australia's Surveyor General, was among the first of the European explorers who observed an open parklike region. Light wrote in his diary: 'The greater portion of this country is covered with kangaroo grass and its general appearance open with here and there some patches of wood'. Others noted that it was 'in a great measure unencumbered with trees ... [and] ready for the plough'. There was no indication that there was any awareness at the time that what they saw was not entirely natural, but that it was a setting altered by man: it was an Aboriginal cultural landscape.

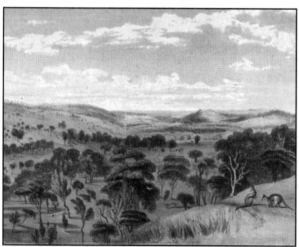

The Barossa Valley's original landscape, created by Aboriginal firestick practices, consisted of a parkland setting of gumtrees interspersed with kangaroo grass, with dense woodland covering the hills. J. Giles lithographer after George French Angas, *On the Barossa surveys, looking north towards German Pass*. Plate from *South Australia Illustrated*, 1846–1847 (private collection).

Aside from their firestick strategy, the two Aboriginal tribes of the Barossa, the Peramangk and the Ngadjuri, had further, though minor, impact through their other cultural activities: they cleared small areas of ground for their camp sites and rings of hearth stones; they scarred large gumtrees through the removal of bark for making canoes, or else hollowed these out to make shelters; they harvested various bush foods from the native plants; they gathered plant material to weave baskets; and they worked stones to make various implements and weapons. They also engraved and painted symbolic images on the inner surfaces of rock caves in the region (one example is located in the Kaiserstuhl Conservation Park).

The European and British pioneers of the Barossa commented on how sparse the population of Aborigines was at the time of early settlement in the region. Johannes Menge encountered these people on a number of occasions during his explorations of the region in 1838, and the colonial Protector of Aborigines reported in 1844 that at Lyndoch valley 'there were several tribes located during the harvest, who assisted Mr Emmett in cutting nearly 200 acres of wheat.' Whatever the population of the two main tribes, agricultural and pastoral activities quickly disrupted the Aborigines' traditional social structures and lifestyle, as well as their culture, gradually forcing most of them to quit the region within the first decade, while newly-introduced infectious diseases from the Old World also took their toll.

Aside from the preceding evidence of cultural activities such as the odd fire-scarred gumtree, remaining signs of Aboriginal culture in the Barossa Valley itself are rare, their stone tools and camp sites ploughed under the fields and vineyards of the valley floor – although some sites in the adjoining ranges have been preserved.

More particularly, the Aboriginal past is memorialised in the retention by the European settlers of some of their traditional place names – such as Nuriootpa which was derived from the original Aboriginal word 'Nguriatpa' meaning 'neck of a giant' – still have the power to evoke the ancient cultural landscape of its original inhabitants. Other lingering Aboriginal place names in the Barossa include: Moculta, for 'large hill'; Bilyara for 'eaglehawk'; Moorooroo for 'meeting of the waters'; and Tanunda, for 'waterhole'.

Cultural Blueprints from the Old World

At its most basic, an explanation of how the Barossa region, once 'a wilderness', came to be as we see it today, begins with the arrival of another group of people, the 'persecuted Christians', a group who held strongly to a particular set of cultural blueprints. They included European craftsmen skilled in the manipulation of stone, wood, iron and clay; farmers who cleared and cultivated the earth and introduced exotic plants; and Lutheran pastors and elders leading a community with pre-determined ideas and values. Also involved were settlers of British origin with their own aspirations and values. All had their influence in altering the natural – and Aboriginal – landscape.

Cultural practices and customs, that is, particular ways of doing things, lead to particular forms: in the way settlement occurs, how the landscape is gradually altered, and in the appearance of buildings and other artefacts. These central Europeans, specifically protestant Prussians later known as Germans, who came to the Barossa, stamped their template firmly and very clearly, more so than their fellow countrymen anywhere else in Australia. Indeed, of all of the German-settled regions of Australia, conditions for the prolonged survival of central-European culture were most successfully met in the Barossa Valley and its surrounds.

Here, in the strange setting in which they found themselves, these Lutheran immigrants held tightly to their old ways, insular in the tight clusters of villages and townships they had established and reassuringly named after their distant homes: Neu Mecklenburg, Langmeil, Gruenberg, Schreiberau, Siegersdorf; or from Biblical place names: Bethanien ('place of dates'), Bethel ('the House of God'); or in reference to their newfound freedom to practice their faith as they saw fit: Gnadenfrei (freed by the grace of God), Ebenezer ('Hitherto hath the Lord helped us'), Neukirch (new church), Hoffnungsthal (Valley of Hope).

A considerable degree of physical isolation from the larger British settlements, in combination with the establishment of close-knit Lutheran communities and a naturally conservative attitude, nurtured cultural traditions in farming, architecture, folk arts and crafts, foodways and village folklife generally. Indeed, it was the direct transplantation of a nucleus of central-European village folk life with its associated customs and values which indelibly stamped the character of these people on the Australian setting of the Barossa.

The layout of villages and townships, the preferred architectural styles, the specific designs for furnishings, their approach to worship, and other details of daily life, were decreed according to the patterns and prototypes of the Prussians transferred to the frontier wilderness of South Australia. Even today, we may see relics or echoes of these early Prussian models in the surviving culture of the Barossa region: the frontier-village layout of Bethany, the medieval layout of Goat Square in Tanunda, in surviving *Fachwerk* cottages, the style of inscribed gravestones, in the character of its cuisine, and in the persistence of its social customs and festivals.

Underlying and driving the urge to establish the Old World's traditional

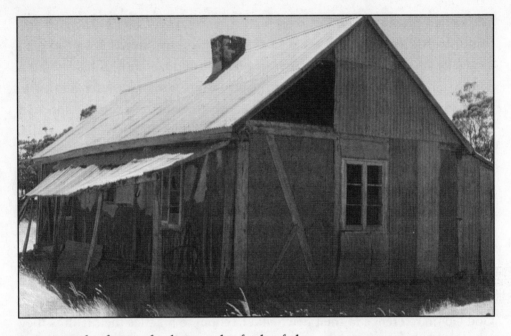

ways was the force of religion; the faith of the pioneer Lutherans included an inherent understanding of rational principles articulated as a sense of order and this, in turn, reflected the inherent order of God's cosmos. The latter may be detected in a multitude of structures and signs which overlay the landscape: in the symbols favoured by the early Lutherans such as the star, the wheel of the sun, and particularly, in the anchor and cross; in the solidity and distinctive style of their crafted works of stone, clay and timber; and in the emphatic symmetry of their Lutheran churches.

The combined institutions of the Lutheran Church – its pastors, schools, newspapers, and communal organisations – directly determined the pattern of settlement and traditional folk-life established in the Barossa Valley. Quite literally, they wished '... to preserve their own

Fachwerk or half-timbered farmhouse, Ebenezer, built c. 1855. Redgum frames with wattle and daub panels; iron sheeting has been recently used to protect the walls. Once common in the region, only a handful of such dwellings still stand.

customs and traditions and to maintain their ancient German way of life'. They ensured that this process of cultural transplantation was firm and, at first, relatively unaltered from the original model. Today, the historic and present-day cultural landscape is the result of this force interacting with the pre-colonisation setting.

Their traditional rites, customs, routines, technical know-how, and practices not only shaped their surrounds, but the environment, in turn, shaped them as they struggled to survive in the alien setting. Thus the traditional Prussian ways were at first applied to the wilderness in direct mimicry of their practice in their homeland, forcibly modified and adapted according to the logical dictates of the social and physical setting of the Barossa.

From this interaction of tradition and environment, over a period of many decades, there eventually emerged the present-day appearance of the place, as well as its customs, lore and legends.

Barossa Vernacular

While traditional Barossa folk culture was long-standing, having been present from the 1840s following settlement by Prussians, it was not immune to change; its expression in the cultural landscape as we observe it today, has evolved over many decades.

Significantly, the inherent vitality of Barossa folk culture has led to its survival – albeit in altered forms – through a process of gradual adaptation. Over the years, homeland Prussian cultural traditions blended with local influences to produce vernacular forms, identifiable or unique to the Barossa. In this process, for example, a dialect of the German language became a manner of speech known as 'Barossa Deutsch'; Prussian furniture traditions changed into a distinctive Barossa Biedermeier style; early European architectural styles absorbed Australian vernacular forms and elements; and traditional foods took in British and other influences to develop into a regional cuisine.

The reader will discover that many of these Barossa vernacular cultural expressions may be specifically traced to Silesian roots. This is not surprising given that, in its earliest years, the Barossa was originally known as 'New Silesia'. Over a third of its founding migrants hailed from the province of Silesia, as well as from the south-east corner of Brandenburg which was itself

once a part of that Prussian state, areas now overlapping the modern Polish–German border. For this reason, the traditions which were part of the cultural baggage of this particular group of migrants conferred the strong Silesian flavour still detectable in the Barossa of today.

Origins: Chief Players and a Cast of Migrants

The story of the Barossa Valley begins beyond the shores of Australia, on the other side of the world in central Europe. Without venturing too deeply into the past, we may pin-point one incident in particular as instrumental in triggering the chain of events which led to the settlement and creation, of the Barossa. That event was the issue of a decree by a king.

Prominent among Prussian social and political circumstances at the end of the Napoleonic Wars was the situation of a royal family long converted to Calvinism and ruling over subjects the greater majority of whom remained steadfastly Lutheran. Desiring to bridge this religious division and engender national unity at a time when the three-hundredth anniversary of the Reformation was looming, King Friedrich Wilhelm III of Prussia considered it timely to take steps to address the situation. In 1817 he issued a decree as the first step towards the union of the Reformed Calvinist with the Lutheran faith. While a majority of his Lutheran subjects accepted this decision for unification, the king had underestimated the strict orthodoxy or fundamentalist world-view held by a stubborn minority who, as a consequence, came to be known as Old Lutherans. Prussian society had always included in its make-up the peasant population of the countryside, staid people who lived in villages and smaller towns, and who were imbued with a powerful, unwavering faith. Quite simply, it was against their conscience to obey the whims of a king above the words of their Saviour. Their beliefs in preserving the doctrinal purity of the Lutheran Confessions, forced the Old Lutherans to take an oppositional stance, albeit with some reluctance, against their king.

Over the following years, their resistance eventually led the king to respond by issuing another decree in 1830, as well as orders designed to enforce his desires. There followed a period of brutal oppression and religious persecution by Prussian authorities who closed churches and fined congregations for attempting to conduct home services and use lay preachers. These decrees and

their associated actions became the main reason which initiated the migration of the first groups of Lutherans to Australia some eight years later.

The involvement of a handful of dissenting Lutheran pastors, notably August Ludwig Kavel and Gotthard Daniel Fritzsche – who both believed that Luther's translation of the Bible into German was an act inspired by God – mobilised and provided leadership for dissenting peasants; this eventually led to the fateful decision by whole village communities to quit their homeland. In particular, it was the Old Lutherans, the minority group which rigidly refused to conform, who eventually migrated to South Australia (and to North America) in search of freedom to practise their religious beliefs. These people, about 8 000, were not voluntary migrants, but a religious group who were forced into exile, pushed out of their cherished homeland, rather than pulled to the countries of the new world – North America and Australia (which received about 1 500).

These migrant Prussians were also mostly farmers and artisans of peasant stock, people of 'small means' who, in the process of migration, had to sell their small land holdings, if they had any, as well as their humble cottages and furnishings. However, they were also a people united, aside from their religious beliefs, by deep historical, cultural and communal bonds. This background and make-up, as well as the alienating experience of persecution and migration which they shared, explains their determined efforts to remain as a group, and re-establish the communal organisations, institutions, villages, occupations, kinship networks and generally, their social, religious and cultural practices, in South Australia, their 'New Silesia' – the Barossa Valley.

Aside from the King of Prussia, there were other key players who had their parts in the events leading to migration. August Kavel, the appointed pastor for the parish of Klemzig and its surrounding villages, especially played a pivotal role in the early migrations. Born in 1798, the austere Kavel was destined to become the spiritual leader of the first group of Lutherans to emigrate in the quest for religious freedom. His appointment to the parish in 1826, led to what has been called a 'revival of religion' in the region. There is some irony in the fact that Kavel was initially a supporter of the proposed union, but in 1835 reversed his stand to become one of its chief opponents. Dismissed from his pastorate because of his active resistance to the decree, he first sought to

emigrate, together with a large group of followers, first to Russia, and later, to North America. In the course of events, money for migration to the latter place could not be found. Eventually, Kavel made his way to London where, in 1836, he met George Fife Angas.

This wealthy businessman, philanthropist, and prominent evangelical Baptist was the next key figure to catalyse and influence the impending migration. Born in 1789, George Fife Angas assisted the operations of his father's extensive business as a shipowner and coach-maker. As a dissenter himself, Angas was sympathetic to the plight of the persecuted Lutherans. At the time of meeting Kavel, he had just formed the South Australian Company as a means of facilitating the free British colony of South Australia, which had itself just been officially announced. The act which led to the establishment of the Province of South Australia (as it was known), included the provision that, unlike previous Australian colonies, convicts were not permitted, as well as an innovative land pricing system. Besides his genuine inclinations to assist these people, Angas was also shrewd enough to realise that Kavel's peasant Lutherans, with their skills as farmers and craftsmen, would make admirable and productive settlers on the lands under the control of his company.

Angas provided a personal loan of 8 000 pounds sterling to assist the passage of Kavel's Germans to Australia. In later years, George Fife Angas was to benefit enormously from this decision and, in 1851, himself migrated to the

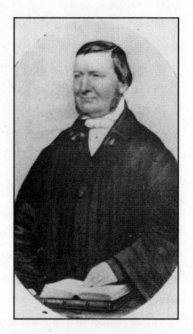

Pastor August Ludwig Christian Kavel (1798–1860)

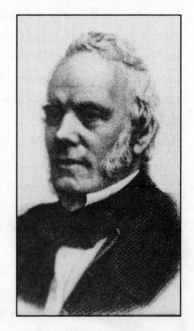

George Fife Angas (1789–1879)

colony to live in the Barossa Valley where he could see the results of his assistance first hand. It is also worth noting at this point that one of his two sons, George French Angas, was one of the chief artists who recorded early scenes of colonisation of the Barossa, and hence, in this way, gave us a means of viewing the cultural landscape of the region – in the making.

After a spell of further provocation and obstructive actions by the Prussian authorities, as well as petitions of entreaty to the king from Kavel, permission to migrate was finally given on 8 June 1838. The Old Lutherans first had to undertake a journey to the seaport of Hamburg, and on 31 July, the first group of about 200 sailed up the River Elbe on barges in a joyful mood which they expressed by singing hymns as they passed through villages. From Hamburg they sailed to England where Kavel joined them, finally setting out on the *Prince George* for the long journey to South Australia. They landed at Port Adelaide on 20 November that year, while two other groups arrived in two other vessels over the following two months.

The majority of the first groups of Lutherans to migrate to South Australia came from a region comprising the adjoining areas of the Prussian provinces of Posen, Brandenburg and Silesia, located about the upper valley of the Oder River. It had been in these areas that dissent against the king's decrees had been the strongest.

Around the time of their departure George Fife Angas wrote (on 23 July 1838), to Governor John Hindmarsh in South Australia, informing him that 'The *Prince George* is the first of three, if not four, ships that are proceeding from Hamburg to South Australia with emigrants from Silesia … As far as we have seen and know of them, they appear to be a body of men in every respect likely to prove a blessing to the new Colony … I am under the necessity of drawing your Excellency's kind attention to them not as Englishmen nor as Germans, but as persecuted Christians seeking refuge amongst the wilds, as our Pilgrim Fathers did …'

'The Garden of the Lord'

The Province of South Australia had been settled for only two-and-a-half years at the time of the arrival of these Prussian refugees. Comprising a single frontier settlement, Adelaide had a bedraggled appearance, for many of its

inhabitants were then living in a collection of mostly 'wood and clay' cottages set on the dusty plains half-way between the coast and the blue-green Mount Lofty Ranges. And in contrast to the disciplined, organised behaviour of the staid migrant Prussians, the entirely (non-convict) British population of Adelaide – brickmakers, other craftsmen, various tradespeople and settlers – was relatively disorderly and more interested in land speculation than in establishing a colony. This chaotic setting strengthened Kavel's view that his people, who at that time comprised some 10 per cent of the colony's population, should not reside among the British settlers, but should establish their own, independent communities where Lutheran faith and culture would be preserved. Accordingly, following negotiations, land (owned by Angas) on which to settle the Prussian migrants, was selected six kilometres upriver from Adelaide.

Here, on the red banks of the Torrens River, surrounded by the unfamiliar eucalyptus and acacia woodland, this first group of Lutheran refugees immediately set out to re-create a copy of a Prussian agricultural settlement which they named after Kavel's home village of Klemzig ('The Garden of the Lord'). Contemporary visitors wrote that it

> resembled a piece of the old country scooped out and conveyed across the ocean, and inserted in the soil of the new colony … It extended along the bank of the river for perhaps a third of a mile. The buildings consisted of earthen walls, newly-whitewashed, and straw-thatched roofs … About the centre of the village we felt as if we were in Germany instead of Australia.

Another description further describes how the land was 'divided into 4 to 5 acre strips … the long line of houses with their gables fronting onto the street … provided a peaceful sight and it was like part of the old home-country appearing there'.

In their newly-founded settlement of Klemzig, the Old Lutherans felled trees and cultivated vegetables and other crops on the alluvial soil, becoming the colony's first farmers. There was some necessity for their haste for, having borrowed heavily from Angas, they needed to begin repaying their debts to him as soon as possible. While the men worked at this heavy labour, the women took it upon themselves to walk the six kilometres into Adelaide, wearing their traditional clothes and white linen field bonnets, to sell their

vegetables – at quite high prices – given the lack of any fresh food in the British colony. Meanwhile, of the other Lutheran groups which arrived shortly after the first, one established another Prussian-style village, named Hahndorf, deep in the ranges.

It was not until some four years later in 1842, that the Barossa Valley would become the final place of settlement of the 'Klemzigers' and subsequent arrivals of Prussian migrants.

New Silesia and the Eccentric Mineralogist Menge

As noted earlier, the Barossa Valley had been first explored by Colonel William Light, Surveyor General of South Australia and founder of Adelaide, in late 1837, and again in early 1839. He named the region 'Barrosa' after the site where a British victory was won over the French during the 1811 Peninsular War in Spain. 'Barrosa' is Spanish for 'hill of red soil or mud' (most definitely *not* 'hill of roses' as has often been erroneously claimed). Its early misspelling of 'Barossa', has been retained. Over the years it has come to evoke an identifiable Australian-Germanic intonation.

However, credit for the full exploration of the region and its assessment as a location suitable for the eventual settlement of the German refugees belongs to one of the most eccentric, and endearing, characters of South Australia's history, Johannes Menge.

Menge was certainly the most colourful of the central group of players which included the King of Prussia, Pastor August Kavel and the philanthropist George Fife Angas, who had a key influence on the settlement of the Barossa by Germans.

Menge was born in January 1788 in Steinau, Hessen. A gifted child (the ninth in a family of ten), he followed his schooling with training in geology, later working for a scientist in a private 'mineralogical bureau'. He married in 1819, travelled extensively about Europe, Russia and Iceland, becoming a self-styled 'professor of mineralogy'. His ideas and philosophy were unusual, being based on a desire to link geological science with the Biblical narrative of creation, a subject he wrote on and published. He was also knowledgeable in medicine, religion, as well as being a noted linguist in Chinese, Persian, Arabic, Hebrew, Latin and Greek!

Following the untimely death of his wife in 1826, Menge eventually left Germany for London where he gave private lessons in a number of languages; it was during this sojourn that he fortuitously met Pastor Kavel and subsequently, George Fife Angas. The latter, impressed by his faith, learning and experiences in mineralogy, employed him as a geologist with the newly-established South Australian Company. His brief was to explore the 'natural productions' of the colony, 'above and below ground'.

Menge soon departed England, arriving in South Australia in January 1837, and immediately set to exploring Kangaroo Island and then the mainland. His sharp mind, eccentricity and fearless explorative spirit, led Menge to become a popular and prominent colonist within months of his arrival. However, his independence and idiosynchratic manners exasperated the staid and eminently British persona of David McLaren, then the manager of the Company. He found Menge's personality and habits too bizarre – and even 'nasty' – for his tastes. In mid-1838, although dismissed from his employment with the Company, Menge's services were retained by Angas on a personal basis and he continued his forays and explorations of the northern Mount Lofty Ranges about the Barossa region.

In March 1839, following his exploration of the Barossa Valley, Menge was quick to realise its mineralogical, viticultural and agricultural potential and, writing to Angas in London, he enthusiastically described the region as 'the Cream, the whole Cream and nothing but the Cream of South Australia ...'.

In late 1839, Menge decided to settle for a spell in the Barossa Valley, selecting a site on the banks of Moorooroo (Jacob) Creek where it joins the North Para River. He built a half-cave, half-hut dwelling, before diverting (with the help of a band of labourers) the creek's water around a few acres of ground, to create what he called 'Menge's Island'. Here, he planted and experimented with the cultivation of various crops. He also used the site as a base from which to further explore the region, discovering in the nearby hills clays and forests of timber, natural resources which he described and published in the local Adelaide press, and which were later to be exploited by German potters, cabinetmakers and other craftsmen (see Chapter 6).

Menge's 'cave' home at Jacob Creek was described as often surrounded by sacks containing numerous mineral samples which he had gathered with his

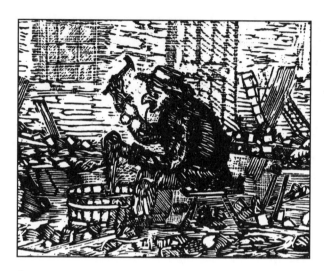

The eccentric and visionary Johannes Menge (1788–1852) cleaning minerals alongside his cliff-cave home on the banks of Jacob Creek. His explorations led to the settlement of Prussians in the Barossa – and to the eventual establishment of viticultural and mining activities there.

'hammer' during his 'ramblings', as he called them, about the Barossa ranges and beyond. Menge would clean and sort his samples, selling bagged collections to Adelaide's British entrepreneurs, and even, to 'supply the cabinets of such colonists as desire to possess similar specimens, on the most reasonable of terms'.

Most of our detailed information about Menge in South Australia comes from his own letters to George Fife Angas, from Menge's own reports published in the early Barossa and Adelaide press, and from the observations of the colonial author and contemporary biographer William Cawthorne, who said of Menge: 'He was highly social in his queer ways, very fond of punning, and startling everybody with out-of-the-way sayings'. Add to this Menge's singular appearance which Cawthorne described vividly as: '... a living, walking caricature of the prevailing fashion of the day ... a face ludicrously grotesque, the great antitype of the immortal Punch, with an enormous pipe in his mouth, his mind wandering far upon the hills of his love ... and eyes that never ceased twinkling ...'

Others also took delight in describing and lampooning this singular personality, this 'strange old Teuton geologist from the Harz Mountains', as Thomas writing in *Family Life in South Australia* published in 1890 described him adding: 'Cold water, soap, tooth brushes, and clean linen were evidently regarded by him as unnecessary luxuries for a new colonist to indulge in, though his qualifications as a "sponge" were of no mean order. In fact, his

self-invitation to dinner became unpleasantly frequent ... But with all his peculiarities ... he was a remarkable linguist, being acquainted with upwards of twenty languages'.

Menge prophesied the growing of '... vineyards and orchards and immense fields of corn throughout all new Silesia ...' His reference to the Barossa Valley as 'New Silesia' (*Neu-Schlesien*), anticipated its settlement by Germans who included a large number from Silesia: about 40 per cent of Fritzsche's followers were Silesian. Kavel's people had also come from both Brandenburg and Silesia, the south-east corner of the former state having once been a part of Silesia. In the following years, most of the migrants originating from this south-east area of Germany settled in the Barossa Valley, hence the strong Silesian flavour it eventually developed and has retained to this day.

Meanwhile, in a story of some intrigue too long to be recounted here, Angas's agent in the colony, Charles Flaxman, on being informed of the richness of the country by Menge, quickly purchased the lion's share of the seven 'Special Surveys' of 28 000 acres, on his employer's behalf – and almost to his financial ruin! Menge and Kavel were also then participating in discussions regarding the suitability of re-settling the Klemzig Germans to the Barossa Valley.

On 28 October 1841, the sense of urgency to find suitable land for these migrants was further heightened by the arrival of another group of some 213 Lutheran refugees from Posen and Silesia, this time led by Pastor Fritzsche. In order to prevent the dilution of what was seen as the communal and religious bonds which had motivated their migration in the first place, Pastors Kavel and Fritzsche agreed on the necessity of settling the migrants in a location isolated from the main British settlement of Adelaide.

Accordingly, in early 1842, some 115 individuals set out and eventually arrived in *Neu-Schlesien*, as they were then also referring to the Barossa Valley, founding Bethany (originally named Bethanien), the first of a group of self-reliant German villages to be established in the region over the 1840s and early 1850s. The second German village, Langmeil, was established slightly north of Bethany later that year. Located some 60 kilometres north of Adelaide, on the frontier wilderness of the Barossa Valley, Bethany and Langmeil were suitably isolated from the 'corrupting' influences of the British.

These German pioneers encountered, as noted earlier, a natural landscape modified somewhat by the now receding Aboriginal inhabitants. Some 60 kilometres north-east of Adelaide, the Barossa Valley consists of a broad and shallow basin-shaped valley formed by the Barossa Range (the northern extension of the Mount Lofty Ranges), which itself defines the eastern boundary. The highest points of this range, Kaiserstuhl (its literal translation is King's Seat) and Pewsey Peak, rise steeply to dominate the valley floor. About 20 kilometres long and 14 kilometres wide, this shallow valley base is orientated north-south. The north portion of the valley consists of the Tanunda–Nuriootpa plains, while the southern end is of undulating land through which the North Para River carves its course. The western boundary is formed by the low relief of the Greenock Hills.

The pioneer Prussians encountered a landscape which appeared strange to their eyes: in the Barossa Valley they found an open woodland of eucalyptus (gumtrees), interspersed with tussocks of kangaroo grass, while a dense woodland scrub covered the hills. They considered this to be a resource which was to be utilised as they progressively cleared the distinctive sclerophyllous vegetation, replacing it with familiar European crops, trees and grasses. The Mediterranean climate of mild and wet winters, and hot, dry summers, the reversal of the seasons, and the unfamiliar vegetation, were quite different to the central-eastern European environment to which the Silesian Germans had been accustomed: in their homeland, the country between the River Oder and River Bober consisted of undulating pine forest with some grazing and farming land. Hot summers and very cold winters, with rivers and lakes freezing, characterises this east-central European region. Much of the settlers' adaptation to the new Australian environment therefore necessitated a trial-and-error approach, for both craftsman and farmer. The undulating slopes of the valley eventually allowed cultivation to extend from the valley floor over the lowlands, hills and high plateau country.

Taking the road from Adelaide, one leaves behind subdued plains to encounter the landscape of the southern entrance of the Barossa Valley, one of steep slopes and small valleys dissected by streams, features which acted as a barrier during its early settlement.

The founding of self-sufficient Barossa settlements by these refugees with

common origins, kinship ties and a strong cultural identity, favoured the re-establishment of their homeland village life. In this way, Prussian rural folk-life with its age-old order of churches, synods, elders' councils and schools, traditional agricultural-artisan basis, and its distinctive Lutheran material culture, was gradually and faithfully re-created in the frontier wilderness of the Barossa. As individuals and as a group, they were cultural pioneers.

Over the years the industry, thrift and piety of the German refugee in the Barossa became renowned. Their hardworking habits were repeatedly praised by contemporary observers. 'It was an inspiring sight to watch them at work at Bethany on their farmlets, men, women, and children, as busy as bees ... the women are a particularly fine type. They not only keep their modest homes neat and clean, prepare the meals and look after the children, but they also work in the field with the industry and energy of men'.

The women folk were also noted for their ability to work at hard labour and, having acted as shepherdesses in their Silesian homeland 'proved to be almost, if not absolutely, the sole persons who could be relied upon to perform the shearing and make the merino wool in proper style for market'. Of course, besides their natural inclination towards industry, another good reason to work hard was the destitute economic condition of the Prussian migrants on their arrival, and their obligation not only to pay back the loans borrowed from George Fife Angas for their passage to South Australia, but also the funds borrowed for provisions and the rental of his lands. And George Fife Angas, despite his philanthropic beliefs, was the thorough Scotsman in expecting a repayment of interest as well as the principal sum loaned in the first place!

Indeed, during the 1840s and early 1850s, years when the British settlers were sidetracked with land speculation in Adelaide or rushing off to the Victorian goldfields to seek their fortunes, the industry of the Prussian migrants, not to mention their willingness to be the first to venture into the frontier wilderness of the province to clear land, open it up for agricultural pursuits and to estab-lish permanent settlements, gave the fledgling colony a core of stability.

The skills of their artisans, together with the diligence of their farmers in making the land productive, permitted these village communities to be rela-tively independent of the mainstream British settlements. Surrounded by a scatter of Prussian frontier-style farmlet-villages including Langmeil, Bethany,

Rowland Flat, Rosedale (Rosenthal) and further afield, Light Pass, Ebenezer, and Moculta, and located in the approximate centre of the valley – it was Tanunda that soon emerged as the heart of Germanic religious, intellectual and commercial activity in the Barossa.

Meanwhile, in Prussia, although persecution of the Old Lutherans began to diminish following the death of Friedrich Wilhelm III in 1840, pressure to conform continued to be exerted upon them until about 1846. Crop failures, political unrest, industrialisation, the military draft, and population growth became the more urgent factors which maintained migration from Prussia between the mid to late 1840s. This flow was further encouraged by those migrants already in Australia who sent letters to relatives and friends describing the new country in glowing terms.

By 1900, a total of some 18 000 German migrants had arrived in South Australia, of which about two-thirds chose to settle in the German areas of the Barossa and the Adelaide Hills. Of these, only some five per cent had migrated for reasons of religious persecution, while the remainder had come to escape social unrest and economic difficulties, and generally, to 'better' themselves.

By 1848, one German settler wrote back to his home stating, with perhaps just a little exaggeration:

South Australia is indeed a paradise for the independent farmer, for the smith, wheelwright, saddler, carpenter, cobbler, tailor, potter, mason; for builders, millers, shepherds, tanners, painters, miners, butchers, locksmiths, turners, linen weavers, gardeners, coopers, labourers. Almost all the Germans to whom I have spoken, and these are very many … consider themselves to be in a worry-free position …

Religion, Language and the Post War Period

While George Fife Angas's tolerance eventually fostered a multi-denominational Barossa, the region still remains essentially Lutheran. Ignoring this fact would detract from an understanding of its present character for, from its settlement through to the early twentieth century, Barossa-German culture was dominated by a pietist spirit. It was on this basis that community life in the Barossa was established – with the Lutheran faith as its cornerstone. The

Lutheran Church was therefore intricately associated with many aspects of daily life, but especially the life events of birth, marriage and death; community events of baptism, confirmation and Holy Communion; and generally, the life of Christ as embodied in the church year. This engendered a shared experience for both individuals and families within the context of a Christian community creating a 'faith-history' of these communities, one still strongly retained to this day.

As a consequence of this deeply-instilled sense of sharing, the concept of 'community' was never taken lightly in the Barossa. During the Second World War and the immediate post-war period, the enthusiasm and practical actions of the Nuriootpa community received national attention and acclaim as an inspiring model.

With the Lutheran Church underpinning most aspects of early life in the scattering of German village settlements about the Barossa – including its various material culture traditions – the well-being of the community and the daily routine of its members were naturally intricately bound to its unity. Congregational church meetings were a regular occurrence within the early Lutheran communities, where religious, family and individual matters were aired and discussed. Nevertheless, schisms in the Lutheran Church led to splits in a number of the early congregations (there were 6 in the first 60 years), hence creating some discord and confusion – and further enclosed communities. This is well illustrated in the story of the Light Pass master cabinetmaker Karl Launer, for example (see Chapters 6 and 3).

Of course German was the sole language used during the long Lutheran Church services, with hymns also sung in German. The German language was exclusively used between family members and their neighbours: 'All of the Elders spoke German, and this was the case until their children went to school and learnt English as a second language, at least until the First World War when teaching in the German language was forbidden'. English did not become the main language until the third generation, while intermarriage with non-German residents was also relatively rare until about 1900.

It is the varied and vernacular expressions of this ethnic character, sometimes referred to as *Deutschtum*, that strongly defined the principal character of the historic Barossa. Any ethnic group of people maintain a set of traditions which

sets them apart from others with whom they are in contact. In this case these include the folk practices, language, religious beliefs and common ancestry of the Barossa's Lutheran community.

Change would seem to be inevitable, and readers will realise the influences of the British, Mediterranean and other cultures which gradually suffused and blended with that of the once-closed Germanic community of the Barossa, and which eventually became moulded within the crucible of the Australian setting.

Industrial Transformations

By the late nineteenth century, the Barossa's landscape as defined by the distribution and growth of its townships, villages, and viticultural activities, had stabilised into a basic layout discernible to this day. However, change is inevitable and the Barossa was not so isolated as to be immune to the powerful influences of industrialisation and modernisation. One particular change, which began to open the region up and further alter the appearance of the landscape, was the arrival of the railway early in 1911.

Despite the opening of a railway from Adelaide to Gawler in 1857 and to Freeling, on the western reaches of the region, in 1859, numerous petitions to Parliament by the Barossa community requesting the building of a line, was not to bear fruition for many years. The perceived benefits included the opening up of markets in Adelaide for the region's produce, namely its grapes, wheat and fruits, not to mention an increase in land values! It was not until 1907 that approval was given for a line to be built, with construction taking four years before reaching Angaston on 8 September 1911, with a branch line to Truro and Nuriootpa another six years later.

The landscape of the Barossa was altered by the arrival of the railway simply by the appearance of its wooden sleeper and steel tracks winding their way into the valley. A series of stations were built, bridges were constructed over waterways, and embankments and cuttings were created along its path. Its presence is felt at the southern end of Tanunda where it crosses the main road into the Barossa, near Rowland Flat, cutting a steep embankment along-side the old cemetery where the bones of pioneers must surely tremble when-ever a train rumbles by. It is also evident at the northern end of Tanunda, where the tracks run alongside the road, creating yet another crossing at the palm-tree

setting of Dorrien winery, buildings constructed by Seppelts in 1911 to take advantage of the line. There are other places in the Barossa where train tracks influence the automobile's direction, including the seemingly incongruent crossing of the road at the western boundary of Bethany. In a park at the southern entrance to Nuriootpa, stands an old RX class railway engine, manu-factured in about 1900 and in use until the 1960s.

In tandem with the railway, further industrial impact on the landscape occurred with the exploitation of the Barossa's geological richness.

The visionary mineralogist Johannes Menge, one of the key players in the Barossa's early history, was the first to recognise its underground wealth. During his exploratory treks through the region he discovered and described an extraordinary range of minerals with potential for exploitation, including more exotic substances such as graphite, beryl, chalcedony, and opal. But it was the discoveries of gold, copper, silver and lead which led to mining over most of the nineteenth century in the region, although copper, and to a lesser degree gold, comprised the most significant operations.

Mining for these metals led to the usual scatter of relics and long-term effects on the Barossa's landscape: various stone and brick constructions which had been necessary for industrial mining operations and which included steam engine pumps, tall exhaust chimneys, mine engine and ore crushing buildings, as well as miners' cottages; waste dumps, shafts and pits; and hills cleared of native vegetation for smelting and mining operations. The latter effect on the landscape is perhaps the most significant remaining evidence of these mining operations, especially towards the north-east districts of the Barossa about Keyneton and Truro where the larger, and more successful copper mining ventures occurred. However, and fortunately for the area, the impact of this activity was not as damaging as it might have been, as it was more eco-nomical to cart ore north to the copper town of Kapunda for smelting.

A greater impact on the Barossa's landscape than mining was caused by quarrying for ironstone, marble, and more recently, limestone. Indeed, the variety of building stones to be found in the region has contributed to the fascinating diversity of textural and colour qualities of its historic buildings, monuments and cemetery headstones – including ironstone, bluestone, sand-stone, marble, limestone and slate.

The local availability of each of these materials led to certain types of stone becoming especially popular in particular settlements, therefore setting the character of the Barossa's villages and townships – especially as the nine-teenth century migrations included a considerable number of skilled Prussian masons keen to exploit these. In Tanunda, for example, the distinctive blood-red ironstone was the easiest to obtain and therefore became most frequently used in the earlier years of the nineteenth century; and indeed, together with Angaston marble, these form the dominant or signature stones of the Barossa. A concentration of nineteenth-century ironstone buildings, homes and wineries, may be seen along the Langmeil Road, including a handful clustered alongside and about Langmeil Church. Ironstone gradually became replaced by the more popular dark bluestone from the 1870s.

The region's historic cemeteries also reflect its geological richness, overlaid with the cultural preferences of its community, with a progression of stone types being used over time, notably slate, sandstone and marble (see Chapter 6).

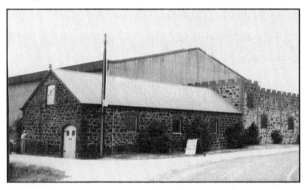

The historic use of local materials such as the distinctive red ironstone as seen at Langmeil Wines, Old Barn Wines and other buildings, adds a strong vernacular element to the Langmeil Road, Tanunda, streetscape.

The historic quarry at Bethany, now the site of the Schrapel Family Winery, provided a bluestone which was used in many of the village's homes. Stone from the Schrapel quarry was also used to replace the original mud wall and thatched roof Lutheran church with a more substantial structure in 1883; Langmeil Church was also built from this quarried stone, as was the imposing Chateau Tanunda Winery. In later years, crushed metal from the quarry was used to surface roads.

In Angaston, the proximity of a quarry which yielded white, pink or grey-coloured marble, in combination with a predominantly wealthier British pop-ulation – including the influence of the Angas family – led to the construction

of many fine public and private buildings in this material. Soft pink and creamy sandstone and bluestone also feature in this town, frequently in combination with the marble.

The Barossa therefore exemplifies a particular aspect of the process of vernacular expression in architecture, whereby the historic use of a specific set of building materials, as decreed by the local geology, in combination with the skills of its prominent craftsmen, in this instance Prussians, made a significant contribution to its characteristic townscapes.

The extraction of these stones also had a considerable effect on the landscape: ironstone removal at Penrice and Truro, especially the former, have created huge quarries; ironstone was also used as a flux to facilitate the smelting of copper ore around the state, while the extraction of limestone from the same site at Penrice for use in the manufacture of soda ash is an important industry today, further impacting on the landscape east of Light Pass. Aside from the expansion of quarrying, it was the attendant modernisation and industrialisation of the Angaston cement works in 1991, that led to the construction of the particularly incongruous feature of a towering concrete chimney stack, and which imposes on the gentle landscape of bordering vineyards and low rolling hills.

Since the early 1870s, marble quarrying just south of Angaston has not only supplied the Barossa's building and cemetery requirements, but also marble for monuments, cemetery headstones and major buildings in Adelaide; Angaston marble was even exported to England where it was used to construct an extravagant stairway in Australia House in London!

The coming of the railway in 1911 allowed both marble and limestone quarrying to expand considerably at the same location. These materials are still carted every day of the week in trains pulling 20 to 25 wagons.

Ancient beds of sand deposits near Lyndoch and at Rowland Flat, have also been quarried since the early 1950s. These operations have some visual effect on Rowland Flat's landscape of low hills which follow the main highway into Tanunda.

Besides quarrying for building materials, the establishment of Krieg's Brickworks at the northern exit to Nuriootpa provided an alternative construction material. Gustav Krieg commenced brickmaking in 1881, and although the

works survived until the 1960s, it has become considerably modernised and continues today as Barossa Ceramics; powered by electricity, the tall brick chimney is no longer used but has been preserved as an artefact of the region's early industry. The availability of bricks from Krieg's, as well as other brickworks established earlier in the nineteenth century, have left their legacy in the brick buildings about the region, but more notably, in the decorative and frequent use of stone with brick quoins.

The extraction of clay for brickmaking similarly led to the creation of clay pits, now mostly filled in, but the most interesting source of brick clay came from the early practice of stripping the top soil, removing the underlying clay, then replacing the top soil and planting vines to create new vineyards (see Chapter 4)!

The legacy of stonework is also notable in the Barossa region, and besides its impact described in the preceding text, it also forms an additional landscape element as dry-stone walls. Extensive dry-stone walls, constructed in the nineteenth century and still in good shape, delineate the fields in the dryer, eastern districts of the Barossa about Keyneton and Graetztown as well as north towards Truro. The outcrop country about Eden Valley eventually leads to Keyne's Gap where farmers cleared their stone-strewn grassy fields, using the stones to build dry-stone walls. Others were constructed here and there about the Barossa, including some walls along farm boundaries in the foothills east of Hoffnungsthal, and one long stone wall on the southern ridge leading to Kaiserstuhl's peak. The construction details of these walls, especially those in the Keyneton area, suggest that some of these were the work of British stone craftsmen: one such Barossa landmark is the considerable length of stone-walling which bounds the east face of Sedan Hill and was constructed in 1872. Running up and down the slopes of cleared hillsides, these walls add sculptural and historical interest to the rural landscape.

Aside from Krieg's wood-fired brickworks and tall stack, other brick chimney stacks of either a square or round cross-section were once a contributing feature of the nineteenth-century industrial Barossa landscape. Many of these flues were built to extract the smoke of steam-driven engines, themselves used to power various operations, such as pumping water out of mine shafts, or driving stone mills for flour milling.

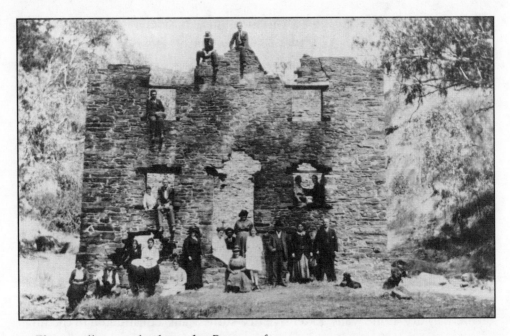

Flour mills were built in the Barossa from its founding years to grind the large acreages of wheat which preceded the establishment of the viticultural industry. Initially, these did not require flues as the first was a wind-powered mill in the Lyndoch Valley (1842), while the second was a water-powered mill built in 1843 by Daniel Schlinke on the Tanunda Creek at Bethany (see also Chapter 5). Steam-powered mills were in operation in the Barossa Valley from 1850, first in Tanunda and later in Lyndoch, Penrice, Nuriootpa, and other sites. In all, at least a dozen steam-driven, wood-fired mills were constructed in the region over the nineteenth century.

Today, although the buildings which housed them still remain intact in Greenock, Angaston, Rosedale, and Stockwell, chimney stacks are still present only at the latter two, with Stockwell's

Ruins of the old water mill, Schlinke's Gully, Bethany, c. 1900. Today, only the foundations remain.

flour mill the only one which remains in operation in the region; it is still owned and operated by descendants of Friederich Laucke, a flour miller from Brandenburg who had owned and operated a number of mills in the Barossa during the 1890s.

Transforming Traditions

The coming of the railway, and other influences of industrialisation, also marked the beginning of the end of a number of European traditions. Handcrafted articles such as furniture, shoes, pottery and agricultural equipment were considerably labour intensive and therefore more expensive than factory-made goods, which were now increasingly available because of the railway and road improvements.

In addition, distances between townships and villages with people either walking or using German wagons, no longer remained the sole determiner of the Barossa's simple village-craft marketplace economy which had flourished since early settlement. With the original need to have a set of skilled craftsmen in each settlement reduced, the unique, and indeed, medieval relationship between village craftsman, farmer, and community, faded and disappeared over the 1920s and 1930s.

Some tradesmen flourished with the introduction of new inventions and mechanisation: the Linkes of Moculta, for example, expanded from traditional blacksmithing into coachbuilding and agricultural implement making, employing as many as 45 men in the 1890s and surviving into the 1920s. Schrapel's Coach and Implement Factory located in Tanunda, was another large carriage manufacturer. Unexpectedly, the turn of the nineteenth century even saw the ingenuity and skills of the traditional Barossa craftsman applied, for a brief period, to automobile manufacturing activity! In 1901 in Tanunda, Fred Modistach constructed a car he called 'The Quad', using an imported English engine and local blacksmith constructed parts. Also working in Tanunda, Johann Ohlmeyer constructed in 1904, 'The Jigger', while in Angaston, C. Trescowthick built his own three models, one a three-wheeler powered by a single cylinder De Dion engine!

Besides the railway, other factors which hastened the breakdown of social and cultural barriers between the Barossa's close-knit Germanic communities

and the British, was the increasing circulation of popular magazines, and the switching to English by German-language newspapers from the turn of the century. British-Victorian attitudes, values and fashions therefore began to suffuse and change the Germanic traditions and culture of the Barossa.

At the onset of the First World War, British-Australia paranoia and ill-feelings towards the German-descendant population of the Barossa created an unpleasant situation which led to much personal and community suffering. By 1917, increased anti-German hysteria led to the passing of an Act of the South Australian Parliament which forced the closure of Lutheran schools! Another Act saw some 69 place names of German origin about South Australia, including the Barossa region, officially changed: Bethanien became anglicised to Bethany, Neu Mecklenburg to Gomersal, Rosenthal to Rosedale, Gnadenfrei to Marananga, and Kaiserstuhl to Mount Kitchener, to list a few examples. A few years after the Second World War, and again in 1975, some of these names were changed back to the original, but most have yet to be restored.

During the years of the First and Second World Wars German culture generally was suppressed, especially the German language which could no longer be taught in the Lutheran schools; amazingly, even preaching and public prayer in German was banned, forcing Barossa Lutherans to speak in German only within closed family settings. It was a time when many of the decorative Lutheran tracts and texts painted on the interiors of the region's churches were removed. This all occurred in a region whose cultural heritage was created out of a religious and historical, not nationalistic, basis. Nevertheless, the use of the language, although already in steady decline from the First World War, did not entirely die out. Even in the late 1990s, a portion of the older generation continue to occasionally converse in German among their friends, albeit with a strong regional flavour, while those of the younger generation often exhibit certain Barossa-German influenced expressions in their everyday Australian-English vocabulary.

By the 1890s, the amalgamation of the German and English languages, as well as the Silesian dialect inherited from the early settlers, had led to a regional vernacular form of the German language known as 'Barossa Deutsch'. As well as its own manner of speech recognised as distinctive, and even 'quaint'

by visitors from Germany, it accumulated its own peculiar vocabulary. It includes terms such as *Schnurrbart* (sometimes shortened to 'Schnurry') to describe the moustache-shape of Barossa wardrobe pediments; 'Bienstick' as an abbreviation for the traditional German cake *Bienenstich*; 'Weinmacher' (wine maker); 'Farmerieren' (farming); 'Stinkerkaese' (traditional quark cheese); 'Schluck' ('a quick nip'); and 'Fruchtgarten' (fruit garden).

The Living Landscape: a Mediterranean Accent

In a process which continues to this day, the interaction between people with the land also dramatically altered and moulded the Barossa landscape. European cultural practices transformed the natural environment as exotic plants and crops were introduced and mixed with existing native vegetation. After 155 years, this has resulted in the creation of a vernacular landscape quite unlike any other, but which has some resemblance to regions in the south of France and Spain where a similar climate and set of cultural practices led to the creation of a characteristic Mediterranean setting.

In the Barossa, this process of landscape shaping occurred both directly and indirectly. In the former, agricultural and agrarian pursuits by the Prussian and English pioneers and subsequent generations, led to the replacement of the original, and ancient, ecosystem of native plants and animals by crops and other exotic plants as well as domestic animal stock.

'Corn', that is wheat, was the predominant crop, with barley, rye, maize and peas also cultivated in the early decades. However, seed crops were not pure, and beside their intended introduction and cultivation, annual grasses of wild oats and rye from Europe soon inadvertently invaded and replaced the vast pastures of perennial kangaroo grass which had so impressed Colonel Light and the region's other early explorers.

As their habitat diminished, kangaroos and other native marsupials disappeared, although some, like the western grey kangaroo, survived in some of the wilder bushland areas fringing vineyards, or else you may encounter them in the Kaiserstuhl Conservation Park.

From the 1870s, the fields of wheat and barley which first dominated the valley floor, gradually became replaced with vineyards as awareness of the region's prime suitability for commercial viticulture spread.

As people continued to interact with the setting there were also many inadvertent consequences of their actions. In particular, there were many garden escapes, exotic plants which spread from the cultivated borders of village gardens into the disrupted environs of the Barossa. These alien plants quickly became naturalised in the region, thereby adding an additional cultural element to the evolving landscape.

Today, many of these weeds fortuitously complement the Barossa's characteristic quilt of vineyards, wheatfields and hillsides. In winter and spring, masses of these naturalised plants flower freely, creating a spectacle of colours. The orange and yellows of the harlequin flower or sparaxis, mix with white freesias to brighten fields, roadside verges and cemeteries; clumps of white-flowering winter iris frame dormant vineyards; the bright yellow of common sour-

The contemporary Barossa landscape of vineyards, wheatfields and date palms and pines; the distant Barossa Range defines the eastern boundary. The highest point, the 600 metre Kaiserstuhl, is visible towards the centre of this view facing south-east.

sobs and the glorious purple of Salvation Jane paint whole hillsides and fields; the pristine white splendour of arum lilies transform creeks into exotic gardens. In late summer, the hot pink of the flowering clumps of belladonna lily, enhance cemeteries and the roadside verges around the palm avenues of Seppeltsfield; at the Lyndoch entrance to the Barossa Valley, stretches of pink wood sorrel present a spring carpet highlighting the blue-green backdrop of the ranges.

Also frequently encountered around the ruins of pioneer cottages and farmsteads, are spectacular rosettes and clumps of winter-flowering giant agaves. Cuttings taken aboard at ports in South America (and South Africa) on the long journey to Australia, were planted as ornamentals in village and farm gardens of the Barossa, as well as for the practical reason of creating stock-retaining hedges. These succulents were well adapted to the hot dry summers and wet winters of the region and soon developed into large specimens: the three to four metre flowering spikes of one type add a dramatic sculptural element to the skyline, while the bright red-hot poker flowering spikes of another energise the late winter landscape.

Besides the vine, the Mediterranean and idiomatic character of the contemporary Barossa landscape has also been created through the introduction of the pine, palm, pepper, olive and carob tree.

Aged specimens of the South American pepper tree, with its thickened trunks and contrasting light lacy fronds and pink berries, shade the ruins of pioneer cottages where they were commonly planted. Sprigs from these hardy trees, a favourite of the German settlers, were traditionally used as decoration at weddings and other celebratory events.

The carob tree's Biblical reference as St John's bread, makes it a particularly suitable street tree in the region as it especially evokes the piety of the Barossa's Lutheran heritage. In Tanunda, Lyndoch and Angaston, the twisted trunks and darkly-dense canopies of carob trees line the streets; if only these aged trees could communicate to us something of the parade of people and historic events they have been witness to over one hundred years of growth! In Rowland Flat they are regularly clipped into neat, cone-shaped forms, providing an interesting sculptural touch to an otherwise ordinary roadway.

A distinctive Mediterranean ambience was especially created around

Seppeltsfield through the extensive planting of Canary Island date palms during the 1930s, especially along the roads and in the gardens of the Seppeltsfield Winery. Other species such as the taller and slender cotton palm which comes from Southern California, were also planted along the steep approaches to the Seppelt mausoleum, as well as along the frontage of their winery storage tanks (now Chateau Dorrien).

No other tree could symbolise the Mediterranean more than the olive. In the Barossa, it has become naturalised everywhere. Old surviving trees and groves indicate early plantings from about the 1880s (126 gallons of olive oil were produced at Tanunda in 1889), with further commercial groves planted in the late 1950s at Dorrien. In more recent years, the revival of olive culture has seen new plantings of various cultivars about the valley, but it is the wilder cousin of the olive that dominates the Barossa landscape, the silver-green of its leaves blending with the grey-green of gumtrees.

Other trees found in the Barossa and which originate from southern Europe include a number of conifers. The Italian Cypress (candle or pencil cypress), that icon of ancient Rome, has an upward (heaven) pointing and neat habit which led to its popularity for cemetery planting; the candle cypress's dark-green foliage and tight forms especially dominate the formality of the entrance at the cemetery of Tanunda's Langmeil Church (see also Postscript). They are to be seen in other cemeteries about the region: the creekside old Lutheran cemetery at Friedensberg (Hill of Peace) near Springton has some magnificent specimens.

The symbolism of a variety of plants figures strongly in the Barossa's Lutheran culture: the common, southern European myrtle was often planted in cemeteries (an old specimen grows between the headstones in the private Habermann cemetery on Mengler Hill). As a symbol of modesty and chastity, it was fashioned into a wreath and used in Lutheran wedding ceremonies (see Chapter 2). The symbolic meanings attached to other plants are noted throughout the text.

We cannot overlook the other pines of the Barossa region. Extensive plantations of the Canary Island pine embrace the Seppelt mausoleum; mixed with wild olives, self-seeded specimens have altered the environs of Menge's cave along the cliff banks of Jacob Creek and other, uncultivated, corners of

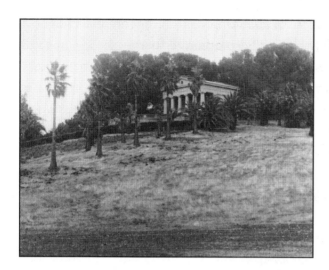

The neo-classical Barossa: the Seppeltsfield mausoleum sits on the knoll of a hill which affords a view of the extensive Seppeltsfield winery. The date-palm tree planted surrounds create a Mediterranean ambience.

the valley. The Mediterranean theme is further reinforced by the mix of exotic pines, most of which originate from southern Europe, including the Aleppo and round-topped stone pine. They are encountered in cemeteries, parks and farms; one old stone pine is renowned insofar as it crowns Pewsey Vale Peak, its distinctive umbrella-like appearance identifying it as a landmark from afar.

In Tanunda, a remnant of the original native (Callitris) cypress forest, as described by Menge prior to the settlement of the valley, has been preserved on its north-east boundaries (privately owned), as well as a small patch in the Tabor Cemetery which is probably regrowth; most pines were cut down to provide posts for fences and for building the walls of pioneer cottages, as well as providing some timber for migrant German cabinetmakers. At the southern tip of the Barossa Valley, just south-west of Lyndoch, Sandy Creek Conservation Park preserves a small sample of the woodland which pioneers traversed to reach the valley floor.

Kaiserstuhl Conservation Park, which may be seen from most points on the valley floor, also conserves a portion of the original landscape early explorers and settlers encountered in the ranges of the Barossa. Near its peak, bushwalkers encounter huge granite boulders, set in dense brown stringybark, bluegum and manna gum woodland; the heath understorey is rich in native orchids, correas, and other sclerophyllous-leafed shrubs so foreign to the European settlers. Kaiserstuhl features frequently in Barossan life: Menge described its geology, potter Hoffmann trekked though the bush collecting its clays, early Lutheran

settlers prayed in an open-air church at its peak, and the apocryphal millennial tale of Pastor Kavel's chase of the devil also occurred there.

Lindsay Park still preserves a semblance of the park-like landscape of grand old redgum and bluegum trees (*Eucalyptus camldulensis and E. leucoxylon*) so admired by the pioneers—especially the Angas family who acquired vast stretches of the countryside.

German botanists who migrated to Australia were especially prominent in collecting and naming much of the floristically-rich and alien-looking native plants; and it may not be so surprising, given its concentration of fellow countrymen, that they focussed their investigations in and about the Barossa region. The latter included Hans Herman Behr, Dr Ferdinand von Müller, Ferdinand Osswald and Johann Gottlieb Tepper.

Once described as a sea of endless blues and greens, early clearing and grazing led to the greater portion of the Barossa region's native vegetation being destroyed by the 1890s. The bare appearance of the landscape inspired the colonial government, through the creation of a Conservator of Forests, to institute replanting schemes from the 1890s. The government encouraged farmers to plant windbreaks and copses on their over-cleared farms, and as a consequence, the tall, spindly sugar gum (*Eucalyptus cladocalyx*), a native of the mid-northern regions of the state, as well as various exotic pine species, were widely planted. Today, these matured trees add their distinctive profiles to the Barossa landscape.

Plants, introduced and endemic, also provided materials and inspiration for the resourceful Barossa folk: the fibrous stems of the giant agaves and palms were carved into duck decoys; arum lilies and other flowers became the subjects for embroidery; pine cone scales were used to make decorative frames; timber from gumtrees, white cedars and other exotics was used to make furniture; pepper tree seeds provided a substitute for peppercorns, while the foliage was used for decoration; carob trees supplied pods for flavouring foods; and the vine (with its Biblical expression of the relationship between God and His people, or as an emblem of Christ, as well as doubling as an icon of the valley) inspired paintings or carvings in wood and marble for church walls and altars.

A Landscape of the Imagination

We may recognise too that, beyond the cultural landscape as created by the region's community of leaders, farmers and artisans, there is also one of the imagination, evoked by its artists, historians and writers, past and present. They have interpreted – through their vision and thoughts, through paintings, sketches or books – other images and stories of the region.

Over the past, this 'fabricated' or imagined version of the Barossa has become intertwined with the physical reality we experience directly through our senses, to create what we speak of as the cultural landscape. It is difficult to separate and distinguish between the former and the latter. Both contain truths and distortions, yet surely both are equally valid in our efforts to journey beyond the facade and unravel the personality of this region. Throughout this text, I present examples of these alternative views: the revealing water colours of the English traveller-artist George French Angas, the sketches and paintings of Eugene von Guérard, the delightful etchings of Skinner Prout; the anonymous folk art paintings of the Barossa's inhabitants. Aside from these historic images are those created by the region's contemporary artists, nostalgic visions of the past, as well as those of a more modern perspective.

Beyond these images, even the cultural landscape may be viewed as an artefact itself, for it crystalises within our minds as a product of our own sensory perceptions and our interactions with what we have gleaned from others: from paintings, photographs, and other records passed down to us; from its surviving oral traditions and social customs; and finally, from other elements of its surviving heritage such as its architecture and its decorative arts.

Traditions and Identity

In closing this chapter, some further explanation is warranted about what is meant by that much-used term 'traditions'. The standard view defines the term as referring to an inherited body of customs, beliefs and set ways of making things. Succinctly put, traditions comprise a core of teachings handed down from the past. More recent scholarship has taken the view that traditions are not immutable and rarely, if ever, survive intact over time.

From this contemporary perspective, traditions embody a process of interpretation whereby each subsequent generation which inherits them also

re-interprets them within their own setting. Hence our concept of what constitutes an authentic tradition can depend very much on our contemporary viewpoint, and this in turn depends on what meaning we decide to assign to any set of traditions. In this manner traditions are not static but fluid, as each generation constantly re-jiggers them to suit their particular values.

This was the case for the Barossa, a region where transplanted European and British traditions could not remain absolutely fixed in their original form as its social and physical isolation diminished. With improvements in transport and communications which occurred from the early 1900s, and as the community had increasing contact with and intermingled more with 'outsiders', new influences and ideas became gradually absorbed so that, over the generations, its Germanic culture gradually transformed to display a unique Barossa character. Besides the changes in the use of language as already noted, other vernacular, that is local forms distinctive to the Barossa region were created in the community's various cultural practices.

Today, we recognise these forms as characteristic to the Barossa region (its cultural icons), *precisely* because they still embody bits or cultural traits of the early traditions. These have been hybridised with other fragments inherited from and interpreted by each passing generation. In this way, continuity has been preserved with the past, yet at the same time there is discontinuity as a sense of the new or contemporary is also created.

Indeed, this is how communities keep their sense of identity intact – by constantly re-inventing themselves through the heritage of the past in the setting of the present. Tradition and community life are closely integrated, and a study of regional folk life such as this endeavours to provide a clearer understanding of the cultural basis of regional personality, through an awareness of how traditions function to maintain a community's identity, cohesiveness and vitality.

Folklore

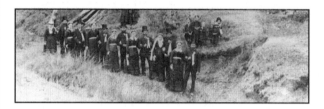

Tales of the Barossa

'He was startled to see a shadow as if a huge flapping bird was hovering above and following him. Looking up, there was nothing in sight ...'
anonymous Barossa local

Long-lost villages; quaint customs such as covering mirror surfaces during thunderstorms, tin kettling and *Federschleissen*; the legend of potter Hoffmann's secret trek; the anecdotes and tales concerning mineralogist Johannes Menge's superstitious nature and odd habits; the folk beliefs of witchcraft and magic held by the early Silesian and Wendish mystics; and the *Siebenschlaefer* myth, are a part of the time-honoured folklore heritage of the Barossa's Old Lutherans.

Taking folklore in its broadest sense, I refer both to oral lore of actual past events and people, as well as to a collective folk knowledge or wisdom embodying traditional beliefs and ways of doing things, and passed on through personal contact.

In the Barossa, this lore includes a wealth of oral tradition or family tales and reminiscences that have survived to this day, not to mention various Old World rituals, customs and folk beliefs. Some stories are based on exaggeration

or even supernatural or folk beliefs and legends, while others are tales or anecdotes of the Barossa's past which were documented, or have been passed down through family oral tradition and, in some cases, have been authenticated through material evidence.

The following is my personal collection of some of the more intriguing historical events, stories, anecdotes, early customs and folk beliefs which have accumulated over the years to become an integral part of the Barossa's lore. Some are confirmed by historical fact, others are derived from folk belief.

The Lost Village

Anyone visiting the sugar-loaf shaped hills encircling the site of the historical village of Hoffnungsthal, cannot fail to be moved by the story of the demise of what was once a thriving Lutheran community.

The story begins in August 1847, when some 20 families hailing from the Prussian Province of Posen, leased this hilly land located on the south-western slopes of the Barossa Ranges to the east of Lyndoch.

Setting to work, the dense bushland was cleared and a Prussian agricultural settlement (*Waldhufendorf* or forest-farm village) was soon established. The village site was located at the centre of the Lutherans' farm grants, with its main street roughly aligned along a north to south orientation. A post and rail fence was built along the length of a second road crossing the first at its southern end: this prevented cattle from roving into the line of cottages built along the east side of the main road. Thirty stone and clay cottages were constructed, while others were built of wattle and daub – all had thatched-reed roofs. Besides farmers, the community included a sizeable proportion of craftsmen including carpenters, masons, cobblers, tailors, cabinetmakers, and even one organ builder (see Chapter 7). These village carpenters and cabinet-makers supplied the timber cut from the surrounding forest as it was cleared, especially the redgum which was used to construct the beams and roof trusses. Even the furniture was made from this dense native timber, including two rows of hand-sawn redgum forms which were used by the congregation assembled on each side of the church: one set for the men, the other for the women.

It was to prove ironic that the village was named 'Hoffnungsthal', Valley of Hope, reflecting as it did the underlying motivation of religious freedom and

economic security which these adventurous migrant Prussians sought. The ordered line of white-washed dwellings was overlooked by the modest village church located on a small rise on the south-east end of the main street. Sited in the centre of a ring of low bush-covered hills, the valley floor a park-like ancient redgum woodland, Hoffnungsthal surely presented a picturesque scene. The Prussian farmers cultivated its rich black soils which supplied an abundance of crops of wheat and vegetables, while cows grazed on the surrounding pastures. Little wonder that they ignored various signs of impending disaster.

But Hoffnungsthal's fate seemed to be pre-ordained: at the time of its founding, the Lutherans ignored warnings of 'big waters' by a small group of local Aborigines, among the last to retreat from the advance of European settlement, that the village site was prone to flooding. Although evident by the rushes, river redgums, and the site's low aspect surrounded by a ring of hills – these signs and warnings were ignored. All appeared well and the Hoffnungsthal community flourished – until its sixth year of existence, 1853, which was to mark its demise. The settlement then numbered some 200 people living in 37 cottages.

The winters of 1851 through to 1853, saw very heavy rainfalls, especially in the latter year when a series of exceptional thunderstorms caused the valley in which the village was sited to become rapidly flooded and transformed into a lagoon. In the words of one chronicler:

There came a heavy and continuous torrential rain, which lasted for one day and one night. One family had to flee their home during the night, and seek shelter under an overhanging rock on the side of the hill, where, with a small child, they stayed till daybreak. When the settlers emerged from their homes in the morning and could overlook their valley, they were astounded to see all their land, together with crops and vegetable gardens, covered by a vast sheet of water ... They wept bitterly, especially the dear women. Many believed it was a punishment from God ... It later dawned on them that it was their own fault in not heeding the Aboriginals' warning, and in clearing much of the native vegetation from the hill slopes, hence increasing run-off.

Although the church, which was situated on the rise, was left intact and continued to be used for another fourteen years, the village was progressively abandoned with families re-locating to nearby settlements about the Barossa.

Today, only a few signs that the village of Hoffnungsthal once existed are apparent: a row of weathered redgum posts from the remains of the cattle fence, and parts of the stone foundation of the church located on the rise, and now marked with a memorial. Remains of the original thirty-seven cottages appear to have been entirely washed away and covered with silt through many subsequent floods; while the site of the Hoffnungsthal's cemetery can only be located through the spring flowering of bulbs planted long ago by its pioneers.

The brooding site of the lost village of Hoffnungsthal. Established by Prussians in 1847, the site was flooded out in 1853. This winter view shows the lagoon and the once-forested encircling hills. The stone memorial in the foreground marks the site of Hoffnungsthal's Lutheran church; the main village street stretched out from here to the distant hills.

The visitor who takes the time to drive to the site, tucked away from the main Williamstown to Lyndoch road, will be rewarded with the serenity and mystery of a rural landscape which mostly hides its sad tale. However, if the visitor pauses for a moment he or she can, in the seclusion of the flat lagoon surrounded by its ring of hills, conjure up in their imagination the sights and sounds of the long-lost village, one which embodied the hopes of those Lutheran pioneers of some 140 years past.

A modern interpretive sign erected at the entrance to the lagoon provides a little information on the village, including a view of the flooded site sketched in 1855 by the visiting Austrian artist, Eugene von Guérard. His detailed, panoramic sketch shows the still-flooded site with its submerged fences, a

greater number of large trees still standing than today and, towards the centre right of the view, a small thatched wooden building, the humble church and school of the village of Hoffnungsthal.

The Great Trek

From the time of the flood through to its final years in the early 1860s, as Hoffnungsthal was progressively abandoned, its pioneer families gradually moved to various places: some re-located just 5 kilometres west to form 'New Hoffnungsthal'; others to nearby German settlements about the Barossa Valley including Rowland Flat, Rosenthal and Neu Mecklenburg (now Gomersal). Some chose to move further out to new farming areas outside of the Barossa Valley as far north as Peters Hill, while others trekked east, a few remaining in Mt Gambier and the majority continuing further, into the Western District of Victoria. For some the disaster had proved to be too traumatic, and they left Australia, becoming migrants once again and journeying, this time, to North America.

Indeed, movements of Lutheran settlers about the Barossa and beyond occurred with some frequency in the early decades of the region's history, for reasons such as Hoffnungsthal's flooding and other natural disasters such as crop failures and drought, and as the availability of land for settlement in the Barossa diminished. Of these movements, one in particular has become enshrined in the Barossa's history and lore as the 'Great Trek'. Once more nature was the main cause of the movement – although, as we saw in Hoffnungsthal, the settlers also played their part in determining their destiny.

This story begins in the mid-1860s when farmers began to notice a steady drop in the yield of their harvests, as the original high fertility of the Barossa's soils became depleted through repeated cropping. In addition, other land was no longer available for the generation of sons and daughters that had now grown up and were marrying and hoping to establish their own farms. Prussian custom decreed that the older son was obliged to leave and take up land away from the parental home, whereas the youngest son inherited the farm and cared for the ageing parents. This situation was worsened by the then typically large families of six to a dozen children which often included four or more mature sons.

Despite an initial run of good seasons with plentiful rainfall and the adequate fertility of the virgin soil, the original land holdings for many of the Lutheran pioneers sometimes as small as 10 to 20 acres, quickly proved too small for the economic broadscale grain farming of wheat or barley. Some of these farmers managed to increase their land holdings by purchase or by leasehold agreements, often with George Fife Angas, who, it may be recalled, owned many thousands of acres of the choicest land in the Barossa, and who had migrated to the colony in 1851 to live on his vast property holdings at Salem Valley. Typical agreements included the lease of 80 acre parcels of land over a term of 10 to 15 or more years. These agreements, between the British landholder and the German settlers whom he had assisted to migrate from Prussia, included the provision to pay George Fife Angas 'in kind', namely: 'with 80 bushels of good clean and marketable wheat with a proportionate paid of such rent for any period less than one year of said term payable yearly'.

In the earlier years, with good seasons, good crops were harvested from on the virgin soil, and the Lutheran farmers were able gradually to pay off their leasehold property with cash. During the mid to late 1850s, following good seasons, German farmers delivered hundreds of bushels of wheat to their land-lord, George Fife Angas. This situation soon changed.

In March 1866, Angas's land steward, William Clark, recorded in his day book the first of a series of crop failures that were to plague the colony over the next few years. In November 1864, for example, one farmer who had 45 acres sown to wheat and two of barley, was then averaging ten bushels per acre, just slightly below the state average. Under his lease entry, Clark records a total failure for his February harvest. And although in December of that year he harvested an average of 12 bushels per acre, much of the crop was 'dirty with oats between stones ...' The following 1867 seasons were once more total crop failures for many farmers. Early 1868 held the promise of a good season, encouraging many hopeful farmers to borrow funds for seed wheat and machinery. But the season proved 'disastrous ... two bad harvests have come together in two years for the first time ... [hence] the depressed state of agricultural tenants cannot be wondered at'.

In addition to the lack of rain, other factors combined to magnify the increasingly bleak outlook for the farmer. A few weeks prior to harvest time

'a new and fearful disease invaded ... crops and fields which up to that time had been healthy and bowed down with the weight of ears, began to assume a red, rusty appearance ...' As it was, the 1867 to 1868 seasons saw 'extraordinary ravages of red rust ... [and] ... Cornfields which had been calculated to yield from twenty-five to thirty-five bushels per acre, were completely destroyed ...' Harvests were reduced to less than a third of the average yield. In addition, the selling price for wheat had dropped considerably, partly as an outcome of a glut of imported American grain. Consequently, farmers were left with even greater debts with 'the labours of years swept clean away'.

Eventually, this series of droughts and crop diseases which followed in the latter part of the 1860s, triggered a major exodus of German settlers from the Barossa. Initially only a trickle, for a short period it turned into a stream as increasing numbers of Lutheran settlers departed from the Barossa and headed for the eastern colonies. The New South Wales government was then offering cheap land in the Riverina plains and western slopes about Deniliquin, Jindera and Albury. Scouting parties sent out from the Barossa to investigate were impressed by the high rainfall, fertile soils and undulating and forested land – remarkably similar to the countryside to their previous Prussian and Barossa homelands.

Among the communities of the Barossa which saw the departure of significant numbers of German families were Light Pass, Neukirch, Ebenezer, and Bethany. It was the most celebrated of these departures which came to be known as the 'Great Trek'. It was an event which was characterised by the mass departure of a number of families as one group as a wagon train. Preparations must have taken months, especially given the drought and therefore the scarcity of hay or chaff for the oxen and horses. A paddle steamer on the River Murray was eventually loaded with chaff which was dropped off at various locations along the river bank, later accessed by the wagon train. The steamer also carried the trekkers' heavier farm machinery such as strippers and winnowers.

In October of 1868, after a prayer and a blessing by Pastor Niquet, and following the tears and well wishes of relatives and friends gathered to see the party off, a caravan of 8 families, comprising 56 individuals in 14 covered wagons, set out from Ebenezer for Walla Walla in New South Wales –

a 1000-kilometre journey. A large stone monument, located alongside St John's Lutheran Church at Ebenezer, records this event.

Over a period of some six weeks, the long line of German wagons with their Lutheran trekkers, led by their elder Gottlieb Klemke, who had been ordained prior to departure, followed the course of the River Murray, first to Albury, then turning north to head away from the river to reach their final destination of Walla Walla. While home furnishings were sent ahead by paddle steamer up the River Murray, other requirements including food supplies, crop seeds, vine cuttings, livestock, horses and poultry, accompanied the caravan. During the course of the trek the families camped in the bush at the end of each day, finishing each evening with a devotional reading from the Bible.

Other caravan groups subsequently set out from the Barossa following the trail of the first group. Over the following years these Lutheran pioneers, gradually established farms in a scattered pattern across the undulating countryside between Albury and Temora. Once more, following the customs of their forebears, these German settlers founded Lutheran communities centred about their church and based on those of their Prussian homeland. By 1880, the local press could report that 'four miles from Walla Walla are purely German settlements ...' However, over the following decades, unlike the experience in the Barossa, the gradual mixing of German and British settlers occurred at a faster pace. In addition these new settlements did not provide the protective isolation or coherence of the Barossa's village community and eventually, Prussian traditions rapidly diminished and had mostly disappeared in this region by the early 1900s.

Wedding Rituals, Black Dresses and other Customs

The customs and rituals of a group are essential in expressing and reinforcing the communal bonds between individuals, as well as defining a shared identity and local pride. The Barossa Lutherans retained and nurtured their Prussian heritage, much of which derived from the church itself. The rites of life and death – baptisms, confirmations, weddings and funerals – became especially richly embroidered with ritual and custom, their origins and original meanings often now lost to time.

One of the most common of the Old World customs brought over by the

The traditional Barossa wedding procession with the couple, bridesmaids and groomsmen in a German wagon drawn by two horses, c. 1875.

Barossa Lutherans, was a type of ritualised and acceptable 'begging'. This was seen in the tin kettling ritual traditionally performed prior to Barossa Lutheran weddings when food and drink is eventually brought out. It is also enacted in the 'barring the way' ritual when the wedding couple approach the church or when they leave, and where sweets are handed out to children. These and other beliefs and customs may be sometimes traced back to pre-Christian, archaic customs which have become interleaved with Christian teachings and popular beliefs.

For the Barossa Lutherans, marriage was considered to be one of the happiest events in their lives and worthy of much celebration, so much so that, in the nineteenth century, a local observer noted: 'their weddings are conducted in the most decorous manner, and although the company enjoy themselves, still their enjoyment seldom exhibits itself in the ordinary uproarious conduct of some other people ...' Characterised by ritual, major feasting, and lavish display, the Barossa Lutheran wedding retained its peculiar formalities in both its material and behavioural appearance throughout the nineteenth century, and at least, into the early 1920s.

As an important rural occasion, the wedding was observed with a set of traditional and symbolic rituals. Weddings were also an occasion which

involved many families, if not the whole village community, and the lead-up to the ceremony itself involved various social gatherings including the popular *Federschleissen* that is, featherstripping evenings (described in Chapter 6). Local weddings were held on a Thursday (but never during Lent), in order to allow three days for the ensuing celebrations, a custom observed until the late 1920s.

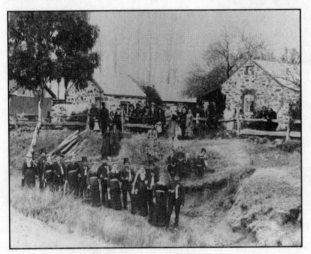

Helbig-Schulz wedding portrait, 20 May 1886, North Rhine, Keyneton, with Helbig's home in the background. The bride is wearing the traditional white veil over the black dress. Note the ironstone farm buildings, and the bake-oven projecting from the back of the kitchen building on the left-hand of the photograph, the pug barn on the extreme left, and the high-peaked cottage with loft on the right.

A week before the wedding, huge quantities of German yeast cake (*Streuselkuchen*) were baked and given as goodwill to the numerous relatives, friends and neighbours. On the night before the actual wedding an evening of 'tin kettling' or *Polter Abend* (literally: 'noisy evening'), began the rituals. Tin kettling would seem to be one of the more peculiar, and time-honoured, of the German customs transferred from Prussia to Australia. The ritual began with the stealthy gathering of male revellers outside the home of the bride-to-be where, on cue, they banged and rattled tins, set off fireworks, sounded ox horns, and even fired shot guns, setting up an extraordinary cacophony. The more popular the couple the noisier the tin kettling! This noise would continue for at least an hour until finally, the revellers were either invited inside the house to feast on *Streuselkuchen*, beer and wine, or the couple emerged to give the group the cake and drink outside, hence signalling the end of the ritual.

So loud was the noise that it often carried for a considerable distance about the district, so much so in once instance in 1901, that one group of tin kettlers were charged in the local court for disturbing the peace! The custom survived

well into the twentieth century: Barossa inhabitant Ruby Fechner recounted that tin kettling was observed at her daughter's wedding as recently as 1966. *Polterabend* or 'tin-kettling night' possibly had its origins in early European beliefs that noise drove off evil spirits – although in the Barossa the custom came to be observed more as a sign of respect – as well as an enjoyable pastime to honour the couple.

Display was an important facet of the wedding, so the costumes worn by the bride and groom were distinctive, being decreed by Prussian, Old Lutheran tradition. This especially applied to the bride's wedding dress which was a full-length gown usually made with silk taffeta, with some lace embellishments – but more importantly, it was always black or a very dark colour. Why black? There seems to be no lingering memory which tells of the origins of this preference to wear black wedding dresses in the Barossa: my interviews with aged descendants always received the response that the black dress was 'traditional', with no forthcoming explanation. However, the early Prussian settlers – mostly Old Lutherans – were a conservative and austere group who also prohibited dancing at weddings. Black wedding dresses fitted into these people's sense of humbleness and pietism. This explanation fits in with the reason given by descendants of similar groups of Germans who settled in Texas (USA), where black and tight-fitting wedding dresses, also worn until the turn of the century, were explained as a reminder to the bride of the hardships of married life!

Traditions are not immutable and, from the late 1890s, the conventional white wedding dress was slowly introduced into the Barossa, although not without some resistance: on 14 February 1898, the bride Mathilde Schilling caused a scandal when, on the day of her wedding, without any warning, she wore a white wedding dress. This was considered so serious that her father, Christian Schilling, was asked to explain this unabashed behaviour before a meeting of outraged elders of the Gruenberg Lutheran Church. By the late 1920s, the customary Barossa Lutheran combination of black dress and white veil had been replaced with the fashionable white gown.

As a symbol of modesty and chastity, the bride wore a long white lace veil – over her dark dress – which was attached to a crown, itself a wreath of myrtle worn on her head. The custom of crowning originally involved both the

bride and groom, but the latter's 'crown' was simply a buttonhole of long white ribbons and a sprig of myrtle, worn on a plain black suit. In classical Roman mythology, the garland of evergreen myrtle symbolised love, as myrtle was sacred to Venus. Absorbed by Christian belief, it had become a symbol of the conversion of the gentiles by Christ. And just as the wedding ring symbolised eternity, so too did the circular form of the bride's garland.

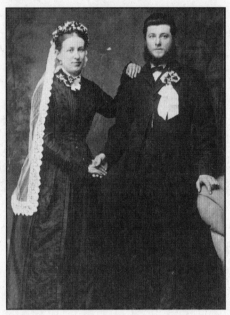

Marriage portrait of Ewald Graetz and his wife Elisabeth, 1889. Note the traditional black wedding dress with white veil and the groom's pinhole (see also Chapter 6).

The wreath and garland feature frequently in various Barossa celebrations: during weddings and confirmation, the church interior would be garlanded in plaited greenery. Once more, this related to ancient customs associated with the repelling of evil spirits, long-appropriated by the Christian church to be given new symbolic meanings of purity, love and victory. David Herbig recalls this custom as a child at the St John's Springton Lutheran Church where the arch was made of hinged wooden pieces formed from cut cartwheels and decorated with flowers and asparagus fern; at the apex of the arch was a large crepe paper bell filled with confetti 'which was scattered over the happy couple at the appropriate moment by the tug of a string'.

The plaiting of fresh branches for decorating the church interior was a custom also observed during Christmas and Confirmations, while plaited garlands are still hung for the harvest thanksgiving festival *Erntedankfest*. During

Confirmation ceremony in Langmeil Church, Tanunda, c. 1910. This was an important religious ceremony in the life cycle of the Lutheran community. Note the decorative floral 'veil' and the wreaths worn by the girls.

Confirmations, the decorated arch often included silver-lettered text which read: 'be thou faithful unto death and I will give thee a crown of life'.

The conservatism of the Barossa Lutherans was such that any attempts to break from tradition were strongly resisted. Hence, on one occasion when the bride-to-be who was known to be pregnant dared to arrive at the church wearing the traditional myrtle wreath and white veil, the church elders 'promptly stripped her of it'! It was more acceptable in this situation for the bride to wear the veil across the bodice of her gown. If, after the wedding, the bride walked to the vestry via a side door, rather than walking directly past the altar, then it signified that she was 'with child'.

Also much ritualised was the wedding procession which began in the morning with the relatives, friends, bridesmaids and groomsmen, assembling at the home of the bride-to-be. A long procession was formed and all followed the bride's garland-decorated German wagon – the usual form of transport to the church at least up to the early 1900s. The procession of traditionally-coloured red and blue German wagons, drawn by horses also adorned in ribbons and rosettes, took the bridal party to the church. On the way, and sometimes on the return of the wedding party, garlands of leaves and flowers or a flower-decorated rope was often held across the road, for the early European tradition of 'barring the way'. It was considered an honour to be stopped, and the bridal couple would throw lollies or coins to those holding the rope. The ritual symbolised the payment required to join a new community

or leave an old one, and is still occasionally observed. By the 1930s this ritual had begun to be less commonly seen, although in recent years it has become re-instated by members of the Strait Gate Lutheran Church in Light Pass, although the sweets are now replaced by a bottle of wine!

On the completion of the wedding ceremony, drinks and cake would be handed out by the bride, before the departure of the party for the home of the bride's parents for the wedding banquet. Festivities began with a wedding breakfast, and continued through to midnight with various courses including giblet noodle soup, chicken, geese, ducks, German meats, vegetables and perhaps sauerkraut, and finally a dessert of hot plum cake (or wine trifle and fruit salad if the weather was hot).

Although musicians were present, in the earlier years dancing was frowned upon by the strict Lutheran pastors. In one instance, a wedding which took place on 19 October 1853 in the Adelaide Hills German town of Lobethal was attended by half of its inhabitants. After the guests had 'eaten and drunk well, and were beginning to get merry', some began to dance, drawing in others until most of the assembly took part. Pastor Fritzsche, who had left soon after the ceremony to travel to Blumberg, returned to be told of the incident and immediately 'determined to stamp out this evil'. Communicants who took part were asked to make a public apology, but three who refused were excommunicated! In addition to normal services, church meetings were subsequently held every Sunday when 'the worldly dance was preached against'. The incident caused a schism in the congregation and the establishment of Lobethal's 'free' church. It was not until the 1940s that this attitude towards dancing was modified.

In the ritual of celebratory events, after the wedding meal, a local wit would entertain the guests with riddles, stories, and the recitation of a poem or the singing of songs specially composed for the bridal couple. Another custom, in the guise of game-playing, involved the sly removal of one of the bride's shoes which would then be 'auctioned' to the guests; the money realised was then placed in the shoe and both returned to the bride.

At midnight, following the wedding toasts, while the bridal hymn was sung, the bride's myrtle garland and groom's buttonhole were removed and hats placed on their heads as a sign of married life and the completion of festivities:

this was an especially sad moment and tears flowed among the guests. The garland and buttonhole were carefully preserved as mementoes within an elaborate frame and displayed in the couple's home. As the couple made their escape, the final 'barring the way' custom would be enacted once more.

The celebrations which accompanied wedding anniversaries were also an occasion for festivity, especially the silver wedding to which many guests were invited to share with the couple their joyful anniversary. Again the event required much food and drink: 'long tables set up for the many guests which father and mother had invited to share with them the joyful anniversary. We prepared and catered for three meals, one hot and two cold'. Typically, these festivities were accompanied with religious observance: '... in the afternoon a thanksgiving service was conducted by Pastor J. Zwar of Point Pass ... Since many of the guests still had to come by horse and buggy from far away, they had to stay with us or nearby for the night. About 80 partook of the mid-day meal with us the following day, including those who had spent the night in our home ...'

The all-important silver anniversary meant the giving of various silver orna-ments, including a framed embroidered declaration (see Chapter 6). As part of the formal ritual it was the duty of the first-born son to pin a silver buttonhole on his father and crown his mother with a silver garland, wishing them 'God's blessings for the years ahead ...' These festivities were always accompanied with a thanksgiving service conducted by the local pastor who had married the couple.

Barossa Funeral Lore

In the setting of the Barossa, the coming together of homeland Prussian customs associated with the rituals of burial, together with pervasive and fashionable Victorian approaches, gradually led to a funeral etiquette charac-teristic of the region.

In addition, the modern role of the funeral director in the Barossa essentially developed out of the trade of cabinetmaking. As factory-made furniture became available in the region, and as the train and other means of transport diminished its isolation from 1911, the cabinetmaker was forced to diversify his services. As coffinmaker and undertaker, this part of the cabinetmaker's work

gradually became the most important part of the business. This was especially so in the 1930s and 1940s, when the passing of aged second and third generation Barossa inhabitants provided one particular cabinetmaker with an average of three funerals per month.

The pastor conducts a service c. 1911. The traditional German coffin, made by a local village cabinetmaker, is decorated with black ribbons.

It was a competitive business: Barossa cabinetmakers regularly advertised in the local German language press, incidentally also revealing details about the funeral rituals within their community. The multi-skilled tradesman even developed a peculiar language and phraseology, so that sometimes he labelled himself as a 'buryer of bodies'. They vied with each for the custom of the bereaved with various enticements and services, such as the promise that 'coffins can be delivered within 6 hours – Hearses one pound [sterling] extra.'

Because of the high mortality due to childhood diseases of the period, some cabinetmaker-undertakers provided funerals for children at a cheaper rate 'from two pounds and five shillings,' in comparison to adult fees which ranged 'from four pounds and five shillings, including hearse, coffin and funeral shroud.' Indeed, competition was so fierce that the self-declared cartwright, wheelwright, builder, cabinetmaker, and undertaker Kleemann placed a notice in which he boasted to have 'corpses embalmed as I have taken a course in that'!

Funeral accessories made the rituals of death even more formal and distinctive: there were glass-covered metal or porcelain wreaths for graves; special shrouds to cover the body called *Sterbehemden* – as the tradition of dressing the dead in the Sunday best did not become commonplace until after the First

World War. The *Totenbahre*, a wooden bier for carrying the coffin by hand, pre-dated the use of the horse-drawn hearse in the Barossa – although even as late as 1989, a *Totenbahre* was used in a funeral service at Gruenberg. By 1937, all Barossa undertakers had replaced their horse-drawn vehicles with motorised hearses.

In the Barossa, there was a preference for coffins which were traditionally German in style – faceted and therefore more expensive. Sealed on the inside with melted pitch, they were then lined with either silk or calico, while black cloth with silvered paper decoration covered the outside with studs and ribbons; text on these included phrases such as *Schlafe wohl. Auf Wiedersehen* (sleep well – goodbye).

Barossa coffin lore includes the anecdote of Pauline, the wife of Wilhelm Schaedel the cabinetmaker, who lived in an elaborate dwelling in Nuriootpa (see Chapter 3). According to traditional family lore Pauline would, during hot afternoons, retire down into her husband's cool cellar-workshop where she would select a 'nice coffin in which to rest and escape from the heat'. Another tells of the cabinetmaker Nitschke of Stockwell who made his wife's and his own coffin in preparation for their future deaths: they were stored in the loft of the house until that time when 'all they had to do was add the lining'.

The typical Lutheran funeral as performed in the Barossa in about 1890, began at the house of the deceased where the coffin was placed under the verandah or in one of the rooms. Here, the deceased could be 'visited' and perhaps a flower placed in the open coffin. After conducting a short service, the entourage of pastor and mourners travelled, usually on foot and slowly, to the cemetery, preceded by a bearer with a black wooden cross on a pole. At the cemetery gates the black-garbed gathering sang a hymn as the coffin was carried from there to the grave. As well as tolling the death-knell on the day of the death, the chosen church would toll the bell at precisely eleven in the morning on the day of the funeral, a custom which is still current; although in earlier years, it was also tolled if the funeral cortege passed the church on the way to the cemetery, and even tolled three times at three intervals during the digging of the grave.

It was also the custom of the early Prussian settlers in the Barossa to ring the bell each day at sunset, summoning those toiling in the fields back home. To

this day, the bell (certainly of the Bethany church), is still rung at sunset on Saturday as a reminder that the next day was one of worship.

Early burial customs decreed that the coffin be placed aligned in an east–west direction so that, 'when the trumpets on Judgment Day sounded, the arisen would face east'. But if the deceased had died 'by his or her own hand', then the coffin was placed in the grave facing north–south, and often some-what separated from the main cemetery area with a shrub planted on the site. In some instances in the nineteenth century at the cemetery of the Strait Gate Lutheran Church in Light Pass, the coffin of such 'outcasts' was located partly underneath the cemetery fence! It was a custom observed by only a few churches, but was certainly no longer practised from the early 1900s.

Segregation of the sexes during the church service was standard procedure in the Lutheran church, but it was especially rigidly enforced by the strict reli-gious sect (of Lutherans) called the Moravian Brethren. At Bethel, a Moravian settlement located west of Kapunda just out of the northern reaches of the Barossa region, custom decreed that women enter by a door separate to that used by the men. This tradition was extended to burial with females and males kept separate even at death, as the earlier portion of the Bethel cemetery reveals. The austerity of these people was also reflected in their use of memorial stones which were restricted to plain tablets which avoided any decorative or symbolic inscriptions, and which reduced the deceased's identification to a number!

Homeopathy and Herbal Folklore

Johannes Menge appears to have been the first to speak of early Prussians' folk cures as a passenger on the *Coromandel* sailing to South Australia. While his fellow passengers suffered the ravages of sea-sickness, Menge was invigorated and refreshed as he 'sat in a bucket of seawater' offering the advice, coinciden-tally closely akin to current aromatherapy ideas, that '… you must take drugs that stimulate the nerves, e.g. ginger for the palate, gingerbread, fragrance for the nose because my snuff has served me very well indeed … Water mixed with some wine is in my opinion most beneficial and cooling …'

The traditions of the Barossa Lutherans naturally included a repertoire of herbal folk remedies and home cures. Chamomile tea, for example, was a

popular beverage drunk for a variety of ailments, and was sometimes homegrown or purchased dried. As early as 1839, in a letter home to fellow Lutherans, pastor August Kavel suggested they bring along with them seeds for herbal remedies such as St Johns wort, wormwood, cantaury, hemp and elderblossom.

East from Keyneton, the gently undulating landscape of the North Rhine follows a winding and steep track down the Barossa Ranges; these eastern slopes rapidly give way to the marginal lands of the Murray Mallee flats. Although this peripheral region of the Barossa was less productive country, from the latter part of the 1860s it became occupied mostly by Lutheran families who established the small settlements of Sedan, Towitta, Cambrai (originally Rhine Villa), and Steinfeld. Two English veterinarians, Lambert and Harris who were among the first to select land about Cambrai, immediately cleared the mallee and planted a garden of medicinal herbs which were to be used as part of their breeding and treatments: horehound (*Marrubium vulgare*) was one of the first plants they introduced. A native of southern Europe, horehound is a perennial herb which prefers dry places, and has long been used as an expectorant and for healing wounds. Unfortunately, as with many introductions of European plants, it became a 'garden escapee', adapting readily to the dry conditions which favoured its growth. To this day, farmers in the district still curse the two English 'vets' who released this plant, now naturalised about the Barossa and a declared noxious weed in South Australia.

An approach which became particularly prevalent among the Barossa Lutherans in Australia was homeopathy, a method for treating disease by the use of small amounts of a selective drug that, in healthy persons, produces symptoms similar to those of the disease being treated.

Among the earliest of the homeopathic practitioners of the Barossa was Johann Zwar of Neukirch, also a lay preacher and leader of one of the larger groups of Wends to migrate to the valley in 1851. Zwar is known to have imported patent homeopathic medicine from Leipzig where homeopathy was founded. His skills and practice were passed on to one of his sons while a second son (Dr Bernard Zwar) became chief surgeon at the Royal Melbourne Hospital.

Homeopathic medicine became an integral part of medical treatment in the Barossa and the Lutheran communities scattered about the colony, so much so

that many of the older folk had their own home homeopathic kits which included various herbal folk remedies – despite the availability of trained medical practitioners in the villages of the region from as early as the late 1840s. Homeopathic medicine also eventually became readily available from a number of pharmacists who worked in the Barossa. A Mrs Altmann was a well-known 'herb doctor' in and about the district of Moculta during the late nineteenth century, one of her sons eventually becoming a qualified physician.

Besides the 'conventional' treatments, the now renowned Heuzenroeder family of Tanunda specialised in Germanic homeopathic folk medicines (another branch of the family became, and still are, solicitors in the town). Moritz Joseph Heuzenroeder migrated with his family to the Barossa in 1845, and together with his brother Joseph, established the first pharmaceutical shop in Tanunda in 1849, where the Heuzenroeders supplied herbal remedies for a variety of ailments for a number of generations.

By the 1860s, the Heuzenroeder clan had also expanded into Adelaide where they supplied, as in Tanunda, numerous:

> prescriptions and family recipes, horse and cattle medicines, English, French, German and American patent medicines, all kinds of official plants, herbs, flowers, seeds and roots; alcoholmeters and areometers for guaging spirits, wines, milk and acid, and gelatine laine, known to be the best for fining wines, spirits and other liquers … [as well as] a constant supply of pure photographic chemicals …

In 1877 the Heuzenroeders were the first to import *Homopathicer Tropfen Kron Essenz* or 'Altona Drops' to South Australia from Germany. Altona Drops were used 'for aiding digestion and relief of offensive breath, loss of appetite and biliousness'. The medicine was made up of a mixture of aloe leaf resin, licorice root, ginger rhizome, myrrh resin and gentil root. In 1901, Moritz Heuzenroeder (not the patriarch, but his grandson), travelled to Germany where he secured the rights to make these and other mixtures from the original German prescriptions, as well as the right to market the mixture under the name Altona Drops. His own green bottles (until 1905 often embossed in a spiral around the small bottles in German *Die Keisserliche Privilegirt Altonariche EW Kron Essents*: Royal privileged Altona Drops or Crown Essence), were used to

hold his own mixture of this medicine. Later, amber and clear bottles with paper labels carried the medicine.

Another pharmaceutical shop was opened by Hermann Brauer in 1929. After much experimentation, Brauer developed his own prescription for Altona Drops which were flavoured with the addition of sweet orange fruit peel to offset the bitter taste. The Brauer family eventually developed into Brauer Biotherapy, manufacturing a large range of homeopathic medicines which are, somewhat ironically, now even exported from the Barossa to overseas destinations. Another family, the Appelts of Eudunda, also developed their own popular stomach tonic in the 1890s, a prescription which eventually became part of the traditional homeopathic prescriptions available from the Heuzenroeders, and indeed, are still available from the present-day Tanunda Pharmacy.

It is extraordinary to recount that Altona Drops are still taken by a proportion of the Barossa community to this day, an indication of how ingrained this medicine is in their culture! Another folk medicine introduced at the turn of the century and still in use in the Barossa is Dr Becker's E.T. *Essigsaure Tonerde* (or sour vinegar), used for a variety of ailments including inflammation and congestion.

Homeopathic medicines were also dispensed from the Willows Hospital at Light Pass, a private establishment which achieved an Australia-wide reputation. The story of its founding and expansion brings together traditional Germanic medicine with the scientific development of the field over the late nineteenth century. It also emphasises the intimate nature of the community of the Barossa, bringing together a number of key personalities mentioned elsewhere in this book, including John Howard Angas, son of George Fife Angas, and the Silesian master cabinetmaker Karl Launer.

The establishment of the hospital occurred almost as a matter of chance, beginning with the arrival in the colony of the forty-year-old Johann Gottfried Scholz, with his wife and seven children, in 1845. They were among the earliest of the German settlers in Light Pass, selecting a large parcel of land on the plains straddling the North Para River. Scholz's intentions were to farm the property, but his skills as a naturopath, and particularly as a 'bone setter' – skills he had learnt in the Prussian Army – quickly became widely known and sought

after by the Lutherans of the valley. As demand for his services grew, it became necessary to erect a pug building alongside his home where he could treat people.

The expansion of this primitive hut into a large, well-furnished hospital is told in a well-known local anecdote. In 1855, John Howard Angas had broken his leg in a riding accident, but had received unsatisfactory treatment in Adelaide with the result that his limb became deformed. When he was told of Scholz's skills Angas decided to seek out further treatment from him in the hope of restoring his leg's use. He was dismayed to hear Scholz's opinion that the limb had to be re-fractured. Angas refused this treatment, considering it too radical. It was then, while Angas was momentarily preoccupied, that Scholz seized his leg and re-fractured it with a sudden, expert movement! Set correctly, the fracture healed perfectly allowing Angas to ride his beloved horses once again. In gratitude, he gave Scholz a generous sum of money which was used for extensions onto the pug and straw home. Later, in early 1883, Johann's eldest son Wilhelm Heinrich who had been trained by his father, was able to build an extensive stone and brick hospital which specialised in fractures and rheumatic diseases, eventually taking over the operations of the hospital, as did his sons in later years. The fourth generation included a registered physiotherapist, while a fifth generation son, Herbert Bernhard, maintained the hospital following his education at Adelaide's medical school. Although the hospital closed its doors in the 1950s, Dr Herbert Bernhard Scholz continued to see outpatients until the late 1960s.

At the time of its expansion in 1883, Wilhelm Heinrich Scholz also needed to furnish the hospital with various pieces of specialty furniture, hence his approach to the master cabinetmaker Karl Launer who then worked in nearby Stockwell (see Chapter 6). The cabinetmaker was commissioned by the Willows Hospital at Light Pass to make some specially designed pieces. Launer was well known by the settlers of the district, including the Scholz's, as the two families had been pioneers in the area, as well as neighbours, their respective properties having once been located less than a kilometre apart. Among the pieces Launer constructed was an apothecary cabinet suitable for storing Scholz's homeopathic medications, poultices, ointments, lotions and liniments – all based on original recipes handed down from father to son. Another

piece, a dresser, also made by Launer, held various medical instruments, in this instance discreetly kept hidden from patient's eyes behind frosted, glazed-glass doors!

Hexes and other Early Magic Superstitions

Although a pious man, as well as an acknowledged genius and master of many languages, Johannes Menge the mineralogist and explorer (see Chapter 1), was also known to hold some strange ideas, and even to be quite superstitious. For example, he strongly held to the belief that the best cure for any form of physical ill health, was 'motion', especially walking. Thus on one occasion when he had influenza, which he attributed to 'little demons', he purportedly rid himself of them by taking 'a walk to Tanunda ...'!

Menge's superstitious nature reveals an aspect of the early Lutherans that is little known. Although the pious nature of the Barossa Lutherans generally left little room for superstition, the peasant backgrounds of these early migrants inclined them towards a literal following of the Bible which sometimes engendered supernatural or folk beliefs. Furthermore, besides the Old Lutherans and Moravians who founded the chief religious-agricultural communities in the Barossa, its settlement included a notable proportion of Wends, a group especially predisposed to hold superstitious beliefs.

The Wends were the survivors of two Slavic tribes which once occupied vast areas of east Germany. By the sixth century the name Wend was only retained by a small ethnic group living in a region of south-eastern Germany called Lusatia. Even as recently as the latter part of the nineteenth century, the Wends (now referred to as Sorbs), were thought to be a mystical people: 'the spirit world was very real to them.' Long-term economic and social forces led to Wendish migration to Australia, the first migrants arriving in 1848, and most in the following decade. Many Wends settled in the northern portion of the Barossa Valley, founding Ebenezer, and further west and north establishing the Neukirch, and the Dutton–St Kitts and Bethel communities. Later, groups of families moved to Moculta and further east to open up and settle about the dryer plains of the Cambrai–Sedan region to the east of the Barossa ranges.

Given the primitive state of existing tracks and roads and the reliance on walking and wagons for transport, these outlying Wendish communities were

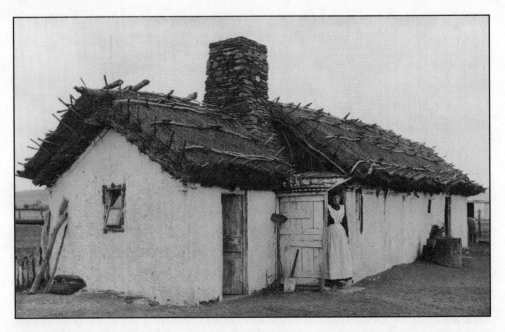

quite isolated from the main Lutheran community which was centred in the Barossa Valley around Tanunda. This was so particularly in the early years of Wendish settlement in the Barossa. Hence, prior to their eventual integration into the region's mainstream Lutheran communities, these Wendish folk (who did not quite see themselves as German but were often bilingual) lived in insular communities where, not surprisingly, the desolate – and mysterious – setting of the Barossa's frontier wilderness, provided conditions which favoured the retention of Old World folk beliefs, including white magic and witchcraft, well into the twentieth century.

Among these Wendish home-grown folk beliefs, one which was especially persistent in surviving in the Barossa, was that of the so-called Sixth and Seventh books of Moses. Beyond the Five Books of the Testament, these Sixth and

Built in the 1860s this wattle and daub cottage appears well-preserved in this 1902 photograph. Note the white-washed walls and thatched roof; today nothing remains. Old World superstitions lingered on the isolated frontier of the early Barossa.

Seventh books were believed to exist in Wendish folklore as a source of knowledge on magic and witchcraft. Copies were apparently brought over from the Old World, accompanying the Wends into their frontier Barossa communities. The books purportedly explained how to cast spells or hexes (from *Hexe* which means 'witch'), while other folk tales explained the necessity of all seven books if such spells were to be counteracted! Copies of these so-called Sixth and Seventh books were eventually destroyed, and one story recounts that when one aged owner eventually died, the books were placed in his coffin which was then ritually dropped three times before its burial.

Sites of Wendish settlement, as listed earlier, are the most usual localities where stories of witchcraft and magic beliefs have originated and were, for a time, perpetuated in the Barossa. These folk beliefs and tales generally date from the period of settlement through to the 1920s, although a few 'white magic' oral traditions survive to this day among a scattering of the older generation.

Any succession of misfortunes evokes a need to seek explanation, and in the medieval world of the early Prussian, and wider European setting, suspicion would turn to those individuals in a community who seemed to stand out or at least not fully comply with group standards and expectations. Such individuals become the scapegoat, or the 'witch'. Other individuals in the community attain the status of the 'wise person' who has the knowledge to deal with what are mistakenly perceived as unusual occurrences; they provide an appropriate magical cure.

Not surprisingly, more often than not, the Barossa 'hex' tales centre around a particular old woman, in a specific community, considered by some to be a witch, and therefore able to curse or 'hex' people. Even as late as the 1920s, one woman who had to visit another rumoured to be a *hexe*, tied a red ribbon around her neck as a precaution in order to prevent a spell being placed on her. Others in a similar situation believed that wearing one's underwear inside out would prevent them from being hexed!

Hexes tended to be relatively harmless and at most, irritating events: one story relates a couple travelling along in a horse-drawn buggy when, on passing a particular cottage, a wheel fell off! A related story tells of a pastor approaching the woman of the cottage and her son, when 'the wheels suddenly

froze and wouldn't turn for about a chain until he was past the couple'. And again, when this couple walked past their neighbour's houses at night, 'the crockery would crack and break'.

Other tales about such hexes or spells have also survived. One recounts the placing of a spell or curse on a neighbour's farm affecting the animals such that the cows ceased to produce milk and hens stopped laying eggs. Another involves the constant problems a particular family was experiencing: 'they were hexed', was the explanation. Approaching someone known to have knowledge of curses, they were advised to slaughter a calf and hang its liver in their fireplace above a fire. 'When this was done, an evil spirit came to the family and begged them to take the liver away as it was slowly being killed. This was done on the condition that the spirit removed the curse from the family'.

Then there are folk tales of the inexplicable, including the reminiscences of a certain Nuriootpa man who was fond of riding horses. One day he discovered that whenever he rode close to a particular house in Light Pass, his horse would buck and refuse to pass. Another story dated to about 1875, tells of a young lady who had to walk through Light Pass on her way to grape-picking. 'On her return home, she saw a white piece of cloth on the roadside which she bent to pick up, only to see it suddenly change into a white bonnet and fly away … it was very frightening.'

Another 'frightening' experience occurred later, in about 1915, to a particular farmer who was making his way home with his horse-drawn reaping machine. 'He was startled to see a shadow as if a huge flapping bird was hovering above and following him. Looking up, there was nothing in sight. It was not until he reached the farmstead that the shadow disappeared'. Other reminiscences disclose simply that 'things happened', such as in Light Pass when 'a root of a tree would suddenly seem to appear and cause some unfortunate person to stumble and trip … it was said to have been caused by someone doing hexen'. Others were convinced that the hexen could make objects 'move across a room'.

Oral traditions also existed about white magic being invoked, such as the instance when a family was puzzled about why they were not getting any milk from their cows. They consulted with someone 'who knew witchcraft, who advised them to put the little milk they were getting into the hollow stump of

a tree. After this was done, their cows produced milk as usual ...' Another story relates how the neighbours feared the local village 'witch', and that when 'somebody threw her magic book into the fire, it jumped out of its own accord!'.

While oral folk beliefs and traditions relating to this topic have practically died out, there is a reluctance to talk about them for fear of ridicule. And while those of past generations who once held such beliefs are lampooned, some nevertheless speak of the sense of 'eeriness and mystery' that such folk tales can still evoke.

Certainly, from a folklorist or ethnographic viewpoint, the evidence for such folk beliefs is gathered from personal experience or from close friends and neighbours, or from those generations now deceased who passed their stories of witches, magic and hexes on to others of their community who relayed these from one to another. As such, even if these are mere folk beliefs, they are stories which cannot be dismissed, for they contribute to the colour and texture of early Barossa folklife.

The End of the Millennium, the Devil and Kaiserstuhl

An early folk tale of the Barossa was first recounted as far back as 1851 by the German visitor and writer Friedrich Gerstaecker. His published account of his travels in the Barossa provided insightful glimpses into the social and political make-up of its German community. In his memoirs of his journey, Gerstaecker described Tanunda with some emphasis and not a little drollery, as 'a nice little place but *entirely* German'. He especially adopted a somewhat humorous and ironical tone when speaking of its early Lutheran community which had, by the time of his visit, been experiencing some discord. Gerstaecker's tendency to satirise these folk no doubt stemmed from his perspective as an urbanised or 'modern' German confronting Old Lutherans, then rarely found in his homeland. He further stresses this when, following his visit to Tanunda in 1851 he later wrote: 'the traveller would believe himself in some little village of the old country between the Rhine and the Oder.' The latter was essentially the region of origin of the early Barossan settlers, and it was their near replication of the 'old' ways, customs and traditions of a past Silesia, one no longer recognisable in his own country, that he was emphasising to the reader.

And it was the peasants of the rural frontier regions of pre-industrial Silesia that had long held to a particularly fervent and even mystical, form of Christianity. Their farming and artisan communities, the source of a large proportion of Barossa pioneers, produced a number of renowned mystics including, for example, the Silesian cobbler-mystic of Gorlitz, Jakob Boehme (1575–1624). It is interesting to note that the mystic and visionary Quirinus Kuhlmann, 1651–1689, a zealot who was himself influenced by Jakob Boehme, published his ideas in a book *Newly Inspired Bohme*, a copy of which is in the collection of the Tanunda Archives and Historical Trust. This copy had been brought to the Barossa Valley by Pastor Georg Heidenreich who was the residing minister in Bethany from 1866 to 1910.

The influence of individuals such as these extended to some of the folk who comprised the early migrant groups to South Australia, and accounts in part for a tendency towards a mystical or literal 'chialism' found in some of the early congregations in the Barossa region; from this background emerged their tendency to hold superstitious folk beliefs as related earlier. Chialism, or millennialism, was an early Christian belief (based on Revelation 20:1–5) of a future millennium (a thousand years) following the Second Coming of Christ and His reign on earth in peace.

Given the preceding background and setting, there is therefore little doubt that the following story, which became something of a legend, was Gerstaecker's way of lampooning the religious conservatism and shreds of mysticism of some of the Barossa Germans he met. Indeed, the Barossa's Old Lutherans had already achieved publicity for running theological disputes which had split their community into two synods. Chialism had become such a significant force in the fledgling Lutheran church in South Australia during the mid-1840s, that tensions between chialistic and non-chialistic groups in the congregations of Kavel and Fritzsche led to a schism during a synod held in 1846: the split was to last well into the twentieth century.

Among the early Prussian arrivals was the strange personality of Friedrich Krummnow, a rebellious and fanatical migrant who was a millennialist and who claimed to work miracles. Contemporaries who held him in awe also claimed he had 'hypnotic powers'. A shoemaker by trade, Krummnow held strong Christian socialist ideals which clashed with those of his fellow Old Lutheran

settlers. His unprincipled dealings concerning land trusted under his name on behalf of the Lobethal pioneers, eventually led to his expulsion. Meanwhile, it is not surprising that, given the setting of the strange country, his influence as a prophet over the refugee settlers of peasant stock was quite powerful. Prior to his departure, Krummnow also reinforced the millennial ideas held by Kavel who had become somewhat obsessed with the prophecy of Christ's return, as indicated in chapter twenty of the Book of Revelation.

It was Pastor Kavel's strongly held chialistic belief that the millennium was nigh, which was especially singled out by Gerstaecker. As a liberated European, he found these beliefs outmoded and ridiculous, and as a consequence, in order to satirise them, he exaggerated and possibly even created the following anecdote. 'Kavel ... had the unfortunate idea of prophesying the very day and hour the world would come to an end ...' Convinced of his prophecy, one day his millennial followers congregated with their pastor at a particular creek outside Tanunda 'to await the Messiah. However, instead a heavy storm broke. It drenched them and that evening they did not sleep in paradise but they slept once again in their own beds ... Meanwhile Pastor Kavel undiscouraged, moved this event forward to 1899–1900.'

Rivalry and conflict between the differing congregations, led by Pastor Kavel on the one hand and on the other, Pastor Fritzsche (the religious leader of the second vessel of dissenting Old Lutherans who had arrived in Australia in 1841 and had settled mostly at Lobethal), provoked various attempts at ridicule as another apocryphal Barossa story reveals. A member of Pastor Kavel's congregation had a vision of Mephistopheles appearing on the Kaiserstuhl (the Barossa's highest peak) at midnight on a particular day. Accordingly, a Tanunda blacksmith was ordered to make 'a mighty chain with which to chain up the devil for 1000 years ...' An extension of this tale recounts how the members of Kavel's congregation followed him up the slopes of Kaiserstuhl with the intention of capturing Mephistopheles and binding him in the chains they were carrying. Yet another story combines this with Gerstaecker's tale, and has Kavel and his congregation climbing to the top of Kaiserstuhl 'to await the millennium', only to be driven down by a fierce thunderstorm!

His chialistic beliefs aside, Pastor Kavel has been accorded the greatest respect as a religious leader, for he was the pilgrim father who guided the

persecuted Old Lutherans across the world to the new land, and even as one contemporary put it, 'a Moses who saved his people'.

There are other anecdotes, less likely to be apocryphal than the preceding tales, relating to these Barossa folk and their relationship to the land. It would seem that the penchant for picnics in the multitude of idyllic settings to be found in the valley and its hills may have begun early on with the pioneers delight in the natural environment they encountered. Stories abound of their treks into the hills in the pioneering years when the bush was uncleared on the slopes, and the abundance of native flowering plants enthralled their eyes.

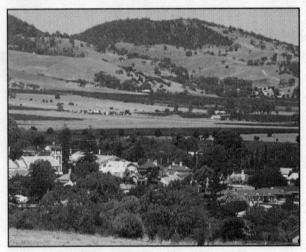

The township of Tanunda. Visible are the spires of one of its four Lutheran churches. In the background looms Kaiserstuhl, the location of a number of Barossa tales and legends.

It was in these early years that a legend emerged of the special services of praise held high up on the peak of Kaiserstuhl. The Bethany congregation, the story recounts, built a crude pulpit around which large stones were arranged as seating. These services were held between 1846 and 1862, when Pastor Heinrich August Meyer was the first resident minister in Bethany. There, at the peak of Kaiserstuhl which commanded a view of the whole valley and beyond, even to the distant gulf waters, Pastor Meyer would deliver a passionate *Bergpredigt*, a discourse on the Sermon on the Mount. And through the gumtrees and sheoaks, high up above the valley, soared the voices of the congregation singing their hymns with such gusto as to be 'heard for miles'. While Pastor Meyer's widow later denied that this occurred, picnics were apparently held on the peak, and stones were arranged as a form of seating for these events. Time and imagination, and perhaps a germ of truth, may have led to the legend.

Although a part of Barossan tradition, there is no evidence of this folk tale to be found at the peak of Kaiserstuhl. Furthermore, the intriguing remains of what some observers have described as possibly being an 'open air sanctuary or church' at the northern foot of Kaiserstuhl – a pile of boulders at one end of a cleared rectangular space lined with planted gumtrees – is unlikely to be connected to this tale.

Siebenschlaefer

Other folk beliefs or customs, such as forecasting the weather, were possibly based on the experience a farmer accumulated over the years. One of these, *Wetterbaum* (weather tree), emerged from the observation of particular cloud formations which resembled the shape of pine trees. If these were seen then rain was forecast to arrive in three days. Arthur Falland, life-long farmer at Moculta, speaking in 1988, related how he read the signs: 'If it rained on the 27th of June, then it'll rain for the next seven weeks ... this was called the Siebenschlaefer'. In fact *Siebenschlaefer* (seven sleepers) was derived from an ancient German myth some 14 centuries old!

The *Siebenschlaefer* myth is based on the complex story of the 'Seven Sleepers of Ephesus'. Briefly, seven brothers, refusing to give up their Christian faith are entombed in a cave on the orders of the Roman Emperor Decius. Giving themselves up to God, they entered a sleep which lasted 196 years, eventually waking up when a passing shepherd discovered and opened the cave. Now, under the Emperor Theodosius, Christians were free to follow their faith, and following the appearance of the seven brothers 'to all believers', they returned to the cave to sleep this time, 'without awakening'. A church was founded on the site of the cave.

In the Barossa Valley, *Siebenschlaefer*, now meaning seven weeks of rain, continues to be linked by some of the older generation to 27 June (the middle of the southern winter).

The Cycle of Seasonal Customs

In the Barossa, the solar year, agricultural activities and the church calendar accounted for a cycle of seasonal customs, including Christmas and Easter, spring festivals and the harvest.

The Lutheran Christmas includes its feast of traditional German foods with *Honigkuchen* or honey cakes, while a plaited Advent wreath with four candles and garlands of tree branches and flowers, together with an ornamental tree, decorates the church (Chapter 5). Indeed, the Christmas tree tradition originated in Germany, and sacred trees are the basis of a number of folk customs and motifs, including the tree of life (from which Adam and Eve ate), and the maypole. In the Barossa, trees were obtained by cutting down small native cypress pines, once common in the valley, or else a German wooden tree based on traditional folk design was constructed and used each year. This consisted of a bevelled base which held a central upright 'trunk' with shaped radiating branches on the sides to which ornaments and candles were attached. Their sizes ranged from a towering three metres to small table models. The village carpenter Adolph Rohrlach made such a large wooden-frame tree for St John's Lutheran Church in Springton, its finial ornament including a wheel arrangement of a central star and angel figures which turned in the rising warm air from the candles. The danger of the candles setting fire to the pine branches tied to the frame was a real one, and David Herbig has chronicled the reminiscences of one of the daughters of the carpenter, Adolph, who recalled how her father sat nearby the tree during the service, blowing out any fires with a long hollow pipe. From the late nineteenth century, the more well-to-do wine families could afford to purchase imported green-dyed, goose-feather trees from Germany complete with decorations and a mechanical musical device which played popular carols.

Easter similarly involved various celebrations which combined religious activities with popular customs retained from the pre-Christian era. The giving of Easter eggs during this point in the Lutheran church calender symbolised new life and its associations of rebirth, renewal and resurrection. This custom takes on even greater significance when we recall that in Europe, Easter followed a long and cold winter. It was a popular family activity, and in the Barossa, hard-boiled eggs are still coloured using either imported dyes or home-made colours obtained from boiled onion skins, beets or other recipes. The children were then set to making 'nests' of paper or straw which were used by the parents to hold these eggs. The nests were hidden about the house and garden and the children would excitedly rise early on Easter Sunday morning to search for these. The latter idea of searching for eggs in the garden evokes

the more ancient custom of hiding them in the forest, or so one Barossa local, Bertha Hahn, surmised.

Another Easter custom imported into the Barossa from Europe by early German migrants, consisted of groups of young girls assembling and singing in front of village homes after midnight on Easter morning.

George Nielsen has recorded that this custom was observed for a time by Wendish settlers at Peter's Hill (north of the Barossa), although they assembled at the local cemetery to sing from sunset on Easter Saturday until midnight.

Erntedankfest, Harvest Thanksgiving, was one traditional German custom celebrated at the completion of the grape harvest. Members of various church congregations decorated the interior of their church with wreaths and examples of farm or garden produce. After a service, thanksgiving songs or hymns were sung. Vestiges of ancient rituals were associated with the giving of thanks for a successful harvest and securing a promise for the next. This once included the making of small straw figures as offerings, a practice that may have occurred in some of the outlying Barossa communities. Ewald Graetz, the local cabinetmaker at Graetztown near Keyneton, in the remote north-east district of the Barossa Valley, for example, was known to make simple orna-mental objects of plaited straw. Usually made at Christmas time, these animal figures and toys were painted in a variety of colours, then sold at fairs.

Covering Mirror Surfaces and Other Folk Beliefs

One belief occasionally still to be found among some of the Barossa folk, is the custom of covering mirror surfaces during a thunderstorm, in order to prevent the lightening from being 'drawn and reflected' from their surfaces: 'thunder and lightning were the anger of God'. Sometimes there was also a specific loca-tion, the cellar or a particular darkened room, to which the inhabitants would withdraw during severe thunderstorms.

Although the special mirror covers which were once crocheted are no longer used, the habit of covering mirrors during thunderstorms – by drawing the window blinds or using a sheet – still lingers! As well, the custom advising against the use of scissors and knives during electrical thunderstorms, is still fre-quently observed, some inhabitants covering or putting them away in drawers.

Another early Barossa folk custom decreed that it was ill-advised for pregnant

women to leave the shelter of the cottage roof where they were protected from 'demons'. Once more, this may have had its origins in medieval beliefs, as might be the delightful custom of the raising of a wreath, or *Kranz*, onto a partly-completed house. This ritual, 'putting the kranz up' as Bertha Hahn recounted to me, involved the raising of a large wreath of greenery onto the roof of the newly-completed timber frame of the house, or 'when the walls were ready for the roof', as another informant, Ruby Fechner, put it. The ritual was finalised with those present having drinks. Performed in the presence of the family, the wreath remained on the roof frame until the tin sheets were attached.

The Barossa folk were also fond of displaying textiles embroidered with quotations from the Bible, catechisms or homilies known as *Haussprüche* – these purportedly protected the home. This custom sometimes extended to the placement of a sign over the front entrance portal.

Barossa Symbolism

The generally austere setting of Barossa folklife was enlivened with a wealth of visual motifs. Barossa furniture, gravestones, embroidery, and other articles were often decorated with a selection from a repertoire of folk motifs: these were sometimes representational, such as figures of Adam and Eve, the ever popular heart, the tree of life, anchors, dolphins, birds, tulips, vines and grapes, and myrtle. Others motifs were geometric, and commonly included stars, whorls, herringbone pattern and diamonds.

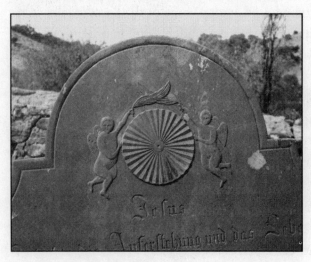

The art of the Barossa stonemason is evident in this 1867 slate headstone with its folk-style angels holding symbolic feathers over the wheel motif, a symbol of Christ, divine power or eternity. Note the early Gothic German text.

Beyond the decorative, these motifs embodied various meanings: geometric and abstract motifs signify order, while the representational indicate life. Each motif had its own meaning, usually associated with Christianity. Hence, the dolphin symbolised resurrection, while the tree of life links heaven and earth; the wheel motif symbolised Christ, divine power or eternity; Christian symbolism relating to the vine and grape refers to the relationship between God and His people; the vine is also the symbol of Christ ('I am the true vine ...'), an especially evocative motif for the Barossa given its emphasis as a viticultural and winemaking region, as well as its strong religious-based cultural roots. It is found carved on altars, gravestones and furniture, painted on church walls, embroidered on religious textiles, and burned as pokerwork on wooden wall plaques.

Geometric motifs such as the star signified the cosmos and its inherent order, or celebrated the creation; the eight-pointed stars symbolised divine guidance or represented the Star of the East. Stars are commonly found on gravestones, furniture and church ceilings.

Given the history of persecution of the early Lutheran pioneers, the anchor, the symbol for a safe haven or harbour, became a traditional symbol for spiritual refuge, as well as one of hope and steadfastness, and often found in combination with the heart and cross, is one of the most common of the Lutheran motifs seen in the Barossa. It occurs on gravestones, house datestones, and on hand-painted illustrations

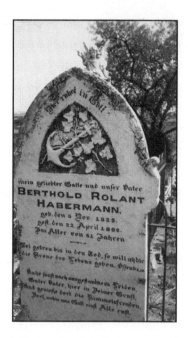

The anchor became a favourite Barossa-German symbol of the spiritual home.

Gravemarker carved from redgum with a cast-lead angel, 1860.

and embroideries. It was so significant to these people that even today, it continues to be used in the form of a floral or baked bread anchor as part of the harvest thanksgiving decorations in church.

Symbolic meaning could also be expressed through colour: blue was the favourite colour of the pious Barossa Lutherans, especially those of Wendish origin. This blue background, *Himmelsblau*, symbolised heavenly love or the colour of truth. The interior walls of churches were once also painted a deep red representing the colour of blood or fire and symbolising confession as well as the Holy Spirit. Over the years, this distinctive blue and red combination was transferred to that ubiquitous Barossa item, the German wagon, with the wheels painted red and the body blue. Furniture was also often finished in this colour combination, especially the German dresser which would be stained a claret red on the exterior and blue in its interior shelf rack, creating a pleasing combination.

These colours and the preceding folk motifs were derived from time-honoured traditions which, in the Barossa's Germanic cultural context, conferred an east-central European flavour to the exterior and interior setting of village, church and home, evoking a sense of familiarity and cultural continuity with the Old World.

Communal existence implied a necessary obligation to conform to time-honoured aesthetic traditions which had been laid down chiefly by Old Lutheran values which, in turn, dictated a sense of integrity, plainness and stability. Because 'worldly-mindedness' was precluded by the strictness of the early Barossa Lutheran Church, there was little room for artistic innovation by the village mason, cabinetmaker, and painter – or even the *Hausfrau* embroidering home or church textiles – at least not until attitudes had softened towards the end of the nineteenth century. Hence the 'acceptable' set of folk motifs which expressed community values and taste.

Therefore, in our enjoyment and understanding of the Germanic character of the Barossa's landscape, we should not overlook the subtle contribution made by its visual and symbolic heritage of motifs, forms, colours and symbols.

Architecture

Medieval Black Kitchens to

Neo-Classical Estates

'The effect of the house ... and the surrounding park-like domain, is quite English; and there is a gentlemanly air about the whole ...'
'Old Colonist'

*F*achwerk and thatched roofs, wattle and daub, dressed ironstone and sandstock bricks, corrugated iron and adzed redgum beams – the defining character of the Barossa's early landscape emerged from its ready supply of natural resources and the cultural preferences of its pioneers. From the humble Prussian pioneer cottage to the proud elegance of a steepled Lutheran church; from the stately estate homes of the British settlers, to the showy facades of wineries, the Barossa is endowed with a rich architectural heritage expressive of its distinctive mix of place and people.

The Barossa's unique village and townscapes consist of a mix of domestic, religious, commercial, educational and public buildings dating from the early settlement period through to the present. The contemporary traveller's journey through the region can be an architectural excursion which focuses on a

fascinating diversity of styles ranging from the primitive to the Germanic medieval and neo-classical, from Victorian villa to Australian rural vernacular.

Beyond their peculiar clustering and layout over the land, these structures tell us much about the use of local materials (and hence local geology), the differing building techniques, the lives of individuals and their community, and the social and cultural changes which occurred in the region over time.

Domestic Architecture

The very earliest permanent dwellings to be constructed by German settlers in the Barossa were built of either wattle and daub, half-timber *Fachwerk*, or stone. Although the necessity of providing shelter as quickly as possible often meant that the earliest cottages were primitive, these were, nevertheless, distinctive one or two-roomed huts, built of wattle and daub, usually with a stone chimney and thatched roof. Amazingly, a handful still exist, due to the frugal habit of pioneers to incorporate them into later building extensions; others survive relatively intact having been built in the early 1850s in outlying, remote, areas of the Barossa.

However, even prior to the building of the aforementioned primitive cottages, pioneers sought various means of obtaining quick shelter: a large hole excavated in the ground and covered by a hessian sheet was one easy means of providing protection from the weather. Others made use of existing features, especially the scattering of massive old redgum trees, many with their huge

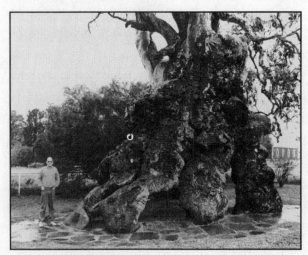

For almost five years, the Herbig Tree, a centuries old redgum in Springton, was home to a Silesian family. David Herbig, fifth-generation descendant, stands alongside the venerable tree.

trunks hollowed out by Aboriginal fires before European settlement, which could provide temporary shelter.

One of these, a hollow, centuries-old, immense gum which is still growing at the southern end of Springton, was once home to the Herbig family. Among the earliest pioneers in the district, Johann Friedrich Herbig (1828–1886) lived in the hollow tree from late 1855 through to 1860. From Gruenberg, Silesia, Herbig was a tailor-turned-dairy farmer; he was joined by his wife Caroline in 1858 who bore their first child in the old gumtree a year later.

In 1860, following the birth of their second child in the tree, it became clear that the family would need more room. They eventually moved, later that year, to a nearby two-roomed redgum, pine and pug hut with thatched roof built by Friedrich. The Herbig family continued to expand so that, by 1864, following the births of two more sons, Friedrich built yet another home, this time a larger, stone house alongside the cottage. The family eventually grew to number sixteen, with the pug cottage used as a dormitory by the boys, and the stone house by the parents and the girls of the family, as well as Friedrich's mother.

The pine and pug cottage is now preserved almost in its original state as is the more substantial stone house, while four hundred metres downstream, the Herbig Tree itself has become a much-celebrated example of pioneer adaptability. It may be visited at Springton, a small borough located in the south-east corner of the Barossa Range, at the head of the 'Valley of the Rhine' as Menge named it.

Other early domestic buildings and farmhouses relied on the more substantial traditional *Fachwerk* construction techniques. These buildings were somewhat more complex and larger than the one-roomed cottages first constructed at Bethany. As well as utilising early East Prussian building techniques, their layouts also followed very early building styles dating back to the seventeenth and eighteenth centuries. *Fachwerk* or half-timber work, consisted of the construction of a timber-frame and panels, usually of adzed and dressed redgum timber neatly held together with wooden pins. These timber-framed panels were then filled with a mixture of mud and straw, or mud bricks, and in some instances with fired bricks. The outer and inner surfaces were then whitewashed to provide a neater appearance and produce a more water-resistant surface.

In Light Pass, a rare surviving *Fachwerk* farmhouse is a time capsule which preserves the lingering medieval flavour of an ancient building technique and style. It combines a stable for farm animals under the same roof as the family which lived and slept in two adjoining small rooms. As such, it is a poignant reminder of the close association peasant farmers once had with their domestic animals in rural Silesia.

Otherwise, the usual plan of the early Barossa *Fachwerk* farmhouse consisted of a rectangular layout with front and rear doors which were centrally-located. These opened onto a central passage called a through-kitchen hallway which housed the family hearth. Here, the housewife prepared and cooked the meals, the smoke blackening the hall space, hence the traditional term *Schwarze Küche* meaning 'black kitchen'. Above, the room tapered upwards and the ceiling opened into a large brick chimney which provided a space for hams and other meat to be hung and smoked; the rafters from which these meats hung were reached through a small trapdoor accessible from the loft above the ceiling. The loft itself was created by the 45 degree-pitched gable roof, originally thatched, but subsequently clad with galvanised iron – now a recognised Australian vernacular material.

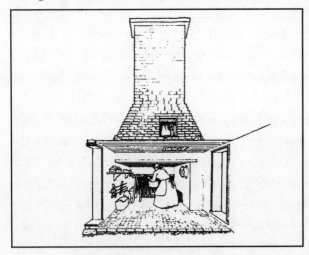

The *Schwarze Küche*, or black kitchen, was a medieval-like structure which provided a cooking area, chimney and kitchen in a single space.

As well as providing useful storage space, the loft was often designated as the place where the younger boys of the family slept; it was reached by either an interior steep ladder leading to a ceiling trapdoor, or else through an external attic door and ladder. While high-pitched roofs may have been

necessary for shedding snow in Germany, it took a few decades for these Prussian settlers to realise that they were superfluous in the Barossa's Mediterranean climate.

In some cottages of this type, alternative layouts omitted the rear door so that entry through the central door led directly to a black kitchen – as the surviving example at Light Pass reveals. From this tiny area, which included just enough space to prepare and cook food, a set of narrow stairs twists down to a surprisingly spacious cellar. The cool cellar was indispensable to the Barossa household as it was here that wine, garden vegetables and fruit, preserves and meats were stored, either on wooden shelves or in a collection of moveable, traditional zinc-meshed and timber food safes.

Luhrs Cottage in Light Pass, built in about 1847, is another example of the adobe style: its walls consist of mud and straw, while the frame is of hand-adzed redgum. Restored in 1984, visitors walking into this four roomed dwelling will note the very low entrance doorway and ceilings, tiny rooms, brick paved floors (originally stone), and furnishings which are similar to those used in the later years of the nineteenth century.

Most families built separate cottages for the living and sleeping areas, with the kitchen being an additional hut or cottage with a substantial brick or stone bake-oven. Examples of the bake-house, in various states of repair, are still to be seen scattered throughout the Barossa landscape. While the open-hearth layout of the black kitchen was generally restricted to the more affluent landholder, as it necessitated the building of a substantial large brick chimney, the more primitive cottages were supplied with simple smoke vents in the thatched roof which proved a risky combination. This ever-present danger eventually led to the idea of the bake-oven being contained in a kitchen building separate from the main dwelling, hence reducing the serious fire risk. It was an innovation which was enforced as early as the eighteenth century by Prussian government regulations. Its transfer to the Barossa in the nineteenth century led the bake-oven kitchen to become a common structure in the Barossa region (see Chapter 5).

Given the ravages of time and progress, visitors to the Barossa will be less likely to encounter the aforementioned types of early dwellings than the considerably more prominent larger and more ornate brick and stone villas,

increasingly built from the 1880s as the expansion of viticultural, farming and trade activities increased family wealth. The bay window, cast-iron lace and return verandah style of the Victorian era dominate the neat, tree-lined suburbs of Tanunda and Nuriootpa, with a number of splendid examples greeting the visitor at the southern entrance to Tanunda.

Throughout the Barossa region one comes across dwellings and other buildings where the galvanised iron and timber verandah appears as a later, and sometimes incongruous, addition. In some cases, the verandah was added to English villa-derived homes as a gesture to the intensity of the Australian summer sun, rather than for practical purposes. This is particularly so when the structure was added to the southern side of the building, rather than to the north and west facing facade which receives the greatest exposure. Derived from the Anglo-Indian verandah, the Australian version adds a vernacular element to otherwise essentially British or central-European structures. As the original, pioneer dwellings progressively deteriorated, their thatched roofs were covered in galvanised iron, while *Fachwerk* cottages had villa-style verandahs added to their southern facades in the late nineteenth century, as examples in Bethany illustrate.

It is still possible to see survivors of earlier, Germanic, building styles close to their original form. One example is the high-lofted Rieschieck house on the north-west corner of Goat Square in Tanunda. The original home of the Silesian shoemaker and winemaker Gottlob Rieschieck, it was constructed on the boundary of the square and intersecting street in the late 1850s, and features a very large wine cellar. It was used for church services from 1860 to 1862 by the breakaway Langmeil congregation while St Johns was being built. Other examples of this early Germanic style include a handful of cottages and barns constructed from the local dark red ironstone along Langmeil Road. A stroll along Bethany village's main road reveals a number of surviving examples of early Germanic architectural styles, including the steep-gabled Keil house with its central black kitchen, and located towards the centre of the village (the only one set at right angles to the road).

Other dwellings, especially those built by wealthier German or British families, stand out as more ostentatious or idiosyncratic styles, reflecting the personal values of their original owners. When the Schaedel family of cabinet-

makers in Nuriootpa outgrew their wattle and daub cottage, they constructed a larger and more substantial home which became, and still is, a feature of the main street. Built towards the northern end of Nuriootpa's main thoroughfare, the two-storey house vied with the two-storey, verandahed Coulthard mansion, located a little further down the road, as one of the most elegant buildings in the town.

Unlike the latter's English, Georgian style – albeit in local vernacular bluestone – the Schaedel house is an unusual but very Germanic combination of stone, brick and pug walls and ceilings with exposed internal hand-adzed beams of redgum, cut and installed by the owner and master cabinetmaker Wilhelm Schaedel (see Chapter 6). It was originally finished with a parapet consisting of a balustrade and four pointed finials or urns on the roof: the latter were unfortunately

In 1875, the cabinetmaker Wilhelm Schaedel built a two-storey house in Nuriootpa. The house included a parapet with a balustrade and four pointed finials on the roof. This c. 1905 photograph shows Wilhelm (far left in top hat) and his family. Note the part-basement furniture workshop on the lower left and the display of chairs.

removed long ago, although decorative fretwork steps cut from redgum, still lead from the street level up to a full-frontage, open verandah on the first floor. Below this level, and accessible from the street, the large part-sunken basement was originally fitted out as the cabinetmaker's workshop.

The stately facade of the steep-gabled Schaedel house was in striking contrast to the more typical cottages of the majority of the German settlers. Although altered in the post-War period, the Schaedel house is the only known surviving purpose-built Germanic cabinetmaker's workshop, combined with a residence, in the southern hemisphere. The building was purchased in 1996 by St Petri Lutheran Church in Nuriootpa, and community members have now renovated and preserved it as a vital part of the Barossa's built heritage.

British Pastoralists, Estates and Manors

Yet another type of architecture and land holding encountered is that of a significant number of country estates with grand manor houses, established by wealthy British families early in the history of the Barossa region. Prior to the coming of Pastor Kavel's Prussian refugees, it was the English settlers who had 'first go' at land selection in the region, their purchases not surprisingly being concentrated about the eastern, well-watered areas of the Barossa Ranges. Over the past century-and-a-half, these estates have in many cases changed hands, some leaving the original pioneering families only relatively recently. The presence of these English-style estates in the Barossa complements the region's characteristic and unique mix of townships, farms, cottage dwellings and wineries – as well as echoing the feudal aspirations of some of their founders.

Following Johannes Menge's favourable report of the beauty and considerable agricultural potential of the Barossa region in 1839, George Fife Angas's confidential clerk Charles Flaxman visited the region, immediately riding back to Adelaide to purchase a huge parcel of three of the Seven Special Surveys of the 'richest and best-watered land in South Australia', and not long after, yet another four of the surveys. The total area comprised a whopping 28 000 acres, the greater portion of which was conveyed to George Fife Angas – which for a time, plunged him into considerable debt, forcing him to relinquish most of his British investments!

Other very early land claimants in the region included the merchant and pastoralist John Hallett who established Arno Vale, on the southern outskirts of the Barossa; John Warren established Springfield, also in this region to the south, while to the south-east of the Barossa, John and Alexander Murray laid out their grand Murray Vale estate; Joseph Gilbert, the brothers William and John Jacob, as well as Joseph Keynes, similarly were quick to lay out their British-style estates by the early 1840s, at the very time the Prussians were establishing the agrarian villages of Bethany and Langmeil.

Elegant mansions were constructed in the Barossa by these and other British settlers, but perhaps the most impressive manor houses were those built by the Angas family: the two-storey Lindsay House, and Collingrove, both set amidst their extensive land holdings in rolling pastoral country and vineyards near Angaston. The former was established in 1850 as a home for George Fife Angas, while the fine bluestone homestead of Collingrove was built in 1854 by his pastoralist son, John Howard Angas, who established it as a famous horse stud. A newspaper eyewitness ('Old Colonist') description of the estate not long after its establishment noted 'its neat white gates and enclosures, and its sloping garden. The effect of the house, which is on arches at the back, and the surrounding park-like domain, is quite English; and there is a gentlemanly air about the whole ...'

The thoroughly English qualities of Collingrove, now a National Trust property open to the public, are expressed in its mid-nineteenth century bungalow or villa-styled structure, typical neo-classical details, and bay window, not to mention its sweeping crescent entrance, and a garden featuring elms, oaks and roses. The English graciousness and styling of the interior may also be experienced first-hand by the visitor. The wholesale transplantation of British culture into the Australian-Barossa context is especially conveyed by the presence of large, majestic gumtrees which form the background for this English-style house, and whose corrugated iron verandahs are its sole acknowledgement to the locality.

From 1874, Congregational services for the Angas family and its employees were held on the estate at the newly-built Collingrove Chapel; once more this was an opportunity to further anglicise the setting, hence its English-style, lynch gateway entrance.

In 1843, Henry Evans, together with his wife Sarah, George Fife Angas's daughter, and accompanied by John Howard Angas (who had been sent by his father to manage his business affairs), arrived in the colony to settle on his father-in-law's land, then called Salem Valley. There, he established Lindsay Park and built what was to become the ancestral homestead for the Angas family, Lindsay House. When George Fife Angas arrived in the colony to move into this residence in 1851, the Evans family immediately moved into another magnificent homestead built near Keyneton, called Evandale. The Evandale estate was planted with vines as early as 1852 and therefore is among the earlier-established wineries of the Barossa and, as well, became renowned for its extensive orchards of fruit trees. Evandale's bluestone and galvanised-iron buildings remain impressive for their size and the graceful simplicity and proportions of their neo-classical facades.

At the time the Evans family moved into the district of Keyneton, it already included an impressive estate and a sheep station, established in the 1840s by the Englishman Joseph Keynes from which the nearby township later took its name.

Indeed, the north-east corner of the Barossa has a concentration of British-style estates and homesteads: besides the Angas and Evans's homesteads there was Moculta House (originally called Teeneeningla), built in 1853 by the wealthy Irish settler William Shannon in the centre of the Duckponds district, already settled and farmed by Germans. Two of Shannon's sons, Abraham

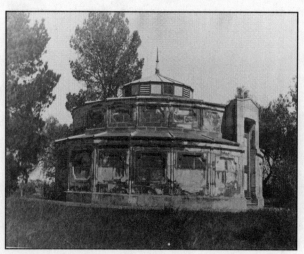

The Italianate-Romanesque, Shannon mausoleum, Moculta, built 1877 (on private property).

and David, also settled nearby, the latter building his own homestead Yatara, further north. William Shannon's two-storey house is now in ruins, but nearby, situated on private land, in the somewhat bleak landscape of Moculta, stands the extraordinary family mausoleum. The imposing tomb is a unique architectural gem, constructed in 1877 in sandstone in an unusual Italianate-Romanesque circular design with twenty faceted sides; designed for the interment of eighty bodies, it currently holds twenty-two members of the Shannon family.

The English vigneron Joseph Gilbert established Pewsey Vale in 1839, the cluster of buildings nestling below the Pewsey Vale Peak; vineyards and an early winery led to other stone buildings becoming established there in the 1850s. By 1900, beside a large homestead, this estate dominated the southern Barossa Ranges, comprising as it did a vast 20 000 acres of grazing land, vineyards, gardens, a deer park, and a village settlement with store, post office and church.

Yet other estates include: Glen Para, now called Corryton Park, built in 1851 by David Randall who established a vineyard four years later and a winery by the early 1860s; Springton, towards the south-east boundary of the Barossa region, is an imposing Georgian-styled homestead and pastoral property, built in stages by the Scottish settler John Warren over a long period from 1839, and completed to 1880; and towards the south-west of the Barossa, one kilometre west of Rosedale, lies the imposing mansion, Holland House, built by Richard Holland on the Turretfield estate, originally owned by Pulteney Murray. Holland House (now an agricultural research centre) was constructed in the Victorian, Gothic Revival style with large bay windows, ornate detailing, and an enclosed courtyard.

The grandeur and extensiveness of these properties (with the exception of Collingrove, most are privately owned), are testimony to the British approach and ideals of settlement, based as they were on a feudal model of land ownership. As such they stand in contrast to the communal and family style of the Barossa's Prussian village-settlements as exemplified, in particular, by Bethany.

Consider too, the contrast between the grand family mausoleums built by a number of these British or wealthy families, and the humbler scale of the headstones of the more 'ordinary' Barossa folk. Aside from the neo-classical

mausoleums built for the Shannon family, and that of the Seppelts (see Chapter 3), there is also the extraordinary vault built near Angaston to hold the remains of the Angas family (also on private land). It consists of a large-scale, white marble angel poised on a tall granite plinth, the whole surmounting the ceiling of a large, circular, submerged burial chamber.

It is interesting to note that these British-built manor houses (and their mausoleums) are to be found scattered over the eastern ridge of the Barossa Ranges, extending from Corryton Park towards the south-east boundary of the Barossa region, Joseph Gilbert's Pewsey Vale estate in the hills south-east of Kaiserstuhl, through to Collingrove in Flaxman Valley near Angaston, and Keyneton further north-east. This was the choicest land, the particularly well-watered countryside of the elevated plateau of the ranges. Gracious and grand, its British-style manor houses, gardens and estates meld with the rolling, park-like countryside of massive redgum, bluegum or other eucalyptus trees, adding a further cultural dimension to the landscape of the region.

Church Buildings

Lutheran churches are perhaps the most immediately prominent indicators of the Barossa Valley's Germanic cultural origins. As one approaches the valley's

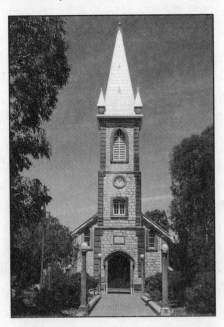

The classical symmetry of Tabor Lutheran Church built 1871, Tanunda, retains elements of the medieval Prussian character of the first generation of Barossa churches.

boundaries their distinctive steeples become visible in the distance, across a rural vista of vineyards and wheatfields: St John's at Ebenezer and St Thomas's at Stockwell appear from this perspective from the Adelaide–Truro road; while the twin spires of Light Pass's Strait Gate and Immanuel churches seemingly tower above the vineyards of the flat northern plains; over the ranges to the south-east, St Petri's spire nestles in the hills about Eden Valley; while the spires of Holy Cross at Gruenberg, and Zion at Gnadenberg distinguish the undulating landscape near Moculta.

In the Barossa's villages and towns, the spires of the various Lutheran congregational churches are similarly prominent, invariably set in orderly and neatly kept gardens, often with clipped cypress hedges or tall candle (or cypress) pines, and with cemeteries of aged slate and marble gravestones located alongside.

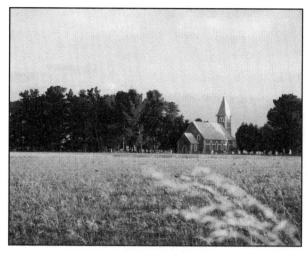

St John's Lutheran Church, Ebenezer, is located on the plains north-east of Nuriootpa. A memorial records the departure from here of a wagon train of Lutherans who embarked on the Great Trek to New South Wales in 1868.

Leaving Adelaide and journeying by foot and bullock-driven wagon over the northern Gawler plains, and then through the undulating landscape of the southern Barossa, the first group of Germans arrived at the site of their first settlement, Bethany, in early 1842. Although the immediate priority was to construct shelters and begin to clear the land and cultivate the soil, religious devotion was not neglected. The congregation of some 28 families first met under the shelter of the larger redgums. Later on, following the construction of homes, that of Albert Grosser, master joiner and cabinetmaker and the first mayor of Bethany, provided an alternative to the open gatherings during cold

or wet weather. It was not until June of 1845 that the first Lutheran church, described as a spacious, thatch-roofed building, was constructed and available for the Bethany and the other early Lutheran congregations of the valley. This church is visible in the watercolour view painted by George French Angas in 1844, and is clearly a much larger building compared to the more primitive and smaller cottages which are scattered on either side (see Chapter 5).

However, the very first building erected specifically for religious purposes in the Barossa was not a Lutheran church, but the Union Chapel at German Pass, Angaston. Built in 1844 in a simplified but elegant neo-classical style, it was George Fife Angas who provided the necessary funds and a portion of his land for its construction, intending the chapel to be used by all congregations. In 1848, writing to his son John Howard Angas who planned and supervised the erection of the building, George Fife Angas expressed his belief: '… why those Christians of all sects who believe the Gospel and now receive the Lord's supper from his hands in Angaston, should not all unite and form a Christian Church.'

At the time, the predominant religious influence among the British settlers in the Barossa was Nonconformist (Methodist and Baptist), but the various congregations preferred to build and use their own churches. Built of locally-quarried stone and red brick sandstock quoins, the roof of the Union Chapel was covered in sheets of slate. In about 1846, a baptismal cavity fitted with a zinc-plated iron tank large enough for full immersion was constructed in the

The restored Union Chapel, Angaston (1844), is the oldest surviving public building in the Barossa.

floor of the Chapel, immediately in front of the small pulpit. The Union Chapel remained in religious use, primarily for total immersion baptisms, only until about 1861 and, following its subsequent usage as a dance and public hall and then a barn, it was sensitively restored in 1992: it is the oldest surviving public building in the Barossa, and it still retains the original baptismal cavity.

The site of the town of Angaston was first known as German Pass, but although German migrants certainly settled there, the town attracted a greater proportion of British migrants, a factor that determined its character. The adoption of the latter name derived from its chief benefactor, George Fife Angas who, together with his son John Howard Angas, were considerably influential in the social and cultural life of the town and district. Because it had a good water supply and was located on the main road to the River Murray, the town flourished, particularly after a bluestone, skew-arched bridge was built in 1865 at the western end of the town. The bridge provided a more direct route than the hilly Penrice way, facilitating traffic flow to and from the valley settlements. By the late 1860s, Angaston had a number of churches, public buildings, a large flour mill, many impressive homes, a Masonic Lodge, Mechanics Institute, two hotels, and a police station and court house – many generously financed by the Angas family. The British influence is evident in the architectural style of these and other prominent and stately buildings, bequeathing Angaston a distinctive appearance in contrast to that of the German-founded township of Tanunda.

The older name of Angaston, German Pass, is memorialised today in its inscription on a stone set high above the door of the south-facing facade of the Union Chapel, where it may be seen today. Coincidentally, soon after its construction, the artist George French Angas (George Fife Angas's son), then travelling through South Australia, painted a delightful watercolour view of Angaston which features the Union Chapel. He also describes the settlement, capturing the appearance and ambience of the place, over one hundred and fifty years ago:

The township of Angaston, at German Pass, is picturesquely situated at the head of a rocky glen, looking towards the Greenock Hills, over which the setting sun throws a purple radiance, as it sinks behind their wooded

summit. The few houses which at present form the nucleus of a future town, occupy a grassy flat between steep rounded hills, which are scattered here and there with park-like trees of the eucalyptus family ... Angaston is a charming spot; and perhaps at no hour of the day does it look more lovely than at the calm hour of sunset, when the orange glow from the western sky lights up the surrounding hills, and the lowering [sic] cattle are returning homewards; there is an air of peace and independence about the scene, with the little chapel on the hill, and the wreath of smoke curling gently up from the cottages beneath the gumtrees, that seems to tell of quiet and repose.

Today, Angaston's predominantly English character, together with its hilly and treed setting, preserves the 'air of peace' and repose appreciated and recorded by George French Angas.

The migration of a relatively small population of British settlers who were mostly Nonconformist, that is, Congregationalists, Baptists and Methodist, saw a number of churches erected about the Barossa according to these denominations. However, it was the much greater influx of protestant, Lutheran Germans into the region which eventually led to the multiplicity of Lutheran churches to be seen today. Indeed, by the turn of the century, some 40 churches were erected and in use by Lutheran congregations about the Barossa region.

As the visitor drives about the valley floor itself, he or she will notice the scattering and concentration of these churches in the towns and villages, as well as those set, seemingly as sentinels, in the rural landscape. This distribution is not accidental but reflects the pattern of settlement of the region by families and neighbours who had migrated from their Prussian homes in social groups; their desire to remain together as congregations based on their village origins, led to churches being built in relatively remote corners of the region, such as Neukirch and Ebenezer on the windswept plains to the north-east of the valley, and St Peter's church in the undulating hills further north, beyond the Barossa Valley at St Kitts.

Various historic events also influenced this pattern of church distribution explaining the proximity of some Lutheran churches which may seem, at first,

odd, given the size of the village or town. We see this at Light Pass where the Strait Gate and Immanuel churches are practically within a stone's throw, a consequence of the religious differences which emerged within the original congregation (see Chapter 6). Stubborn adherence to particular views on scripture and religious ceremony similarly led to splits in other congregations and the close proximity of two of Tanunda's churches – Langmeil and St John's.

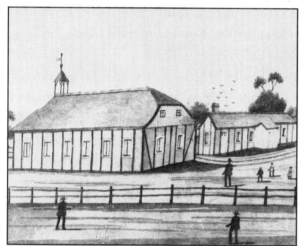

Sketch of the first church and school built in 1850 in Light Pass with traditional half-timbered construction techniques. A small bell tower with a weather vane is visible on the church roof.

Lutheran church architecture was based on the Prussian model, as one would expect, but there were significant differences and variations due to the available labour, the nature of the material resources, as well as the particularly conservative make-up of the early German migrants. There was a scaling down in the overall size of the church building, while the use of redgum timber, iron and bluestone, and other local materials conferred a vernacular quality. The interiors of Barossa Lutheran churches were also simplified, and were generally less ornate than their homeland antecedents. Nevertheless, the distinctive character of the traditional model was essentially retained.

We may distinguish four generations of Lutheran church buildings in the Barossa. The first was that of the pioneer period when churches were often *Fachwerk* constructions, such as that built at the agrarian-crafts village of Light Pass in 1850. It had massive redgum posts and beams, a clay-straw infill and a thatched roof, while a ceiling of calico painted with 'many golden stars', finished the interior. Some of the other Lutheran communities built their first churches from local stone, including those at Bethany and Langmeil in 1845, at

Neukirch and Nain in 1856 and 1859, and at Rosedale and Gruenberg in the 1860s. Nevertheless, even as late as 1869, the community at St Kitts built St Peter's Church using the *Fachwerk* style of construction.

These early, first generation, churches were mostly based on a long, barn-like layout, the entrance doors centrally-located, while the high-pitched roof was thatched. A small open bell tower was usually installed on one side of the roof, or else the bell tower followed an ancient tradition and was constructed as a separate feature, such as those of the Keyneton and Dutton Lutheran Churches.

From the mid-1860s, beginning with Holy Cross Lutheran Church (1864) at Gruenberg (Moculta), the second generation of Lutheran churches involved the rebuilding of earlier structures and included St Peter's, Keyneton in 1866; St John's, Tanunda in 1868; Tabor in 1871 in Tanunda; and St Michael's Gnadenfrei at Marananga, in 1874 (and the tower in 1913). This rebuilding activity was repeated from the 1880s as a continuation of this second genera-tion of Lutheran churches which constitute most of the buildings seen today. Although mostly constructed from local bluestone, these buildings retain the essentially medieval Prussian appearance of the first generation of churches. This is especially so in churches such as Holy Cross at Gruenberg, Moculta

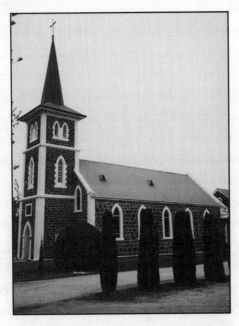

St John's Lutheran Church, Tanunda (church of the statues). Note the 'witches hat' metal spire, and walls built of local red ironstone.

which, although built in 1864, had its belfry or bell tower added 50 years later in 1914!

The majority of the Lutheran churches seen in the Barossa are based around the traditional plan of a towered belfry which soars above the entrance portal, located at one end of the rectangular nave. There is an interesting variation in the style of their bell towers, although most are finished with a metal spire. The saddle-back shape of this spire which sometimes resembles the 'witches hat' as seen on the Gruenberg Church, echoes the early medieval forms seen in Lutheran Churches in Prussia, including that of the seventeenth-century half-timbered church at Klemzig, in Brandenburg, and which was still in use when the pilgrims departed for South Australia.

The original interiors of these early churches have mostly disappeared as congregational tastes changed and the desire to 'upgrade' church interiors surpassed the notion of preserving heritage. But then these were communities whose exercise of their faith and its attendant rituals included constant inter-action with their buildings of worship. Nevertheless, we can gain an idea of the original simplicity and decorative highlights of the early Barossa Lutheran churches from surviving photographs and from sympathetic restorations. For example, the interior of Zion Lutheran Church, Gnadenberg shows a subdued decorative scheme with the portraits of Martin Luther (1483–1546) and Philipp Melanchthon (1497–1560), his co-worker in the Reformation and writer of the Augsburg Confession, displayed on each side of the pulpit. The Gothic text above these and a painted portrait of Jesus Christ reads: 'A Mighty Fortress is Our God', the first line of Luther's Hymn. The relatively plain wooden pulpit was reached by a steep staircase and was originally located above and behind the altar. From the 1920s and later, this arrangement was mostly superseded with the pulpit being replaced by a reredos, usually a wooden screen constructed and carved by a local cabinetmaker, or sometimes a wall painting or tapestry (St John's Ebenezer, for example, has an early life-sized crucifixion mural). The pastor would now conduct the service from a lectern set to one side of the altar.

In the 1890s, Gottlieb Schulz, a member of St John's Church, Tanunda, com-missioned a wood carver in Germany to make five statues: Jeremiah, Moses, St Peter, St Paul, and Jesus (represented as the Good Shepherd). However, the rest of the congregation were not informed of this commission and, when the

statues were delivered, they were somewhat annoyed. Schulz responded by implying that he would donate the statues to the Anglican church if they were not accepted, eventually winning his way. In 1893, on the occasion of the 25th anniversary, they were installed thereby earning the church its alternative title 'church of the statues'. Today, they still form an impressive and striking tableau. The five statues themselves are carved from mahogany, and were originally finished with polychrome paint and gilding which wore off over the years; they are now painted in white. Strangely, given the saint to whom the church was dedicated, there is no statue representing St John. In 1993, on the occasion of the 125th anniversary of the church, a lectern with a carved eagle representing St John (deriving from his Gospel of the eagle's eye) was commissioned from local sculptor David Nitschke.

The original lighting for early Barossa Lutheran churches consisted of elegant candle chandeliers. These were made by local tinsmiths from sheet tin which was cut, hammered and joined into surprisingly elegant designs reminiscent of the rococo – and the more elaborate versions to be found in their homeland churches. From the late nineteenth century, these graceful, handmade chandeliers were replaced by imported kerosene glass and brass lamps produced in factories in central Europe! Typically, church ceilings were painted in blue (to symbolise heavenly love), and dotted with golden stars; other features included wooden pews constructed by the local cabinetmaker with traditional Germanic profiles and painted graining. This early decorative style survives in the Holy Cross Church, Gruenberg, which also includes an organ made by Daniel Lemke in about 1864. In this church, the original painted Biblical texts and symbolic ceiling decoration have been restored, evoking something of the original ambience of the early Barossa Lutheran church (see Chapter 7).

The building of the tower on the Zion Lutheran Church, Gnadenberg in 1904, also included a phase of remodelling into a more elaborate decorative interior based on historical revival styles. These included wall script with decorative patterns, stencilled neo-classical columns, neo-Gothic arches, neo-classical motifs, and a portrait of Christ. An elaborate pulpit and sounding board with a decorative woodwork crown surmounting the carved altar replaced the earlier and plainer pulpit. This decorative scheme was painted over in 1955, leaving only Christ's portrait and the wooden altar.

Interior of Zion Lutheran Church, Gnadenberg, 1904 showing the typical Barossa decorative scheme, including stencilled classical columns, Gothic arches, neo-classical motifs and painting of Christ. Also note the elaborate pulpit and sounding board with woodwork crown above the carved alter. Painted over in 1955, only the Christ portrait and the altar remain.

Early Lutheran christening fonts were usually based on a renaissance revival style, often featuring a chamfered cedar column and scrolled legs, and finished with cotton lace borders – as an example preserved and still used in Gnadenberg Church reveals. From the 1890s, fonts tended to be carved from white marble, sometimes with the religious Gothic text picked out in gold leaf, as seen in the example at Holy Cross Church, Gruenberg. Today, most of the wooden church furnishings date from the late nineteenth or early twentieth centuries and are neo-Gothic in style, with carved altars in wood or marble. These interior furnishings provided much work for local German cabinet-makers and carpenters. Texts are still displayed, although mostly on contemporary embroideries in a colourful folk style. Numerous stained glass windows created in Adelaide and by overseas firms also survive, as do locally-constructed traditional wooden choir galleries and organ lofts.

A third generation of churches was built in the Barossa in the years following the First World War, beginning with the Good Shepherd at Gomersal (Neu Mecklenburg) in 1925, and Bethlehem at Schoenborn in 1927. However, the main wave of twentieth-century building began in the post Second World War period with Trinity Lutheran Church at Rowland Flat in 1956, a rendered building of neo-Gothic style; Strait Gate at Light Pass, 1961, in the cream brick modernist style, with the original bluestone and red brick belfry retained alongside the new building; and St Petri, Nuriootpa in 1968, the largest church in the Barossa and again, with the original 1867 belfry retained alongside the newer building.

The concentration of these church buildings, scattered as they are throughout the Barossa, set in rural landscape or village and township, comprise a heritage which in itself is unique to Australia. As major cultural elements in the landscape, these churches, old and new, are visual expressions of the strength of faith which led to the migration and settlement of the Barossa region – as well as symbolising the spirit which so strongly influenced the making of its character. Today, fifth and even sixth generation parishioners, descendants of the Prussian pioneers who erected their walls and spires, continue to attend and worship in these churches.

Winery Buildings

Departing from the religious to the secular realm, it is not surprising that the Barossa also contains the most varied and comprehensive collection of winery buildings in Australia. Their architectural diversity spans from the earliest pioneer stone constructions, to culminate in the splendour of the Victorian heritage of Seppeltsfield, Yalumba and Chateau Tanunda. Between these two extremes are a number of styles which reflect the extent and success of the winemaking operations of particular wineries, whether historic or contemporary. Their construction and style also documents the development of viticulture in the region, indicating its origins in a unique mix of British-inspired commercialism with Germanic, family-scaled operations.

In the earlier years of the establishment of the wine industry in the Barossa, prior to its first major commercial expansion in the 1870s, domestic cellars or simple stone buildings provided the necessary processing and storage areas (see Chapter 4). Masons and carpenter-builders, who were plentiful among the early Prussian settlers of the Barossa, were employed to construct functional and attractive buildings in dressed stone, timber and iron, or in simple but effective combinations of the latter two materials. Within these, the simplified and small-scale processes of winemaking, including foot-crushing, fermentation in casks, blending, hand-bottling and storing, were readily conducted.

However, the majority of winery buildings which the contemporary visitor is most likely to see, date from the 1870s when a rapid phase of commercialisation and industrialisation in the industry led to the simpler winemaking processes being taken over, or at least supplemented, by steam and mechanised

methods. These larger-scale and more complex modes of production required extended processing and storage areas, hence initiating a period of construction. Corrugated iron cladding on timber frames became an easy means of adding to and enlarging existing stone buildings, but many new ones were erected, often designed by Adelaide architectural firms who were versed in the late Victorian style. Other changes which affected the visual appearance of wineries included the replacement of traditional wooden casks by huge fermentation tanks made of slate, cement or brick, today themselves mostly replaced with even larger tanks of stainless steel.

The Seppeltsfield Winery consists of a collection of mid to late nineteenth century buildings in a palm-tree setting. Constructed of bluestone, brick and corrugated iron, they express an Australian vernacular neo-classical style as seen in the three-storey bluestone cellars complete with balcony, verandah and parapeted facade.

This process of expansion and development was nowhere more pronounced than at Seppeltsfield. Today, any visitor entering the Seppeltsfield district of vineyards, wheatfields, and date palms, is immediately struck by the impressive buildings and immaculate hedges and rose gardens of the extensive Seppeltsfield Winery.

The main cellars themselves are housed within a magnificent three-storey Victorian bluestone building complete with an imposing balcony, verandah and parapet facade. The adjoining offices were built in the Romanesque revival style, while other cellars and the stone bond store are similarly built with elegant neo-classical lines. This classical character is enhanced by the columnar style of the prominent distillery chimney. Castellated, painted concrete, fermentation tanks, arranged in terraces along a slope – to provide gravity-fed control of the fermenting mixture – are an additional feature; worker's cottages

and workshops in galvanised iron and timber are dotted about the setting. Seppeltsfield's combination of building styles is a fascinating mix of the vernacular and classical.

Nearby, located on the knoll of a dominant hill, the Seppeltsfield Winery is overlooked by the Seppelt family's mausoleum. Visitors are astounded when they come across this Greek Doric temple-style building, so well located in its pine-tree grove approached through a steep avenue of palm trees; it adds an extraordinary, almost surreal, element to the viticultural landscape of the Barossa. Constructed by the Tanunda cabinetmaker and builder Bernhard Freytag and completed in 1927, it is typical of the Greco-Roman revival architecture so admired by nineteenth-century Europe, particularly as a model for funerary monuments.

The numerous date palm plantings of the 1920s and 1930s which line the roads leading to the mausoleum and the Seppeltsfield Winery itself, add yet another distinctive, Mediterranean, element to the landscape. These palm avenues were themselves a response to the decline in employment during the depression, when their planting was executed: as such they are a historic social marker as well as cultural indicator. Beneath the palms, mass plantings of pink belladonna lilies flower in late summer, while white irises provide a display in spring.

In continuous use since their construction between 1876 and 1906, these buildings and their garden setting comprise one of the most impressive wineries in Australia. This combination of landscape and structure, specifically of vineyards and date palm avenues, together with Australian verandahed, corrugated iron and stone, Victorian classic-revival buildings, has created Seppeltsfield's special character. It is a setting unique to Australia in that it exemplifies both Barossa vernacular architecture and its contribution to the cultural landscape.

Similarly impressive in its architectural style and splendid garden setting, is the Yalumba winery complex located on the outskirts of Angaston. Established in 1849, it is now Australia's oldest family-owned winery. However, its central building, the main feature at Yalumba which first strikes the visitor's eyes, was not constructed until 1908. This impressive two-storey building was constructed with blue-grey marble and features a centrally-located clock tower,

with two small pavilion-like towers adding additional formal elements on each end of the facade (see back cover). Among the other buildings at Yalumba, the Octavius Cellar is an especially elegant vernacular outcome of the late nineteenth century, neo-classical architectural style melded with Australian elements, specifically the local brick and stone facade, the massive redgum framework and beams of the interior, and the corrugated iron cladding.

Another impressive winery building is that of the former Chateau Tanunda. The formation of a co-operative venture in 1889 led to its construction over the following two years. A massive two-storey winery building of bluestone and red brick quoins, Chateau Tanunda's imposing facade includes a three-storey centrally-located tower flanked by three-storey, Dutch-gable bays. At the time of writing, this ornate building, with its potential for conversion into a museum, was on the market.

The modest, vernacular style of the Henschke Cellars stands in contrast to the grandeur of the preceding buildings. As the founder Johann Christian Henschke was a mason and wheelwright by profession, he was able to construct the buildings himself using local bluestone and timber, the human scale of which generates a warm ambience. Another family winery worth noting for its architectural interest is The Willows at Light Pass. Located alongside the original, 1840s pioneer cottages of whitewashed wattle and daub, is the main building, once used as a hospital and now the family home (see Chapter 3). It is a gracious, symmetrical Victorian villa with long verandahs, fronted by a sweep of lawn and gardens and set amidst vineyards which have been cultivated for over 100 years.

Many wineries are located within buildings recycled from previous uses. On the northern flank of the small valley created by Jacob Creek, Grant Burge Wines are housed in the restored bluestone walls and brick quoins of Moorooroo Cellars, the site of the Barossa's first vineyard and winery. The more recently planted cork-oak tree drive to these cellars provides an attractive and suitable entry, passing the restored buildings and ruins of other parts of the Jacob brothers' old estate, once the site of Aboriginal camping grounds, while nearby lies the location of the cave and 'island' home of the Barossa's seminal personality, Johannes Menge – all intensify the historic interest of the setting. Located on the northern banks leading down to the valley and creek, the

present building with its distinctive peaked tower, sits comfortably among the old bush vines and gumtree studded landscape, the whole set against the backdrop of Kaiserstuhl to the immediate east.

Karl Seppelt's Grand Cru Estate is similarly set in splendid surroundings, in this instance on the eastern boundary of the Barossa region between Springton and Mount Pleasant. This winery consists of a restored, nineteenth-century complex of stone buildings and courtyard constructed by German farming pioneers in 1889 who used the local, grey-coloured sparkling schist scattered about the fields; a two-storey tower has also been recently constructed, its 'Wagnerian' bell-topped roof introducing an imaginative touch. Similarly, Old Barn Wines, one of the more recent and smaller family wineries, was established in 1990 in a restored barn built in 1861 in Tanunda. Located at the northernmost end of Langmeil Road, the building is considered one of the finest existing examples of Germanic stone barn architecture. Because its richly-textured ironstone was quarried from the site, it also presents an example of the vernacular process, in this case a fusion of local material with European culture.

At the more southern approach to Rowland Flat, as one descends the hill heading north, the sight of the 1950s Gothic revival Trinity Lutheran Church rises from its picture postcard setting of vineyards, flowering prunus and date palms. To its left, the Jenke family has established its winery in an immaculately renovated cottage, a high-pitched, Welsh slate-roofed, ironstone building

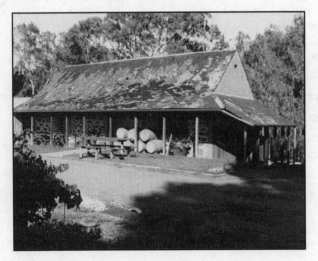

Built in Rowland Flat in about 1844 by Friedrich Koch, one of the pioneers of the district, the settler's home of ironstone and a slate roof, has been converted into the present-day winery by the Jenke family.

constructed by its forebears in 1855. Nearby, Barossa Settlers is another small family winery (established in 1983) and, in this instance, is located in renovated 1860-built horse stables and set alongside the sugar-loaf, wild-olive-tree slopes of the adjoining Hoffnungsthal lagoon.

These more domestic-scaled settings contrast considerably with Rowland Flat's huge Orlando winery complex, fronted by the old bluestone Lutheran schoolhouse, now the wine-tasting centre, and backed by its extensive industrial buildings and towering stainless-steel tanks. The Rowland Flat streetscape itself is also characterised by a clipped carob tree avenue which fronts three Gramp family homes, including the majestic, two-storey, tudoresque brick and sandstone mansion built in 1935 by third generation son, Hugo.

More recent winery buildings have been built in a variety of styles which range from a stark functionalist approach through to various amalgams of historical revivalist elements. The extremes which the latter reached may be seen in the French or European chateau style of Kaiserstuhl (taken over by Penfolds), and located at the southern approach to Nuriootpa; Chateau Yaldara (near Lyndoch); and the nearby castellated facade of Charles Cimicky. On the other hand, Kaesler Wines have retained an authentic style which blends completely with the historic Barossa: their attractive collection of vernacular winery buildings with their high-pitched roofs, include renovated and new structures in corrugated iron and timber, and even *Fachwerk* construction. Similarly, Rockford Wines have recreated a nineteenth-century ambience by restoring an 1850s cottage as well as constructing further winery buildings, closely following traditional techniques and using local stone, redgum and corrugated iron.

These earth, timber, iron and stone buildings have the potential to take the visitor on a many-layered and textured journey: through the history of the Barossa region's founding, its religious impetus and its communal, commercial and viticultural vitality.

chapter

4

Viticulture & Winemaking

Valley of Vines

'New Silesia will furnish the province with such a quantity of wine that we shall drink it as cheap as in Cape Town.'
Johannes Menge

The inspiring panoramic view from the Mengler Hill Look-out reveals a meticulous patchwork of lush vineyards clothing the valley floor, straddling waterways and roads, draping the gentler contours of gumtree-graced foothills to finally merge into steepled villages, and clusters of winery and farm buildings. It is a living patchwork quilt which heralds the changing seasons: in the spring the bright green of sprouting vines is set against the purple of Salvation Jane, the yellow of soursobs, and the orange of sparaxis; in summer, the deep green of lush-leafed vines contrasts with the cultivated rich brown soils and grass-golden fields and hill slopes, providing relief from the haze of the day's heat; in autumn, luscious golden or purple grapes are harvested from vines soon to transform into tapestries of tawny, glowing ochres.

Indisputably, the Barossa's vineyards and wineries form an indelible aspect of its landscape, but not only as a vital element of its visual allure: their infusion

of a powerful sense of place and an intimate, singular history, has resulted in a cultural complexity evoked by the sensual palate and bouquet of their renowned wines.

The Barossa's intertwining of place, story, vineyard and winemaker is unparalleled in Australia, or for that matter, anywhere else in the world: consider, for example Zion Lutheran Church facing the Hill of Grace vineyard and its gift of superb wine; or Yalumba wines born from vines planted in moonlight; the entrancing palm-tree embroidered setting of Seppeltsfield, its grand buildings and award-winning wines; Bethany Wines embraced by an old stone quarry overlooking the birthplace of German settlers in the valley; Turkey Flat winery, also at Bethany, where its vineyard of ancient shiraz vines is backed by the nearby blue-green slopes of Kaiserstuhl; and then there is Mountadam Vineyard, located in the wedge-tail eagle soaring high plateau of the Barossa Ranges, whose clarity and coolness produces an extraordinary chardonnay and other celebrated white wines.

Stories of these locations, their founders and their wines are but a few of the many which make up the history of viticulture and the winemaking industry in the Barossa. The following can therefore only sketch out the more salient stories and details of this region's viticultural and wine heritage as one which is unsurpassed in Australia, as well as being increasingly honoured internationally.

Origins

The commonly-held belief that it was the Lutheran settlers who established viticulture in the Barossa region is not entirely accurate. Instead, its present-day thriving grapegrowing and winemaking industry has its origins in the vision, skills – and the toil – of both British and German pioneers of the region.

However, it is clearly evident, and widely acknowledged, that it was the German mineralogist Johannes Menge who first realised the considerable potential of the Barossa to emerge as a winegrowing district. As early as 1840 he wrote to George Fife Angas with the prediction that 'You may put vines round Flaxman's Valley, The Rhine Valley ... [and] I am satisfied that New Silesia will furnish the province with such a quantity of wine that we shall drink it as cheap as in Cape Town' ('The Rhine Valley' was Menge's name for the region about Keyneton). Although winemaking did not become the primary

industry of the region until the turn of the century, within a decade of settlement it was established as a significant facet of the Barossa's rural activities.

Despite the conservatism of the early Lutherans, who even disallowed dancing at weddings, wine drinking during meals or celebrations was an acceptable part of their culture. Indeed, the Prussian custom of growing sufficient vines to supply grapes for making wine to be used by the family and for religious purposes was also an integral part of the cultural legacy of these settlers. The Silesian Lutheran pioneers, in particular, were certainly versed in the techniques and skill of viticulture and winemaking given that their place of origin, notably the rolling hills about Gruenberg, Silesia, were long known for their wines.

Vines were first planted in Bethany soon after its founding in 1842, though initially this was essentially to provide wine for family use. As Lutheran settlements spread throughout the Barossa over the 1840s and 1850s, viticulture became a part of their standard, mixed agricultural practice: 'every farmer also grew some vines and made his own wine – it was often potent stuff'.

Among the earliest Prussian settlers who were successfully making wine was the migrant Johann Fiedler: his thriving farm in Bethany included the earliest documented vineyard which he planted in 1847. By 1850 he was producing at least three types of wine, judged by a passing visitor as 'two good, one indifferent'.

Johannes Menge, the visionary linguist, explorer and mineralogist. As early as 1839 he predicted the Barossa's potential to became a renowned wine region.

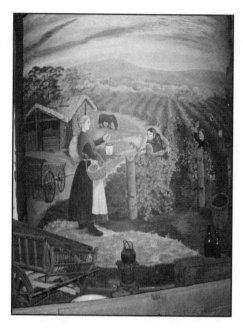

Una Grimshaw's (formerly Leybourne) painting (on a wine vat at Chateau Dorrien), of an Prussian pioneer family harvesting grapes at sunset, depicts the early family-based approach to winemaking.

Fiedler, described as an elderly gentleman of 'great readiness and alacrity', was also producing a 'sweet and strong' port wine from muscadine grapes. These dark-coloured, sweet wines were typical of German family wine production of this early period. Fiedler's interest in winemaking was considerable: by the mid-1850s, he was growing a surprising range of some 70 varieties of grapes in his efforts to determine those best for the region. Some of his wine output was also directed at making brandy, which was also used to produce fortified wine. Today, a portion of Fiedler's shiraz vines survive as among the oldest of this variety world-wide (now part of the Turkey Flat winery – see later).

Among the early Lutheran settlers, even Pastor Kavel, their spiritual leader, established his own vineyard of some three to four acres near Tanunda in the late 1840s – no doubt mainly for liturgical use.

One of the earliest German settlers who made winemaking a prominent part of his primary production, and hence has the distinction of being the first to establish a commercial German family winery in the region, was the Bavarian Johann Gramp. Arriving in the Barossa in 1847, Gramp chose a site on the lower flank of the eastern foothills at Jacob Creek near Rowland Flat, only one or two fields to the north of potter Hoffmann's farm (see Chapter 6).

As well as sowing grain crops such as wheat, he also had the foresight – or had possibly even been encouraged by the visionary Johannes Menge – to plant vines on his property within the first year of his settlement.

Within three years, in 1850, Gramp had produced his first wine, a variety of hock. Although he began to exhibit his wines from 1859, his winery remained a small family concern, even up to the turn of the century. The restraint that held Johann Gramp back from expanding the winery was not a part of his son's character and, between 1900 and the 1930s, following his entry into the business, he successfully oversaw and managed Orlando Wines to promote its growth to one of the largest in the industry in Australia. It remained in the family until 1971. The winery, now owned by the French company Pernod Ricard, produces the popular Jacob's Creek wine – not only Australia's biggest selling wine, but with 80 per cent exported overseas also one of the world's largest.

Meanwhile, British settlers in the Barossa were also establishing vineyards and wineries and indeed, they have the claim of being the first to venture into commercial operations. Unlike the predominantly peasant origins of the Lutheran migrants, the British were mostly middle-class settlers and gentry who had the means to establish and underpin the growth of the region's wine industry.

A year or two earlier than Johann Gramp, the two Jacob brothers, John and William (the latter was a surveyor for Charles Flaxman), had already established a farm on 500 acres at Moorooroo (an Aboriginal name of various meanings including 'big fella waterhole'), also near Rowland Flat. The site was some three kilometres down from the site Gramp himself later settled. On the gentle slopes of a lush valley created near the junction of Jacob Creek with the North Para River, and dominated by massive, ancient redgums, they planted a vineyard which soon flourished in the rich alluvial soil. The brothers then built a bluestone cellar and winery where they produced shiraz, cabernet and riesling grape varieties. By 1851 their winery had grown to become quite substantial and, given the introduced trees and hedged fields, had taken on the appearance of an English estate as the following published description in the press by the 'Old Colonist' reveals:

The house is a substantial brick dwelling, and there is an equally substantial barn, with various other farm buildings. The garden, which is at some

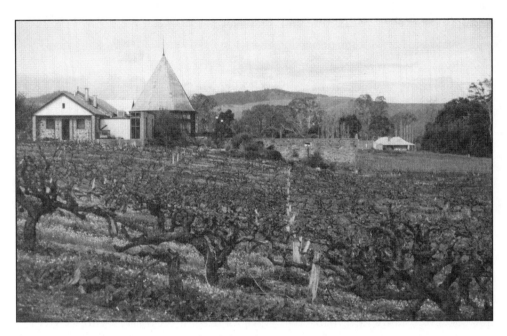

distance from the house (the latter being on a rise, and the garden skirting the stream below) ... contains a considerable extent of vineyard and orchard ground. Near the stream was a very fine weeping willow, which brought remembrance of English homes as it droops gracefully over the waters; the pomegranate was also in blossom, and the prickly pears on the bank. The Kangaroo Island acacia had been adopted for fencing along the garden, and for enclosing much of the land adjoining, promising a future thick live hedge ...'

The Barossa region contains some 50 large to small wineries owned and operated by either multinational companies or family concerns. The Grant Burge winery, nestling above the gumtree-lined Jacob Creek, is housed in the restored bluestone walls of Moorooroo Cellars, the site of the Barossa's first vineyard and winery. In the background the home of the Jacob brothers' old estate is visible. Johannes Menge's cave home is also in the vicinity.

Today, the old bluestone cellars have been sensitively incorporated as part of the new cellars of the Grant Burge winery estate.

Samuel Smith, also a British migrant, and originally an English brewer, made the decision

to apply his skills to viticulture and winemaking. His employment as a gardener at Angaston on the Angas family estate Tarrawatta had included the cultivation of vines; it had given him suffi-cient experience in viticulture to venture out on his own. After purchasing a 30 acre parcel of land just beyond the south-eastern boundary of Angaston, Smith and his son began to clear it of native vegetation in 1849. As Smith was still working as a gardener for the Angas's, he was forced to clear and plant his own property at night! Family tradition states that they planted the first vines by moonlight also in that year, although it appears more accurate that this prob-ably occurred in the following two years. Smith named his estate Yalumba, Aboriginal for 'all the land around'.

A lucky sojourn of gold digging at the Victorian goldfields during 1852 permitted Smith

A late nineteenth century view of Yalumba showing the Australian vernacular style of corrugated iron winery buildings and the fruit canning factory.

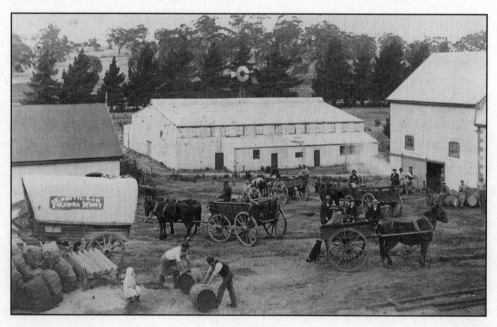

to return with sufficient funds to purchase more land. Beside vines, he also established orchards and gradually expanded the winery into a complex of buildings, so that the present-day estate compares with the splendour of Seppeltsfield, albeit with its own character; Yalumba Wines is one of only two founding Barossa wineries which are still owned as family concerns to this day.

Yet other extensive family wineries were established as part of English-style estates by middle-class British settlers in the early decades of the Barossa's history. These include the Gilberts of Pewsey Vale, the Greens of Gawler Park (near Angaston), the Evans of Evandale, and the Salters of Mamre Creek. Joseph Gilbert, Henry Evans, William Jacob, David Randall and Abraham Shannon were among the British settlers who became well-to-do Barossa estate owners and who also had the benefit of the experienced German wine-maker, Carl August Sobels.

When Sobels arrived in the colony in 1847 aged 45, he was an experienced vigneron, winemaker and distiller. He provided the expertise necessary to these aforementioned landowners, eventually operating from his residence in Tanunda. His knowledge and perspective on the emerging industry was con-siderably influential, including his involvement in establishing an interstate and overseas market for himself and other Barossa winegrowers from 1854. He also established his own winery in Tanunda in about 1860, buying his grapes from a number of German growers about the district. His untimely death in 1863 saw his business taken up by his son Julius. Sobels was the first in a tradition of distinguished Barossa winemakers who have, to this day, dedicated their skills and expertise to creating the region's fine wines.

By the late 1850s, the success of pioneer viticulture and winemaking in the Barossa was such that its extensive wheatgrowing fields now began to gradually give way to vineyards. The foundations of the Barossa's viticultural landscape as we see it today were being laid.

In 1859, an account in the *Register* (the Adelaide press) could proudly proclaim (with some spelling errors) that 'Pewsey Vale is noted for its superior Hock and Verdeilho; ... Gawler park for Cabernet; ... Evandale for Shiraz, Riesling, Muscatel and Espanoir; White Burgaundy, Frontignac, Hock and finer Clarets are produced at Tanunda and neighbourhood'. At the time, wine was also being exported to a modest market already established in England.

The early viticultural and winemaking pioneers had quickly been followed by a number of German families who also planted vineyards and established wineries on a commercial scale, some of which have survived well into the twentieth century. These include familiar Barossa names such as Boehm, Bradtke, Burgemeister, Graetz, Gramp, Henschke, Hoffmann, Kies, Schmidt, Scholz, Schulz, Semmler, Obst, Rothe, Seppelt and Schrapel. However, the conservative nature of the majority of the Lutheran settlers was such that most of these family wineries eschewed the expansive, and necessary, entrepreneurial approach of the British-established companies, preferring to remain as small grower-winemaker concerns. Today, only a handful survive.

Prominent among these survivors is the Henschke family of vignerons, currently run by the fifth generation Stephen Henschke. His great-great-grandfather, the Silesian migrant Johann Henschke, had established a mixed farm towards the north-eastern boundary of the valley at Keyneton in 1861. As well as planting vineyards Johann Henschke also built cellars, and by the mid-1860s was producing wine. The winery was not expanded until 1914 when the third generation took control. However, it was the knowledge and skills of the fourth and fifth generations, principally Cyril followed by Stephen, which led to the production of high quality varietal table wines and which have earned the winery's present-day exalted, international reputation.

Out of this generational tree of winemaking was born the renowned Hill of Grace wine which took its name from the Gnadenberg Lutheran Church built of local stone in 1860, and which proudly stands in a shallow valley amidst rolling hills three kilometres south-east of Moculta. The Hill of Grace vineyard lies immediately opposite the church on a low rise and was planted by the Henschke family with shiraz vines in about 1890. The latter originated from European, pre-phylloxera, cuttings which were carefully nurtured and transported by German emigrants to the Barossa in the mid-1880s. The fertile soils and high altitude of the shallow valley (not a hill) where the Hill of Grace vineyard is located, appears to be among the reasons for the longevity to its vines and the unique quality of its fruits. Or perhaps, on a more romantic note, we may muse whether it is the guardian shadow of Zion Lutheran Church's noble steeple which sweeps across, caressing the venerated vines of this historic vineyard, during the course of each day.

The handpicked grapes which the gnarled vines bring forth (and which are nurtured under the expertise of Prue Henschke), are processed in the traditional way by fermenting on skins in open-top fermenters, the wine eventually matured in new American and French oak barrels. Whatever the reasons — soil, climate, vines, or the human touch — this vineyard and the Henschke winery have created Hill of Grace, a shiraz now widely considered to be one of Australia's greatest wines.

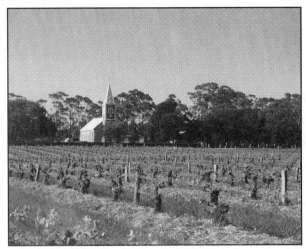

The Zion Lutheran Church at Gnadenberg, stands before and gives its title to the 'Hill of Grace' vineyard, whose 100-year, dry-grown shiraz vines are used by the Henschke winery to make the renowned wine of that name. The Barossa contains the oldest survivors of shiraz vines anywhere in the world.

Indeed, through the combination of modern equipment with traditional approaches to winemaking, not to mention five generations of experience, Henschke's produce one of Australia's most praised ranges of varietal wines. These include the aforementioned Hill of Grace, and other reds such as Mount Edelstone, Keyneton Estate, and Cyril Henschke Cabernet Sauvignon. Their white wines include Eden Valley Riesling, a Dry White Frontignac, Gewurtztraminer, and a Noble Rot Riesling.

Although no longer owned by the original founding family, one of the most prominent wineries in the Barossa Valley is Seppelt. The story of this venture begins with the arrival in the Barossa in 1851 of the Silesian migrant Joseph Seppelt and his family — as well as a group of servants and thirteen of his neighbouring families. Unlikely as it may appear, his original idea was to plant and process tobacco, but he soon realised that the region's climate was unsuitable for this crop. However, the enterprising Joseph Seppelt, who was not only a tobacco and snuff merchant, but also an experienced manufacturer

of liqueurs, had the foresight to plant vineyards – no doubt he had investigated the successful vineyards pioneered by others about the valley. He proved to be among those German settlers who early on realised the considerable potential of the valley for making wines on a scale suitable for export, rather than simply for local or family consumption. With this vision, and with his determination and skills, Joseph's endeavours had created Seppeltsfield as the leading winery of the valley by the late 1860s.

In 1868, at the age of twenty-one years, his son Benno Seppelt inherited the winery, immediately setting out to expand it over the following two decades into a large-scale commercial and industrial enterprise. By the turn of the century, Seppeltsfield was Australia's largest wine producer. The reasons for this success, beyond the founder's expertise and vision, was Benno's determination to keep up with the latest in winemaking knowledge and technology, an attitude maintained by later generations.

Between the late 1860s and the 1880s, Seppeltsfield grew and developed into a hub of many fine stone buildings and cellars, to become the influential centre of a community of winegrowers and winemakers – led by the Seppelt family dynasty. The winery became a showcase of winemaking in the valley, and in Australia generally: today, visitors who tour its extraordinary grounds, buildings and wine-tasting centre are invariably impressed.

This success and the manner of its achievement through the enterprising endeavours of the Seppelt family, played a significant role in underpinning the expansion of the Barossa's wine industry as a whole in the following years.

A critical period occurred between the late 1880s and 1890s when viticulture and winemaking shifted from the cottage industry approach of its founding families, and rapidly expanded into a commercial industry of national and international scale. Among the factors which stimulated this growth was the devastation of vineyards by phylloxera disease in the eastern states (but not in the Barossa), the advent of Federation which removed tariffs, expanding inter-state markets, the opening of the British market, and the encouragement of the industry by the state government. These changes catalysed the rapid expansion of the Barossa wine industry stimulating many of its families to switch from wheat farming to grapegrowing, while others also took up winemaking. The potential of the London market also encouraged Adelaide businessmen to

join this 'wine rush', and a number of new, large-scale wineries such as Chateau Tanunda, Angas Park Distillery, and Kalimna Cellars, became established during these years.

Following the disruptive periods of the First World War and the Depression, growth continued into the 1940s. The post Second World War period resulted in further significant changes brought about by economic and cultural factors whereby some wineries have closed, some have been sold to outside corporate groups, while other new ones have opened. Among the latter we may mention Bethany Wines established by the Schrapel family (sixth generation descendants of a Silesian migrant) in 1975; Wolf Blass Wines, a winery established by the post World War German migrant Wolf Blass (now sold to outside interests); Grant Burge Wines at Jacob Creek from the mid-1980s; Burge Family Winemakers, established in 1928 in Lyndoch; Richmond Grove Barossa Winery, originally the Leo Buring of Chateau Leonay established in 1963; Chateau Yaldara, established by German migrant Hermann Thumm in 1947; Peter Lehmann Wines in 1979; Mountadam Vineyard, established in 1972 in the Barossa Ranges on the High Eden Ridge; Gnadenfrei Estate Winery, established by Malcolm Seppelt in 1979; Jenke Vineyards, a winery established at Rowland Flat from 1989 (although the family have been grape growers for six generations); The Willows Vineyard at Light Pass in 1989; Liebichwein established at Rowland Flat in 1992, on the old farm site of the Barossa's only potter; and Rockford Wines in early 1970.

Among the early German migrants who settled in the Barossa Valley was one Johannes Basedow. Apprenticed to a German cabinetmaker and carpenter in Tanunda, the young Johannes grew to become one of the town's chief builders, constructing a number of its more significant buildings including Chateau Tanunda, the Nuriootpa Institute and the Lutheran church at Bethany. Johannes Basedow was also possibly influenced by his older brother Friedrich who, as a member of the South Australian parliament was instrumental in the establishment of Roseworthy Agricultural College, which today, as one of the world's leading training institutions continues to be the 'Alma Mater' of many of the Barossa's winemakers.

Johannes Basedow also owned a vineyard and built his own winery; following his death it was taken over by his nephew Oscar Basedow in 1902 who promptly expanded the winery and established considerable markets,

locally and nationally, for the wines. Basedow Wines continues to be the Barossa's second oldest family-owned winery, although in 1987 the winery passed out of the family to be eventually taken over by Grant and Helen Burge in 1993 (Hill International Wines purchased ownership of the label in 1995). In 1996, the winery celebrated its centenary, drawing on its long tradition to highlight the quality of their wines ('100 Years of Tradition in Every Bottle'), a small range of premium regional varietals made from grapes supplied by a group of local growers was produced. In 1996 and 1997, Basedow's won five trophies for their premium white wines, as well as the award for the best dry white wine of 1996–97 (for their 1995 chardonnay) at the International White Wine Challenge of the Year, held at the International White Wine Show in London.

Most of the aforementioned wineries have links to the historic Barossa in one way or another, often through family or other connections. Turkey Flat Vineyard is exemplary of the latter. Located between Bethany and Tanunda, Turkey Flat is the name of the location of Johann Fiedler's farm and vineyard planted in 1847 as mentioned earlier. The property was held by the Fiedler family until 1965 when it passed into the Schulz family who have been grape-growers in the Barossa for four generations. In 1990, Peter Schulz established the Turkey Flat winery and began to make wines. Old shiraz vines, survivors of Fiedler's original planting in 1847, are considered to be among the oldest survivors of this variety anywhere in the world. Their unique berries are now used to produce a shiraz wine of noteworthy fruit flavour and colour, high-lighted through French and American oak fermentation and maturation.

New partnerships, co-operatives and family enterprises continue to emerge, one of the more recent of these being Barossa Vintners, a consortium of wine-makers. It includes Colin Glaetzer (formerly with the Barossa Valley Estates), Stephen Henschke (Henschke Cellars), Peter Schulz (Turkey Flat), Scott Collett (Woodstock), Geoff Hardy (Partaringa), Reg Tolley (Malcolm Creek Wines), Kym Tolley (Penley Estate), Don and Andrew Thompson (from the Murray Valley region), and Robert O'Callaghan (Rockford). Three share-owning partners provided the funds to establish this wine business which takes in the fruit from a number of vineyards of a variety of sizes owned by the group, processing the grapes at a modern plant at St Hallett located on the southern fringes of Tanunda.

The individual wines of these members are either produced at Barossa Vintners according to the styles each has developed over the years, or else their fruit is processed to the stage of barrelling from which point they take over the winemaking. Colin Glaetzer, however, is also making his own wine under his own label on site (see later).

There are now some 50 wineries in the Barossa region, ranging from the giants of the industry through to smaller family wineries: some have been established quite recently, while a small handful of others are survivors from the early settlers and their first plantings of vines in the 1840s, over 150 years ago.

These numerous family and company-owned wineries have tangible links with the Barossa's past, either through the origins of their vineyard plantings, their heritage buildings, or generational family histories. Invariably, they are inextricably tied to the location itself, the Barossa, a valley of vines and tradition, a place steeped in a history which, in some cases, literally finds its way into the bottle. Next time you sample a taste of Barossa wine, think of the generations of toil, skill and expertise that have preceded its making, but in particular, contemplate and savour its powerful essence of *place*.

Growing Grapes, Making Wine

While the seasons and the processes associated with grape growing and the making of wine have remained constant, there have been many changes in technique and approach since these activities began the early 1840s in the Barossa.

The actual varieties of vine planted today have changed considerably from those favoured in the early years of the industry. The first grape cultivars or varieties were imported both from the wine-growing districts of Europe, as well as from vineyards in South Africa. For red wine these included grenache, mataro, hermitage, shiraz, black portugal, and black morocco; white wine varieties commonly included madeira, verdelho, tokay, frontignac and rhine riesling. Early winemakers produced wines which catered to the taste of the times which favoured heavy, sweet or fortified wines, especially the Portuguese styles of vintage and tawny ports. The planting of varieties suited to the production of fortified wines was maintained well into this century, although poorer quality cultivars had begun to make way for the high-yielding varieties of shiraz, cabernet and riesling from the 1890s.

It was not until the late 1970s that the trend for premium tablewines has seen a radical shift in the varieties planted to suit contemporary palates. Today, popular grape varieties include cabernet sauvignon, malbec, merlot, pinot noir, chardonnay, riesling, semillon, sauvignon blanc, chenin blanc, and some traminer (see later).

The actual methods for the cultivation of vines have also changed. In the early decades, there was considerable experimentation to determine the most suitable spacing of vines and rows: spacing is critical as it determines yields, given the particular soil types, water availability and the grape variety. The method of trellising also varied and in the earlier decades most vineyards had untrellised bush pruned vines or traditional low-trellised vineyards. A few vineyards are still maintained in this manner, often dry-grown and hand-pruned, in order to obtain fruit with particular characteristics. Today, most vines are pruned to high trellises facilitating hand or machine grape harvesting.

The Barossa skyline enhanced by the ornate, 1890s Chateau Tanunda cellars; before them, neatly-cultivated rows of vines with a winter crop of wheat growing between them.

Cool-climate plantings of vineyards in the ranges 480 metres or so above the valley floor, were initiated as early as 1841 by the British settler Joseph Gilbert. Vine plantings seen today in the locality are the Pewsey Vale Vineyards, established in 1961. Nearby are the High Eden Vineyards, with further extensive high plateau plantings of chardonnay and riesling grapes by Mountadam and other wineries, most established in a wave of activity since the 1970s. Indeed, this wine growing region, encompassing the High Eden Ridge through to Springton and Eden Valley itself, is considered

distinctive to the valley floor plantings and is referred to as the Eden Valley Wine Region.

Here, high up on the plateau, vistas of rolling hills and dales, vineyards and gumtree-studded open fields are criss-crossed with creeks fringed with native bush – all punctuated by rocky outcrops and granite boulders. In this magnificent country, at a height of 600 metres above sea level, the coolness of climate compared to the valley floor provides conditions suitable for white grape plantings, especially chardonnay and riesling varieties. Soil characteristics and micro-climate also vary considerably, and these factors, together with the expertise of a younger generation of winemakers and the latest viticultural technology, are among the complex of elements which become expressed in white wines of considerable regional character, such as the distinguished Eden Valley Riesling.

Colin Gramp, formerly of Orlando Wines, was a pioneer in this respect, taking advantage of the cooler, east-facing slopes of the land high above Rowland Flat, when he established his vineyard of riesling grapes there in 1962. Known as the Steingarten Vineyard, its name derives from the Steingarten track or road which leads up to Trial Hill and Pewsey Vale Peak. It was certainly a trial to establish these vineyards: first, the soil was deeply dug by mechanical ripping to break up and expose large slabs of underlying schist rock. These were hand-hammered to break them into smaller pieces which were left on site and which form a natural mulch over the soil surface; the close planting of vines increased the density by a factor of three above usual plantings. The cold and windy site creates a high natural acidity in the fruit when fully ripe.

More recently, in early 1997, recognition of the Eden Valley's qualities as a distinctive wine district within a wider, premium wine region, was underscored when winemaker James Irvine won the 'world's best merlot' award in an international competition held in Switzerland, for his Irvine Grand Merlot 1992. James Irvine has managed a small holding of some fourteen hectares of vineyards in the Eden Valley since the early 1980s. From the small vineyard plots of chardonnay and merlot, and the only meslier grown outside France's Champagne region, Irvine creates relatively small quantities of premium wines of intense flavour and regionality.

In the Barossa Valley the grape harvest is carried out in March and April, and some three weeks later in the cooler districts of the high plateau fields about Pewsey Vale and Eden Valley. A 1903 description of grapepicking, in this instance at Seppeltsfield, evokes an idyllic image:

> … we drove through undulating country, with vineyards on every side, to the quaint, clean, and inviting township of Tanunda. In most of the vineyards they were picking the grapes. Pretty, fresh-looking girls were the principal workers. When their vessels were filled with fruit they carried them off to the German wagon and emptied the contents therein … I saw 20 or 30 wagons at Seppeltsfield and there was not a poor-looking horse in one of the teams … As we passed by the fresh-complexioned girls, nearly all dressed in blue print dresses, got up from under the fruitful vines, and, seizing their large sunbonnets by the long strings, waved them round their heads, smiled at us, and showed their even rows of pearly white teeth. They were soon hard at work again, cutting the big bunches of juicy red grapes.

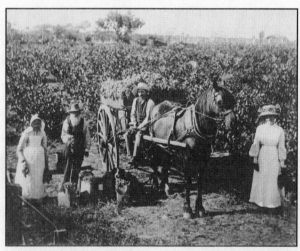

Grape harvesting by the Dier family near Tanunda, c. 1910. Barossa Valley Archives and Historical Trust. Note the traditional field bonnet still worn by the older generation at the time.

Grapes were picked by both young men and women who collected the fruit in wicker baskets which were then emptied into the German wagon. Grape-growers then delivered their harvest to particular winemakers to whom they remained faithful for generations.

Until the third quarter of the nineteenth century methods for winemaking tended to be based on age-old techniques considered 'primitive' even by the

standards of visitors to the Barossa in those years. The most evocative of these was the retention, at least up to the 1880s, of the pressing of grapes with bare feet in 'treading boxes'; it was claimed that this method led to larger quantities of juice and prevented the crushing of seeds and unripe berries. Later, bare feet gave way to those clad in leather boots made specifically for this use; William Salter, of Saltram Winery, certainly swore by this method, his treaders wearing special knee boots to facilitate the crushing! Mechanised rollers and the hydraulic basket press gradually, and inevitably, replaced this labour-intensive method. Indeed, portable wine screw presses used in the late nineteenth and early twentieth century are still occasionally used for small batches of wines, and may now be seen displayed as decorative features in wineries about the Barossa.

An idea of the early, pre-industrial, technology of winemaking may be gleaned from an old Saxon grape press at the Yalumba Winery, just out of Angaston. Hand-crafted from beech and a centuries-old oak tree in 1895, this wine press was in use in Transylvania (Romania) until 1993 when it was purchased and transported to the Barossa; it is now displayed as an item of interest for visitors in the Yalumba wine-tasting room.

Constant improvements were introduced as winemaking technology advanced. As noted earlier, the Seppelt family were at the forefront in this as they had established an advanced laboratory, the first in the Barossa. Here, the chemistry of wine, the processes of fermentation and other stages of wine-making were investigated and improved. Among their innovations, Benno Seppelt patented a pasteuriser which permitted greater control of fermentation. His laboratory also began testing cultured yeasts imported from Europe: these eventually replaced the traditional dependency on fermentation by wild yeasts which occur naturally on the skins of grapes.

Despite modern improvements, one or two Barossa winemakers prefer to use the winemaking machinery developed in the late nineteenth century. Robert O'Callaghan of Rockford Wines is one such person who has resuscitated early pieces of machinery to make his wines – in combination with contemporary knowledge and techniques. He uses an old hand-operated Bagshaw Crusher constructed in the 1860s to gently crush over 200 tonnes of his best fruit hand-picked from old vines.

Another item which has remained practically unchanged since winemaking

was introduced into the region is the barrel. The necessity of storing and maturing wine in wooden casks has remained an essential part of today's technology, and as a result, has supported the associated industry of coopering which developed alongside the activities of viticulture and winemaking. In the Barossa, Paul John, born of Silesian migrants at Light Pass, became a cabinet-maker and carpenter, later specialising in coopering. His son, Arthur John established the A.P. John & Sons Cooperage in 1898, which, as a fourth generation family business, still makes vats, casks and hogsheads at Tanunda using imported European or American oak for local, national and overseas winemakers. Yalumba Winery has its own cooper of many years, Harry Mahlo, who often gives demonstrations of the age-old craft of barrel-making.

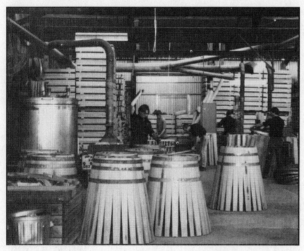

Barrel-making at A.P. John and Sons Cooperage in Tanunda.

Today, the Barossa is recognised as Australia's premium wine-producing region, accounting for over 40 per cent of national wine exports (in 1997/98, wine industry figures showed that the Barossa produced 135 million litres of wine out of an Australian vintage of 690 million litres). Little wonder that the Barossa is now also acknowledged as one of the world's premium wine-producing regions. Some 400 grape growers, a large proportion of whom are now in their sixth generation, provide the region's 55 or so wineries with about 68 000 tonnes of grapes. From this fruit are created numerous wine blends – reds, whites and fortifieds.

Anyone touring the Barossa wineries has the opportunity to observe various stages of the winemaking process and its tangible manifestations which figure

strongly on the landscape: the tall stands of gleaming modern stainless steel fermentation tanks, and the more romantic concrete versions built as crenellated towers or other architectural forms in the nineteenth century; the extraordinary variety of winery buildings with the cool cellars and stacked vats and hogsheads; and finally, the ubiquitous strong smell of fermentation wafting in the fresh country air. They may also note the workers pruning the vines in the crisp late winter air, or harvesting the vintage during the balmy and colourful days of autumn. Of course the visitor may also partake of this cultural heritage in a more pleasurable manner by sampling the region's world-class wines and savouring the taste of history.

From limited release varietals, to tawny vintage ports and luscious dessert wines, the Barossa's wine abundance and diversity can be overwhelming. The varieties of red and white grapes grown in the region are also considerable although certain types predominate according to their regional suitability. Among the latter, chardonnay is a vigorous, trouble-free variety widely planted in the Barossa and suitable for machine harvesting. After fermentation and maturation in oak casks, the popular dry white wine produced from these grapes is usually rich and complex in character, or of a lighter, fruitier style.

Since the origins of the wine industry in the region, the larger wineries (especially those owned by the British landowners during the nineteenth century) employed specialist winemakers or consultants. As mentioned earlier, one of the most sought after was Carl Sobels who was considered, from his arrival in 1847 until his death in 1863, to be one of the most experienced winemakers in Australia. After Sobels, a veritable pantheon of winemakers has seen to the creation of the Barossa's reputation for fine wine. Today, this widespread fame rests on the work of makers such as John Glaetzer and his brother Colin, John Duval, Stephen Henschke, Adam Wynn, Peter Lehmann, Robert O'Callaghan, Graeme Melton, Grant Burge, Philip Laffer, Brian Walsh and James Godfrey, to name just a handful.

Peter Lehmann's story is, like every other individual's in the Barossa, unique, and very much tied to the place. As the son of a Lutheran pastor and a fifth generation Barossan, Lehmann worked in a number of wineries about the valley, beginning with Yalumba. As a winemaker at Saltram during the 1960s and 1970s, he was responsible for the company's success during that period

until Saltram was taken over by a multinational. A grape glut forced the company to renege on its deals to take in fruit from local grapegrowers, an action Lehmann deplored. So he devised a plan whereby surplus grapes were purchased, processed under contract at Saltram and then bottled and sold under the Masterton Barossa Vignerons label. This arrangement worked until 1979 when Saltram was sold once again. Lehmann then established a new winery under his own name from 1986; in 1993, Peter Lehmann Wines was floated as a public company.

Peter Lehmann himself has maintained the tradition of purchasing grapes from a large number of local growers, sometimes as many as 150 a vintage, many of whom are fifth and sixth generation descendants of Barossa vignerons—such as Harry Schmidt of Light Pass, Ron Seelander of Angaston, Albert Schmidt of Vine Vale, Lloyd Schrapel of Neukirch, and Allan Falkenberg of Ebenezer—most of whom still live on vineyards established mid-last century. Lehmann still follows time-honoured traditions: he and his son Doug show interest in the vines, visiting the vineyards frequently to keep in touch with the quality of the fruit, preferring where possible the low yields obtained from non-irrigated shiraz vines during dry years, and paying a premium for these, as these produce the award-winning wines; they also continue to seal as many contracts as possible with a handshake, in preference to the use of formal contracts. To this day, Peter Lehmann continues to be involved with the vintage grape weigh-in, enjoying the contact and a 'schluck' with each of the growers. As he notes, the Peter Lehmann label continues to be produced solely from Barossa fruit, and this together with his and his son's winemaking expertise, continues to ensure their ongoing achievement of award-winning wines.

Each winemaker has his approach, and at Mountadam for example, David Wynn has developed the traditional French method of fermentation of chardonnay in small oak barrels as a standard practice since 1984, and which is still carried on by third generation Adam Wynn. This approach brings fruit and wood together from the point of fermentation, integrating these elements to produce a complex character; it also provides a means of closely following through and controlling the process of maturation. Every year some 25 chardonnays are produced and combined to result in vintages of the

Mountadam Chardonnay lauded world-wide: it invariably has a complex bouquet which can suggest the flavours of grilled cashew nuts and even chocolate!

As a classic grape variety from Germany, rhine riesling was one of the earliest varieties planted in the Barossa, and those vineyards in the cooler areas of the region, about the ranges and Eden Valley, are considered as among the best rieslings in the world. Riesling grapes produce a wine which may range from dry to sweet, with a fruity citrus and often floral bouquet. Riesling wines often have excellent ageing qualities, their youthful green-gold colouring developing into a golden hue. Late picked rhine riesling grapes produce luscious dessert wines with strong natural sweetness and balanced acidity, and sometimes with botrytis 'Noble Rot' which introduces an even greater sugar concentration and complexity of flavour.

Other white grape varieties grown in the region, although not as widely, include sauvignon blanc, semillon, traminer, crouchen, and pinot blanc. Some small patches of early, more obscure, varieties have survived in the Barossa, such as a small vineyard of white temprano vines at Yalumba, thought to be survivors from the original cuttings collected by James Busby from Europe for the New South Wales government in 1838. These vines, probably planted in about 1850, are used as a base for making sherry.

Other white wines of note produced in the Barossa include: Basedow's White Burgundy, Basedow's Semillon, Burge Family Chardonnay, Charles Cimicky Sauvignon Blanc, Craneford Rhine Riesling, Krondorf Eden Valley Rhine Riesling, Saltram's Mamre Brook Chardonnay, Schmidt's (Tarcharlice) Botrytised Rhine Riesling, Tolley Gewurtztraminer, (Yalumba) Pewsey Vale Rhine Riesling. Aside from their celebrated reds, Henschke's produce a range of notable white wines which include an Eden Valley Riesling, Tilly's Vineyard Burgundy, Dry White Frontignac, Gewurtztraminer, and Noble Rot Riesling.

Red vine varieties grown in the Barossa include cabernet sauvignon, grenache, malbec, merlot, pinot noir and of course, shiraz – the latter currently considered among the most popular variety Australia-wide. Connoisseurs are attracted to the unique flavour or rich fruit, especially ripe pluminess and soft tannins of shiraz wine. Sadly, during the mid-1980s, an ill-conceived, government-subsidised Vine Pull Scheme saw much of the Barossa's nineteenth-

century heritage of shiraz vineyards tragically ripped out. I remember driving through the valley during the late afternoon of an autumn day, and feeling despondent and puzzled at the sight of huge piles of the bulldozed and burning vines. This misfortune is even more highlighted given the perception that shiraz has a rapport with the particular soils and climate of the region, similar to the affinity cabernet sauvignon is said to have with the Coonawarra district in the south-east of the state.

The few remaining precious patches of old shiraz vines in the Barossa (including the aforementioned Turkey Flat Vineyard at Bethany, a vineyard of 1908 vines at Yalumba Winery, and a patch of shiraz vines planted in 1887 at Barossa Settlers) yield only relatively small quantities of about 1.5 tonnes per hectare (these surviving Barossa old shiraz vines probably constitute the largest acreages of its type in the world). This sought-after harvest therefore commands a premium from winemakers who use it to produce intense and concentrated wines of wonderful character and considerable longevity. These include classics such as St Hallett Old Block Shiraz made from 104-year-old vines which produce a rich and generous red wine whose deep-layered black-berry, black cherry, plum and spice flavours linger long on the finish; Rockford Basket Press; and Peter Lehmann Stonewell – the latter is embodied with a deep purple colour, a rich aroma and explosive peppery, earthy and spicy flavours. Henschke's world-famous Hill of Grace and esteemed Mount Edelstone, both made from old shiraz vines from two vineyard locations (see earlier), are a further testimony to the potential of old shiraz vines and the art of wine-making to produce wines which are highly esteemed.

However, as a red vine variety, the vast majority of shiraz produced is usually blended with other fruit to produce a contemporary, softer, fruitier style with soft tannin and oak especially suited to the modern palate. Shiraz is emerging as Australia's most significant quality red wine grape variety with the Barossa region commanding the reputation as growing the finest available. Among the shiraz wines of note produced in the Barossa (besides the afor-mentioned wines made from fruit obtained from old vines), we may single out Charles Melton Shiraz, Veritas Barossa Valley Shiraz (Hanisch Vineyard), Grant Burge's Meshach (made from hand-picked 70-year-old vines and named after Burge's great grandfather), Elderton Command Shiraz, Barossa Valley

Estate's E & E Black Pepper Shiraz, Yalumba's Octavius Shiraz, Rockford Basket Press, and Peter Lehmann Shiraz.

Of course there is also Penfolds Grange, considered in 1995 by the US magazine *The Wine Spectator*, as the world's 'number one' wine. Made from fruit harvested from a mixture of water-deprived, old and young shiraz vines located in the Kalimna and Koonunga Hill vineyards about Nuriootpa, winemaker John Duval oversees a complex process of blending, whereby environment, art and science interact to produce Australia's greatest wine. It is variously described as having an incredible, deep-purple crimson colour, with smoky oak, high tannin, and sweet fresh fruit, as well as vanilla and coconut, nose and flavour; given the long and limited production, it is little wonder that Penfolds Grange is so highly sought after by the world's connoisseurs and investors.

At the new consortium business, Barossa Vintners, winemaker Colin Glaetzer is the only member to produce and sell wine under his own family label of Glaetzer Wines. Glaetzer earned a reputation as one of the more prominent winemakers of the Barossa while working for Barossa Valley Estates over 11 vintages. At Barossa Vintners, he is using fruit (mostly shiraz with some semillon) predominantly obtained from low-yielding but highly flavoured and very old bush vines, growing in the dryer Ebenezer district of the north-western Barossa Valley, to produce small batches of a suite of about seven premium wines. These include a grenache mourverde blend made from hand-picked fruit at its optimum maturity and fermented on skins to obtain rich red hues; its final stages of fermentation were completed in seasoned American oak hogsheads to produce a balanced and complex wine of soft palate and intense depth of flavour complemented by subtle oak tannins. Glaetzer's distinctive bush vine semillon exemplifies the Barossa Valley semillon characters of soft-ness and delicate fruit flavour, with a nose of fresh citrus overtones and subtle French oak influences—a result of partial fermentation in Nevers hogsheads.

Glaetzer also produces a special sweet semillon ratafia, so named because of the Old World tradition of sealing a ratified treaty with a toast of sweet wine. Made from fully ripened Barossa valley semillon, this semillon ratafia inter-mingles the luscious aromas of peaches and pears with dramatic taste intensity; as such, it has gained the attention of Tanunda's 1918 Bistro which has created a special pear dessert to complement the wine.

Cabernet sauvignon is another premier grape variety widely grown in the region where it produces fruit that results in wines of a fuller body and softer finish than other areas. Winemaker Stephen Henschke details the following qualities as desirable in a good cabernet: intense varietal fruit evocative of violets, anise and blackcurrants, cigar-box oak, rich and full on the palate, excellent depth and length and fine-grained tannins. Districts in the Barossa region which have the conditions necessary to produce the spicy and ripe berry fruit flavours which result in the Barossa cabernets of note are the valley floor itself, as well as particular sites in the Eden Valley, such as the north and west-facing slopes where sufficient sunshine achieves full maturity. Elderton Wines, for example, takes its name from an old vineyard of red grapes which have sent their 55-year-old roots deep into the geologically-aged and deep alluvial silts of the Nuriootpa area, eventually to be converted by winemakers Lorraine and Neil Ashmead into an award-winning, cabernet sauvignon wine.

Among the most noteworthy cabernets produced in the Barossa region mention must be made of the Cyril Henschke Cabernet Sauvignon which is a regular trophy winner, and described as an elegant wine of 'astonishing depth' whose bouquet has the violets, blackberry and cedary oak necessary in a good cabernet. A selection of other cabernet sauvignon wines which merit a mention include the highly-awarded Seppelts Dorrien Cabernet Sauvignon, Peter Lehmann Barossa Cabernet Sauvignon, Schmidt's Tarchalice (Walter Blend) Cabernet Sauvignon, Eden Valley Cabernet, and Rockford Cabernet Sauvignon.

An account of the Barossa's viticulture and winemaking cannot be considered complete without some mention of its renowned fortified wines. In the earlier years of the Barossa's wine history, fortified wines contributed to a high proportion of the overall output and included tawny and vintage ports and sherries, and more recently, luscious dessert wines. As well as table wines some 27 Barossa wineries have maintained production in this category, of which Seppelt Wines is among the largest producers of fortified wines in the southern hemisphere. An extraordinary 28 000 hogsheads of maturing ports and sherries are stored in its massive cellars, which include that unique creation – Para Liqueur Port.

Named after the Barossa's Para River, the three types of Para ports which

Seppeltsfield produces include the rare (and of necessity, very expensive) 100-year-old vintage Para which Benno Seppelt initiated in 1878, following the completion of yet another stage of his building expansion at Seppeltsfield. The puncheon he laid down became a tradition, with one being laid down each subsequent year to be left unopened until 100 years had passed – he was clearly an extraordinary visionary! In 1978 Seppeltsfield began bottling the port from the first puncheon (this extremely rare wine now commands several thousand dollars a bottle: a 1896 bottle realised $2 400 at the 1997 Barossa Vintage Festival Rare Wine Auction), and later, less expensive vintage Paras were also bottled beginning with the release of the 1922 in 1953.

Not unexpectedly, given the 100 years of maturation, Seppeltsfield's Para ports are a luscious, complex taste experience. The Para Liqueur Port is succinctly described as having an extraordinarily intense and unforgettable flavour. The vintage Para Ports are a tawny-gold liquid rich in raisiny, fruit and even sweet orange flavours with nutty, licorice and spicy overtones, while the Bin Series are a melody of dried raisins, black pepper and chocolate hints, the flavours combining to create a spectacular taste sensation.

There are other ports which Seppeltsfield produces including its elegant Old Trafford tawny port which their winemaker James Godfrey creates from Seppeltsfield's store of old ports including a small proportion of the Para Bin Series; and there are also its award-winning Show Tawny Ports made in the classic Portuguese style.

Also in the classic style are Seppeltsfield's 'trio' of sherries which emerge from the winery's historical context. The Palomino grape is the usual variety from which a white wine is made as the first step in sherry production, although the Pedro and Ximines cultivars are also commonly used. The wine is then inoculated with a selected Flor yeast culture which flourishes on the surface of the casket wine, eventually producing the lightest and driest of the three sherry styles – Fino. The cathedral vaults of the sherry cellar are the location of nineteenth-century soleras, essentially a network of casks where the new, or Fino, sherry slowly blends with older vintages over a period of decades. The matured sherry is drawn off for bottling according to the master blender's expertise – about 16 years at Seppeltsfield – when it has acquired a deeper colour and more complex flavours to be classified as Amontillado. A longer

period in the solera allows the sherry to mature into the rich, spicy and fruity flavours typical of the Oloroso style.

Other renowned fortified wines made by wineries of the Barossa include the St Hallett Old Crock Tawny Port, and their Pedro Ximenes-based sweet white wine; Penfolds Grandfather Port, and Yalumba Galway Pipe (port); and Schmidt's Tarchalice Winery's Old Ports and quite luscious Liqueur Frontignac.

The preceding are but a few the examples of the variety of wines of great character produced in the Barossa region. They serve to demonstrate that, just as vernacular forms of architecture, food, language and furniture may emerge from the blending of elements of ethnic and local cultures and settings, so too are the unique flavours of the wines of the Barossa region an outcome of this process. Long-established and new vine varieties, local soils and climatic conditions, viticultural approaches and the accumulated expertise of local winemakers, all interact to infuse the wines with a distinctive personality and sense of place – this is, quite literally, the vernacular flavour of the Barossa.

And it is this particular historical combination of physical, economic and cultural factors which has led the Barossa to become, not only Australia's leading wine producer, but also a region with a viticultural and wine heritage which makes wines that are celebrated around the world. It is also this unique combination of features which attracts the sojourner in search of flavour within an authentic, cultural setting.

So drive through the gateways of the Barossa – proclaimed at Tanunda's southern entrance by its wine-advertising archway and at its northern exit by the Seppelt archway – twin arches which triumphantly herald the historic and living wine culture of the region.

Cuisine, Food Traditions & Farming

Kuchen and Cucumbers

'On enquiry I was told that those "goose eggs" were a sort of white cheese made from sour milk, with salt and caraway seeds added for flavouring.'
'Itinerant'

The Barossa is the only place in Australia where it can be said that a distinctive regional cuisine was established in the historical past, and which still exists as a vital component of its present-day community and cultural heritage.

As with their Lutheran faith, German language, music, architecture, crafts and folk customs, the Barossa Lutherans also transplanted and retained their heritage of Prussian-based food preparation and cooking customs, usually referred to under the collective term of 'foodways'. Pickled dill cucumbers, egg noodles, sauerkraut, home-smoked meats, wursts and sausages, pickled pig, and home-baked breads and *Streusel* cake – these are but a few of the traditional foods which may appear to be clichés of what is considered German food. And although they are still prepared and are available to be sampled in the Barossa to this day – they alone do not comprise its regional cuisine.

Contemporary Barossa cuisine consists of much more than simply being a

descendant of traditional Prussian food and is based, often with little change, on a nineteenth century central-European migrant culture which has developed over a period of just over 150 years. It is generally considered that regional cuisines consist of much more than their actual foods and preparation methods, but emerge from a region that has developed a strong sense of identity through its generations of traditional folklife activity. The Barossa, with its intertwining strands of Prussian and English history, enduring community, premium wine industry, distinctive landscape and its traditional festivals of celebration, has created a regional character and identity unique to Australia. Add to this its developing cuisine which has a strong Prussian peasant cultural inheritance, as well as its reputation as a region for producing high quality foodstuffs, and you have the making of a true regional cuisine.

Prior to sampling the distinctive tastes and flavours of contemporary Barossa cuisine we need to examine its culinary origins and the processes which led to the present-day mix which preserves facets of tradition, yet is responsive to modern-day tastes and influences.

Traditional Prussian Cuisine

As part of their yearning for the homeland, their determination for cultural preservation, and their strategy towards self-sufficiency, the Barossa's Prussian settlers were quick to exploit the natural resources of their new country, establishing mixed, self-sufficient farms, and generally cultivating the valley soils to bring forth a bounty of produce. However, as we have noted on a number of occasions, traditions are not static and when transferred to a new setting influences are inevitably absorbed which lead to their gradual transformation; eventually, new vernacular forms replace the original cultural types. I have spoken of the notion of new vernacular forms elsewhere, but in brief, I mean those which preserve a core of the original model which have been adapted or modified according to the resources to be found in the new environment – or through any social or cultural pressures responded to by the seedling community. In this way, vernacular types become tied to their locale, and the peculiar mix of influences which moulded time-honoured traditions into somewhat differing forms.

Hence, just like the other traits which identify their cultural heritage,

Prussian 'foodways', that is, the totality of traditional cuisine and its associated customs, similarly underwent a process of change as they were adapted to the local resources and conditions of their Barossa setting.

At first, the Barossa Germans emulated as closely as possible most aspects of their traditional cuisine. This is not surprising given that any migrant group naturally seizes on its core cultural characteristics, especially religion and language, in order to establish some stability and offset the sense of alienation that migration to a new country usually engenders. So too, can traditional cooking and foods confer a sense of familiarity and comfort. At first, given these factors and the frugality and Old World conservatism of the early settlers, much of the character of their original central-European cuisine was retained; indeed, a number of strands of the original culinary Prussian approach have survived to this day. However, over the years, two major factors acted to change the original Barossa cuisine: new cooking methods were borrowed from the British colonists, and new varieties of local produce were also introduced, both enriching the traditional German cooking methods and food ingredients. Gradually, over a time span of 155 years, traditional and new ingredients and preparation approaches blended to create what we now recognise as a regional Barossa cuisine.

Naturally, the characteristics of this regional cuisine were especially strongly influenced by the make-up of the early Barossa settlers. Because the greater proportion of migrants were Silesian, or at least came from a region of the Oder River Valley which also took in parts of Brandenburg and Posen, it is this down-to-earth Silesian peasant character which has become one of the strongest cultural influences and identifying features of present-day Barossa cuisine. Its influence is seen not only in a number of specific dishes and cooking methods, but also in the particular frugality practised by these peasants, one which dictated that wastage was to be avoided to the point that all parts of an animal, including the offal, were prepared and cooked – hence the endearing Barossa adage 'everything but the squeal'.

Early documents or references regarding the food culture of the early Barossa settlers are disappointingly sparse. One of the few snippets of documentation regarding their original cuisine is the following description written in 1849 by a visitor under the curious nom de plume 'Itinerant'. The village of

129

Bethany had then been established for seven years, so the account reveals how faithfully Silesian food traditions were being retained by the Prussian pioneers:

> I noticed from a distance some white objects resembling goose eggs placed on wide planks on the roofs of some of the buildings. On enquiry I was told that those 'goose eggs' were a sort of white cheese made from sour milk, with salt and caraway seeds added for flavouring. When properly matured, this white cheese is said to be both tasty and nutritious. The Germans put thin slices of this cheese on their bread and butter, and are very fond of it …

The visitor was describing traditional quark, also known in familiar Barossa Deutsch as 'stinkerkaese' due to its rather strong and unpleasant odour – and it was made as described using curdled skim milk. Other variations of stinkerkaese include the same soft, white curdled cheese wrapped in cabbage leaves then allowed to ferment in a crock before eating.

In the absence of documentation, surviving artefacts used in the preparation of their food, as well as a knowledge of their agricultural methods and customs, especially permit us to piece together a more complete picture of early Prussian-Barossan cuisine.

Early kitchen implements such as cabbage shredders, waffle irons, earthenware jars and baking forms, as well as the traditional black kitchen, the bakehouse and smokehouse, all contribute to a picture of a people who took their cooking seriously and who ate well. Thus examples of earthenware cooking and preparation pots made by the Barossa's only early nineteenth-century migrant Prussian potter, Samuel Hoffmann, as well as the black kitchen and ubiquitous bakeoven and other utensils, are tangible surviving components of their traditional foods and associated customs.

On the other hand, some particular foods and their preparation or cooking methods have remained almost unchanged from the original. This especially applies to a number of cake recipes and pickling techniques. This living component of traditional 'foodways', that is, the preparation methods and the customs associated with them which have been handed down from generation to generation, are especially cogent reminders of the force of tradition and its links to community values.

Baking: German Cake and Bread

The early Barossa kitchen consisted of a small hut or cottage with a substantial brick bake-oven located in the garden separate from the the main dwelling (see Chapter 3). The brick or stone walls of the bake-oven were first heated to a high temperature with a substantial wood fire. The ashes were then scraped out and the oven floor wiped as clean as possible. The dough was then placed inside the tunnel-shaped oven using special wooden implements, to be baked by the retained heat. Prior to this, the dough mixture had been allowed to rise in traditional wooden doughbins of sloping sides and sliding lids.

Baking was organised on a weekly routine, usually on the Friday, whereby the housewife would prepare large quantities of breads and cakes for the coming weekend and following week.

There are a number of variations of the popular Barossa yeast cake originally referred to as *Deutscher Kuchen* (German cake), the most common being *Streuselkuchen* and *Bienenstich*. Kuchen was usually plain, but was served with various toppings, the most common being one made from flour and sugar moistened with butter then crumbled over the top. *Streuselkuchen* was baked in large quantities in the form of huge slabs to provide sufficient cake to go around the large families, or for the many guests at a wedding, birthday or other celebrations. Toppings depended on the seasonal availability of fruits with plums or apricots typical favourites around Christmas time.

Bertha Hahn has kindly supplied her grandmother's traditional recipe for *Streuselkuchen* which includes the original huge quantities of ingredients—enough to last a three-day wedding—which may be scaled down: 48 pounds plain flour, 18 pounds of sugar, 10 pounds butter, 12–15 dozen eggs, 2 tablespoons mace, and one-and-a-half tablespoons almond essence, a handful of salt, a gallon of active yeast made with potato and water hops, sugar and flour (if compressed yeast is used it would need to consist of about a pound). These ingredients are placed into a dough vat and a well made in the centre into which the active yeast is poured and mixed gradually with the flour. When 'cracked' on top the eggs and butter may be added and worked in well for fifteen minutes (previously the butter should have been melted on low heat and the almond essence and mace added). Allow to rise to double thickness then spread on slides to rise again. Finally brush the top with a mixture of 4 cups of cream beaten with 12 eggs, then

Large slabs of traditional *Deutscher Kuchen* (German cake), such as *Bienenstich* (left) and *Streuselkuchen* are still baked daily in huge slabs in the Barossa. Tanunda Town Day, held during the Barossa Vintage Festival, provides one opportunity to sample these baked delights.

spread with *Streusel* topping and bake in a fairly hot oven on the bottom shelf. The latter is made from 12 pounds plain flour, 12 pounds sugar, 6 pounds butter, four grated nutmegs and 2 teaspoons of lemon and 1 tablespoon of vanilla essence. This is rubbed between the hands until lumpy, then crumbled over the spread dough (a scattering of chopped almonds is a popular addition).

Today you can still see large trays of *Streuselkuchen* in commercial bakeries around the Barossa; among the longest-established of these is the Apex Bakery in Tanunda, operated by the Fechner family since 1948. An old open wood-burning brick oven, the only one still in use in the Barossa, bakes the Fechners' breads and pasties. Linke's Bakery in Nuriootpa, established in 1941 by Jack Linke, also maintains the Barossa bakery tradition, and is still run by the family: their *Bienenstich*, a yeast cake filled with custard and topped with honey and crushed nuts (usually almonds but peanuts may be substituted), is a specialty. *Bienenstich* translates into 'bee-sting cake', possibly because the honey attracted bees!

Gugelhupf or pot cake, was a turban or wreath-shaped German cake also brought over by families from particular regions of Germany, the traditional recipe later being shared around the Barossa. Again, the evidence of surviving earthenwares by the Barossa potter, Samuel Hoffmann, demonstrates that this

was also an early tradition in the region: among his wares was a heavy earthenware form (*Backform*) used for the baking of *Gugelhupf* (see Chapter 6). The grooved wreath-shaped form has a central cone which conducts the heat to the centre of the cake mix, ensuring a well-cooked cake, as well as an attractive shape. In later years, tin moulds took over from those made of pottery. To make the cake, the shaped mould was filled with the prepared cake mixture which varied depending on the regional origin of the recipe and the cook's creative flair (although the usual ingredients included flour, yeast, milk, butter, eggs, lemon juice, raisins soaked in rum, and fruit).

In Lyndoch, the arrival of Walter Eder from Munich, Germany, in 1980, saw the fresh infusion of German tradition following the establishment of the Lyndoch Bakery. This establishment specialises in the baking of a very large range of traditional German breads derived from many regions, and includes volkorn brot, walnut vienna, tre-korn brot, Vogel, onion rye, and Bavarian brezel. Although dark rye bread was baked in the Barossa's earlier years, its Prussian pioneers and their later generations predominantly ate a plain white bread. Nevertheless, from time to time, their descendants continue to bake a traditional, wholegrain, bread by first soaking 2–3 cups of wheat grains for two days until very soft and swollen, then mixing these into an ordinary white bread dough mixture prior to baking; sometimes the soaked grain was put through a mincer to produce a finer texture.

Another traditional Barossa-German baked delight is *Honigkuchen* or honey cake, a biscuit-like cake made with honey, flour, butter, eggs, rose water, soda, vinegar, cloves and cinnamon. The mixture is rolled into a centimetre-thick slab and baked. It is then cut into the shapes of various animals, often using home-made cutters made of tin, and decorated with icing and topped with chopped almonds or candied peel; it is still made on special occasions, especially Christmas when fingers of *Honigkuchen* are hung on the tree as edible ornaments.

The eccentricity of Johannes Menge was evident in his reputation for a fondness of pancakes, said to comprise his main diet! Certainly pancakes and waffles formed a part of the food culture of the early Barossa Lutherans, and cast and blacksmith-beaten iron plates and implements for cooking this food still occasionally turn up in the antique shops about the region. Waffles were simply made from flour, milk, butter and egg mixtures, and cooked in the

greased waffle iron until golden brown and served with caster sugar and jam or honey. They were usually baked for particular feast days or the new year.

Pickling Dill Cucumbers & Hawking Noodles

The preparation of pickled dill cucumbers (*Saure Gurken*) was a specialty of the Silesian migrants. It is a foodstuff which the Barossa is renowned for and so serious has the art of producing the perfect dill cucumber become, that The South Australian Dill Cucumber Championships, a state-wide competition, is held every year during the Tanunda Agricultural, Horticultural and Floral Show. Judges taste samples of dill cucumbers noting their shape, colour, crispness and flavour. The best characteristics are considered to be a bright green colour, crisp texture, and a piquant but not excessively salty taste.

Every January, each family would pickle sufficient cucumbers harvested from their kitchen gardens to last through the year. They followed recipes handed down from generation to generation, each family holding closely onto their particular variation or 'secret' ingredient. Cucumbers are first carefully laid in earthenware or stone crocks, then a layer of vine leaves, followed by a layer of dried dill (seeds and stems), then the next layer of cucumber follows and so on, until the crock is filled, finishing with leaves. Brine is then poured in, although vinegar is sometimes substituted, then an old plate is placed over the top with a stone to weigh down the layers and allow the pickling or mild fermentation process to occur for 12 to 21 days.

Bruno Fechner gave his recipe for pickled dill cucumbers (*Saure Gurken*) as follows: one 4 gallon tin of cucumbers, three-quarters of a cup of salt, half a cup of white vinegar, use grenache vine leaves if possible and add one layer of cherry leaves to impart additional, slightly bitter flavour, as well as the necessary handful of dried dill. A period between 12 to 21 days allows the pickling or mild fermentation process to occur before the cucumbers may be removed and placed in another container with some wine vinegar.

In March, the cucumbers would be packed with home-smoked meats and home-baked bread, and eaten during a well-deserved lunch break in the vineyards during the grape-picking season. Over March and April, hand-painted signs advertising home-pickled dill cucumbers for sale are a familiar sight along the Barossa's roads.

Pickled dill cucumbers, *Saure Gurken*, were a specialty of the early Silesian migrants. This Barossan food is still produced according to traditional recipes.

Other favourite vegetables used for pickling include the cabbage, broad beans and turnip. Cabbages were once sliced using a traditional hand-held wooden slicer which was fitted with two blades, the handle sometimes decorated with a profile of the popular folk motif of the heart. The shredded cabbage was then sprinkled with salt as it was packed into jars. After a period of about a week, fermentation produced the traditional sauerkraut.

Wiech's Noodles of Tanunda are an example of a traditional Barossa food which has been successfully transferred from its humble family origins to larger-scale commercial production. Jacob Wiech migrated from southern Germany in 1928, his wife and family arriving a year later. Their traditional egg noodles were so impressive that a friend suggested they make sufficient noodles to supply her hotel's dining room. At the time, Jacob was a tailor but needed to increase the family's income.

The opportunity was taken up and became so successful that, by 1955, Margaret, Jacob Wiech's daughter, was hawking the family-made noodles around Adelaide. Today, the family-based operation still produces the noodles in the traditional method of rolling out the batter, not extruding it as in the Italian procedure – hence the characteristic texture. The Wiech traditional recipe and method for making egg noodles also uses the best local flour and fresh eggs with just a little water to make three kinds of noodles for use in soups, salads or casseroles.

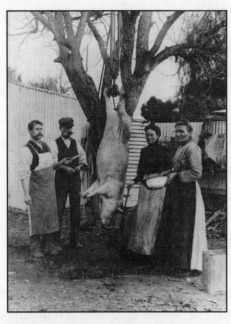

Pig slaughtering and its accompanying preparation was a busy two days with the whole family assisting in the various chores which led to a year's supply of wursts and other traditional German food products. Indeed, 'every thing but the squeal', was said to have been utilised! In this phototgraph taken in 1913, the *Hausfrau* is preparing to collect blood for making blutwurst.

'Everything but the squeal'

The preservation of food was critical in an age when refrigerators and modern preservatives were unavailable and when large families needed sufficient food stored on shelves or in the ubiquitous food safes – usually located in the cellar – to tide them over winter. The Barossa folk practised Prussian food preservation methods which soon established an Australia-wide reputation for their traditional smoked meats and pickled vegetables, jams, jellies and chutneys.

Foodways, as I have already mentioned, is a term which describes the paraphenalia of rituals and customs associated with food growing, preparation and eating. Among these, that of pig slaughtering was one of the most observed in terms of its traditions and associated family ritual. On the Barossa farm it was traditional to set aside at least two days for 'Schweineschlachten' – the Barossa Deutsch term for pig slaughtering and its accompanying preparation.

Pig-killing occurred in winter when cold weather meant that flies were not around and other farm chores were less pressing: but in particular, the cold weather was necessary to cool the meat prior to processing. It began with Father announcing to the family that 'we will have a Schweineschlachten next

week!' It was a very busy two days with the whole family congregating to assist in the various stages. Father slaughtered the animal which was then left to hang overnight before being cut into portions. Blood, collected during slaughtering, was used with the darker meats obtained from the lungs and kidneys for making blutwurst (blood or black pudding). Sometimes rice cooked in broth was added to the blood pudding.

Other portions might be cut and preserved in brine or salted for preservation, usually in wooden casks with linen cloth covers. These were kept in the cellar until there was time to further process and smoke cure them to make a variety of wursts and sausages, including: metwurst, leberwurst (white pudding which consisted of the white meats), reisswurst (rice wurst), *Laschsschinken* (smoked pork fillet), and sugar-cured bacon and ham. Finally, the stomach was cleaned and turned inside out, packed with cubed pieces of the heavier meats such as the tongue and heart which had been cooked in broth with some blood, the whole 'package' then being cooked in the broth left over from the previously cooked sausages. The swollen stomach was then removed and very firmly pressed between two boards; once flattened the 'presswurst' as it was called, could then be sliced and served. Making wursts also involved the addition of various spices and herbs including thyme, garlic and onion, allspice,

The Braunack family farm near Gomersal still has its original stone and brick rendered smokehouse. Constructed in 1855, it functioned to smoke the various wursts and hams, and could hold the products of four pigs. The end of the capped chimney is missing, but originally it had a couple of smoke vents which were blocked with a beam when damping was necessary.

nutmeg and mace. Indeed, a large pig could supply the average (large) Barossa family with sufficient 'wursts' for the remainder of the year.

The hams, bacons and wursts were smoked in the family's own smoke-house, sometimes a small wattle and daub structure, or else a more substantial stone and brick outhouse – a few of which still remain in the region. Smoking utilised any scraps of fuel including almond husks, fine chips of native cypress pine, peppermint or redgum (various eucalyptus species), and even onion skins – these conferred specific flavours to the meat. A slow fire using the dampened chips, placed on the floor on top of a bed of hot coals, was kept going from early in the morning through to late at night or even longer, until the meat coloured to a golden brown.

Some of the early Barossa settlers' cottages included the medieval-style *Schwarze Küche*, that is a black kitchen where smoking could take place high up in the chimney in its smoke compartment. The base of a black kitchen included an area where food was prepared and cooked, while its vaulted brick flue was supplied with beams and hooks where meat could be hung to be cured by the rising smoke and heat (see Chapter 3).

The thrifty German settlers ensured that very little was wasted and it was often said with a touch of humour that 'the only part of the pig not used was the squeal'. Even the fat was processed and '*Grieven*' were made by straining off the hot liquid fat from the scraps. The former became cooking lard, while the latter was put through a hand mincer to become a tasty, crispy '*Grieven Schmalz*' to be eaten with great relish on a piece of bread. Animal fats such as lard and butter were typically used for cooking, whereas olive oil, which was sometimes also made locally with small hand-presses, was kept for medicinal purposes. In the contemporary Barossa, the culinary use of offal survives as an enduring influence of the peasant pioneers.

Schulz's Butchers of Angaston are among those who have successfully adopted the traditional Barossa family smoking of meats to commercial production: as well as their plain and garlic smoked wursts they also smoke kangaroo fillet using redgum and mallee chips. Other retail outlets such as the Tanunda Wursthaus sell their smoked and preserved meats as well as those supplied by a number of other family-owned producers including those of the Steiny, Lange and Linke families. Maggie and Colin Beer's Pheasant Farm paté, smoked

kangaroo and other products have also been instrumental in spreading this and other specialty products derived from the region's Silesian food heritage.

Pottery and Food

In the middle to later years of the nineteenth century, the Barossa's only potter, Samuel Hoffmann, supplied traditional wares for the preparation and storage of the Lutheran settlers' food. The first reference regarding the use of earthenware pottery by these people comes from the journal of Captain Hahn who, among his recorded observations of the Prussians under his care on the *Zebra* during their long journey to Australia in 1838, commented on their use of such vessels for cooking on board his ship. In the Barossa, it was the bake-oven which provided the Lutheran household with baked foods such as breads, cakes and biscuits, not to mention roast meats.

Samuel Hoffmann, made a variety of wares at Rowland Flat from the early 1850s through to 1883. Most are earthenware, although the large crock is stoneware. The two-handled vessel in the rear right was his traditional jar – used to pickle and store traditional foods. The mould was used to bake cakes, while the pierced vessel was used to drain milk fats when making quark, a type of cheese.

Pottery complemented and supplemented the wooden mixing troughs, cast iron containers, and tinware used in the Barossa kitchen (there were three tin craftsmen in Tanunda alone in the 1860s). Hoffmann's earthenwares and stonewares were useful for a range of food preparation and kitchen tasks, including direct cooking: cakes, for example, were baked in his earthenware moulds called *Backform*, handmade forms which gave them their characteristic turban shape (see *Gugelhupf* above). Other wares, such as the equally curious earthenware colanders, called *Käsesieber*, were used to drain milk fats when making traditional quark (curds).

The most frequently utilised form of earthenware vessel made by Hoffmann and used by his community was his traditional two-handled jar. Available in a range of sizes, the larger jars were used to pickle and store a variety of foods, especially dill cucumbers, beans, onions, cabbage, turnips and meat (such as pork in brine). With their generously wide openings and swelling body, these jars were well suited to such food storage, as well as permitting the contents to be scooped out whenever needed. When empty, the interior could be easily cleaned, a task assisted by the smooth, inner glazing, while their large sturdy handles facilitated handling. Liquids such as milk, vinegar and wine were also stored in similar jars. Jams, especially fig, plum and apricot, as well as quince preserve, were often stored in smaller-sized jars, their openings covered by a cotton cloth tied with a string around the grooved neck.

Other wares included a range of shallow bowls useful in the preparation of a variety of foods including the mixing of ingredients.

Rosenzweig family tradition fondly recalls Mother sitting under the porch and grinding poppy seeds (for use in cake mixes) in a heavy earthenware bowl on her lap. Smaller bowls would be used for skimming cream from milk. In his homeland, pottery churning-pots for making butter from milk fats were common, but Hoffmann does not appear to have made these – most likely because the making of wooden butter churns was a specialty of his neighbour, the farmer-cabinetmaker Gottlieb Kleemann.

Hoffmann's wares were also to be found at the table where they provided dishes for eating the meal, for serving butter, and for holding salt, mustard or other condiments, while large or small jugs held water, milk, or wine. Yet other table wares included the medieval-style one-handled porringers useful for soup. Another unusual vessel, a stoneware jar supplied with four handles, appears to have been designed to hold hot liquids such as oil or lard. By the 1870s, this locally-made, heavy earthen tableware had generally been replaced by imported English whiteware and porcelain.

Nevertheless, a testimony of the practicality and durability of Hoffmann's traditional handled jars was my discovery, in 1987 in two Barossa kitchens, of two examples still in use for pickling cucumbers and storing salt – well over 100 years after their creation! In the latter years of their use, worn and cracked examples of Hoffmann's larger jars were often recycled and put to use by farmers

for 'pickling' wheat, that is, soaking seed wheat in copper carbonate solutions as a fungicide prior to sowing. In about 1900, a large example of one of Hoffmann's traditional jars had even been 'converted' into a decorative item, with a folksy painting depicting a traditional German cottage on one side and a bunch of roses on the other! (Chapter 6 details the legend of Hoffmann's extraordinary clay searches and other aspects of his traditional pottery in the Barossa.)

On The Barossa Farm

We gain an even better idea of the original Barossa cuisine by examining the farming methods and crops planted by the early settlers. The Prussian pioneers were a methodical people who invariably sent out explorative groups to examine and assess prospective settlement sites, with a keen eye for good farming land. Johannes

Pastor Spanagel of Light Pass ploughing with the primitive single furrow plough, c. 1900.

Menge even went so far as to establish an experimental farm which appears to have been the first in the Barossa Valley in 1839 – some three years prior to the region's settlement by British gentry and the refugee Prussians. Menge himself stated the reasons for his pioneering agricultural incursions: 'I thought it necessary to have a garden for examining the nature of the soil and the fertility thereof upon European seeds'. His experimental farm, located at the junction of Jacob Creek with the Gawler River near Rowland Flat, was described by Cawthorne:

> It was a rich alluvial flat, [where] he cut a ditch from a point up creek and turned it into the creek again before the junction with the Gawler River, so that it formed an island of about 10 acres which he called Menge island and himself Robinson Crusoe.

On this 'island' of rich alluvial soil laid down over many years by the waters of Jacob Creek, Menge planted a variety of seeds including hops, hemp, flax, millet, tobacco and garden vegetables, in order to see 'which would grow best in New Silesia'. He had considerable success, although small native marsupials, 'rats' as he called them, were something of a problem, nibbling through the stems of his ripening melons!

The first Prussian farms in the region were established in early 1842, when some 28 Lutheran families settled on 720 acres of land leased to them by George Fife Angas (through his German-speaking agent Charles Flaxman), at the foot of the Barossa Range. They cleared the woodland to establish a village which closely followed the plan of the Prussian *Hufendorf* or farmlet-village model (*hufen* are 'farmlets'). A few years later it was officially named Bethanien (now called Bethany), after the Biblical meaning 'place of dates'.

The farmlet-village layout had a long history, having been first developed in Prussia during the medieval period as a model for frontier village settlements; it spread into the valleys of Silesia, along the River Oder, during the eighteenth and nineteenth centuries. Now, in this New Silesia in Australia, thousands of kilometres from its origins, Bethany's pioneers emulated this time-honoured layout, applying the medieval Prussian approach of dividing the land into 18 narrow strips. These averaged between 40 metres to 120 metres in width by

about 600 or more metres in length, the area varying from under 4 to 40 acres. Their cottages and barns were built on the southern end of each allotment, abutting to and facing a road which ran at right angles to the strips, so that each neighbour's house was located alongside the other. Land for a church, manse, cemetery and schoolhouse was reserved towards the middle of the village. While the entire village area was defined by a post and rail around its perimeter, each family honoured their respective boundary.

Despite the amalgamation of some of the smaller farms into larger holdings in the latter years of the nineteenth century, the ancient, medieval basis of Bethany's layout is still visible today. Its *Hufendorf* pattern is most readily discernible if the traveller takes in the view of Bethany from the elevated heights of Mengler Hill, or approaches the village from its far northern boundary. Although the original narrow strips of land became amalgamated into larger holdings over the years, and are now covered in vineyards, the narrowing of perspective towards the high-pitched gables of surviving early homes conjures in the mind's eye the original layout.

The Tanunda Creek – perhaps not as romantic as its original namesake, the Biblical Kidron, the watercourse which runs between Bethany and Jerusalem – flows across the northern proximity of the once-narrow allotments, thereby providing each family with the necessary access to water. The length of these strips was especially suited to single-furrow ploughing – the Prussian farmer's method. Self-sufficiency was the rule, and immediately behind each farmhouse, on the rich alluvial soil, mixed vegetable gardens were planted, then rows of various fruit trees to form orchards, the household's small patch of vineyard, then larger areas of seed crops such as barley, wheat or rye. Within a year, some 300 acres had been cleared and were under cultivation, while the population numbered close to 200 persons.

While Pastors Kavel and Fritzsche initially shared the duties of ministering to the Bethany congregation, from 1846 Pastor Heinrich August Eduard Meyer became the first resident minister in the village. Besides paying some money for church dues each year, it was traditional for Bethany's farmers also to donate a quantity of wheat and other garden produce to their pastor and to their resident teacher. This varied according to the success of each year's harvest, but in 1862 for example, Meyer received some 97 bushels of wheat.

Another agricultural Prussian tradition practised by the Bethany villagers and farmers was their setting aside of an area of land for communal grazing — essentially the village common (now the Bethany Reserve). They employed a herdskeeper, dressed in his traditional herdsman costume, whose duty was to collect cattle from the various farms early in the morning, herding them onto the pastures (*Kuhweide*) on the adjacent hills. In the evening, he would drive them back to the farms for milking, announcing his imminent return by blowing a horn — a custom which appears to have survived at least until the early 1870s.

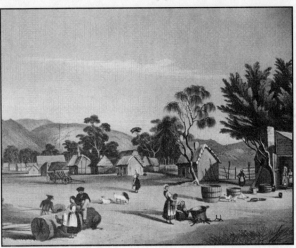

Established in early 1842, Bethany was the first place of settlement of Prussians in the Barossa. Note the white-washed farm houses of clay and straw, the earthenware jars on the extreme right, and the villagers' traditional dress. J. Giles after George French Angas, *Bethany, a village of German settlers*. Plate from *South Australia Illustrated*, 1844–1845 (private collection).

Certainly the industry of the early German settlers and the family basis of their work is revealed in the following notes recorded in 1849 by an English observer:

> It was an inspiring sight to watch them at work at Bethany on their farmlets, men and women, and children, as busy as bees. It happened to be on a Saturday, when the children were not at school. Organisation on this little farm seemed to be perfect, even the children appeared to know their particular task, and how best to perform it … the women are a particular fine type. They not only keep their modest homes neat and clean, prepare the meals and look after the children, but they also work in the field with the industry and energy of men.

In 1844, George French Angas, George Fife Angas's artist son, captured the pioneering character of Bethany in a watercolour view looking south-east

(printed in 1847 in the large and lush volume *South Australia Illustrated*). In his painting we see the Prussian settler's small white-washed cottages and farm houses built of timber frames, clay infill and high-pitched thatched roofs – arranged in a line with the immediate backdrop of the blue-tinged Barossa Ranges. The church, the largest timber frame and mud infill building, is just visible in the centre of the line of dwellings towards the far left of Angas's view. A few drooping sheoaks and eucalyptus trees have been retained for their shade here and there among the dwellings. Some post and rail fencing made from the less than straight eucalyptus branches is also visible just beyond the cottages, separating the agricultural land from their grazing herds and the uncleared forest beyond.

Angas's watercolour provides other details: some male and female figures represented in the illustration are wearing colourful traditional Prussian dress, including the ubiquitous field bonnet. The women are preparing meals or are busy with other chores such as carrying water, making butter in wooden churns, cooking in a large cast iron pot, or feeding chickens. In the fore-ground, one figure, evidently the village carpenter, appears to be splitting planks from a large gum log. Other visible Prussian artefacts include iron-hooped half-barrels, probably containing water, and two red-brown earthen-ware jars (imported) whose forms were subsequently replicated by the Barossa's sole migrant potter Hoffmann, a decade later, not far from this site (see Chapter 6). George French Angas's view provides the earliest evidence of Prussian material culture as it was then transforming the Australian landscape of the valley.

George French Angas further recorded his personal observations with the following brief description:

One of the most interesting and beautifully situated of the German settle-ments in South Australia is the village of Bethany, at the foot of the Barossa Hills. Although less regularly built than Klemzig, this peaceful hamlet of Prussian emigrants is more rural and picturesque; the open country, and rich, undulating districts in the vicinity, with the mountain ranges beyond, render the situation a desirable one. Water is abundant, and among the hills about four miles distant is a large overshot water-mill, belonging to a German

settler ... The time chosen for this scene is a calm evening towards the end of summer (February), when all is glowing in the violet warmth of departing day; the effect represented is one peculiar to the clear, dry climate of Australia, at this season of the year.

The water mill, used to grind the Bethany farmers' wheat, was located a kilometre-and-a-half upstream from the village in a narrow creek and redgum-shaded locale; it bears the name of its Prussian pioneer builder and is known as Schlinke's Gully. It was nearby the point where the Tanunda creek formed a waterfall, that the enterprising Daniel Schlinke constructed a massive two-storey stone mill, the water being diverted along an aqueduct (a wooden trough three hundred feet long) to power and drive a large wooden wheel. Within three years, the subsequent destruction of the elevated trough by a flood led Schlinke to abandon the mill and build another, steam-driven mill, this time in Tanunda. The water mill remained relatively intact at least until 1869, when further floods and the passage of time led to its progressive destruction: today, only a trace of its foundations remains, and these, together with the quarry opposite the mill from where its stone was obtained, as well as an old fig tree, are the only signs of a once thriving enterprise. Over the years, the mill's remains and its picturesque setting, were recorded by a number of artists, and became a popular picnic site (see Chapter 1).

Meanwhile, some six years after the aforementioned watercolour rendition by artist George French Angas, and nine years after its founding, an 1851 description of Bethany reveals that the agricultural settlement was flourishing:

It contains about 40 houses, but there are many dwellings scattered beyond it. Most are small farms, some with good gardens ... There is a garden here which bids fair to rival many of the best market gardens near Adelaide ... We conversed with some of the German settlers, who, with their wives and daughters, were very busy threshing and winnowing wheat, in which former operation the ladies whirled the flail with a most vigorous adroitness ...

Aside from salt, sugar, coffee and a handful of other provisions carted in from Adelaide or later obtained from stores in nearby Tanunda, the Barossa

The pioneer Barossa farm, in this case located on the dryer, mallee flats near Sedan to the east of the Barossa Ranges. Note the stone bakeoven protruding to the right on the extreme right-hand building.

farm provided the Lutheran family with all of their food needs. On small allotments of about 20 acres or so, the settlers established the Prussian home-land practice of mixed, self-sufficient farming. An idea of the variety of produce cultivated from the earth is given in Carl Messner's description of his 10 acre Rowland Flat farm in 1856, which then supported his family of ten:

> This land we sow with wheat and it has provided us, yearly with bread and some to sell. In our garden are 400 vines in bearing, 2 almond trees and 2 fig trees, without the other planting of vines, apples, cherries, plums, peaches and such like. Water and sugar melons are a beautiful fruit ... which

The old Bradtke farm at Gnadenberg shows a progression of Germanic-influenced building styles, from the original pug-walled and thatched cottage on the left, to the second, slate-roofed cottage and bakehouse, and then iron-roofed stone house. The walled kitchen garden once included fruit trees. Bradtke was an early winemaker beginning in the mid 1860s.

everyone enjoys. Our cattle comprise 4 oxen, 2 cows, 2 pigs … we have no food worries and every industrial worker if he is not slovenly can make ends meet comfortably.

Chicken, geese and ducks were often also part of the farmyard menagerie. Later, the Barossa farm usually also included quince, carob, apricot, and pear trees, while a kitchen garden supplied a variety of vegetables and herbs.

Little has been recorded concerning the use of native plants as food sources, although it seems to be unlikely that experimentation with the sparse native flora did not occur. The earliest use of native plants for food in the Barossa appears to have been by the eccentric Johannes Menge who was said to live on 'wattle gum' during his early explorations of the region! (Wattle bark, used in the tanning of leather, provided an industry when it was stripped from trees and exported to England during the late nineteenth and early twentieth centuries.) Certainly, we know that the resourceful Barossa folk found the fruits of the native peach or quandong (a Santalum species), a relative of sandalwood, as well as the native currant (*Acrotriche depressa*), once common in uncleared bushland, useful for making jams, chutneys, or jellies. Certainly, the pulpy flesh of the quandong fruit which has a tart, apricot and plum flavour, was also used to make 'peach pie'.

Kangaroos, native turkeys, emus, ducks and other native animals and birds were plentiful, and were also hunted and cooked for food until these became rare as their habitat became progressively cleared for crops; although wild ducks continued to be hunted well into the twentieth century, around the outer reaches of the Barossa and beyond, further east along the banks of the River Murray. Rabbits and hares imported in the early years of settlement also replaced the smaller marsupials and became an additional source of protein for the settlers. Hares are still common in the Barossa where, although they have established themselves as the bane of the viticulturalist due to their destruction of young vine shoots, they are sought after by local restauranteurs for hare pie, casserole or other regional dishes. Today, the kangaroo is the only marsupial which is fashionable as a source of meat for use in the region's restaurants, or is smoked and sold in specialty butchers.

The traditional Barossa shoulder yoke had two buckets attached on each end, either for carrying water or milk. This early example was handcarved from native pine as was the naturally-branched pitchfork.

The Prussian migrants who had pioneered farming in the Barossa held the belief that the land was given to them in trust by God and that it was to be cared for and passed on from father to son. It was a spiritual bond with the land, in part a reflection of the piety of these pioneers, their experience as religious refugees, and their belief in Divine Providence: God had led them to the valley, and it was from the nurturing soil that the gifts of produce came from God. Indeed, the granite memorial erected to the pioneers (by their descendants) in 1992 on Mengler Hill is engraved with the Biblical quote: 'The Lord has given us this land'. However, the religious base for this belief was replaced in later generations by a folk-based tradition that it was important to keep the land in the family.

It was also necessary, according to this belief, that the farmer act as a steward, caring for the land so that it would be inherited in good form by succeeding generations. In later years, particularly from the late 1860s when the valley floor had been constantly tilled for some 25 years by people who were accustomed to the more fertile soils of Silesia, a considerable decline in productivity had occurred.

At the time, a series of droughts, and the necessity of providing land for the now-mature first-generation of the pioneers – as well as for migrants who were

continuing to arrive in the Barossa – led to the exodus of a notable proportion of the region's German population into the far-flung reaches of the colony and even into the eastern colonies (see Chapter 2).

Harvest Thanksgiving, the offering of their first fruits or harvest of the land to God was an important ritual in this respect, further reinforcing the attitude to good stewardship of the land. Although its significance may have declined somewhat, the Harvest Thanksgiving service is a tangible symbol of the religious belief which links the land to God and the farmer and is still observed in most of the Lutheran churches about the Barossa (see Chapters 2 & 7).

Contemporary Barossa Food Culture

The preceding outlines the historic base from which a contemporary Barossa regional cuisine has emerged, and which is still acting as an influence. As a cuisine it combines its inherited Silesian-peasant tradition together with past and contemporary Australian and Mediterranean preparation techniques and ingredients. However, it is not just the ingredients or preparation methods which lead to a distinctive regional cuisine, but its links to the past and its focus in a specific locale. A regional cuisine emerges when local influences have been successfully blended with, or at least acknowledge in some subtle manner, the food heritage of the region's pioneers and succeeding generations.

The produce of the Barossa is abundant and varied: the Mediterranean climate permits the growing of grapes, olives, berries, grain crops, herbs, market vegetables and a variety of stone fruits. The latter has been a specialty of the Barossa region since the planting of extensive orchards in its early years: almonds, apricots, peaches, and quince trees.

As noted earlier, most of the German settlers had their collection of fruit trees, but it was the enterprising pioneer, August Fiedler of Bethany (the first German recorded as growing vines – see Chapter 4), who planted a larger, commercial orchard of plums, peaches, pears and apricots as early as 1846. Other orchards were soon established, including the flourishing business founded by Henry Evans of Evandale in 1858. By the 1880s his orchards (as well as others in the region) were exporting fresh apples and canned fruits to Europe! Fruit drying and canning was also carried out on a large scale in the

region. There was Trescowthick Brothers' Mexican Vale Factory for fruit packing and processing at Angaston, Wilton's preserving works, also at Angaston, Fowler's Lion factories at Nuriootpa, the Hillside Drying and Preserving Works in Tanunda, as well as the aforementioned Evandale factory. The expansion of the Murray Riverlands as a fruit growing district from the 1960s led to a decline in the industry in the Barossa; today, extensive orchards are to be found only in Light Pass, along the Para River, or in the hills about Angaston. In the latter, Gawler Park Fruits and the Angas Park Fruit Company (established in about 1900 and 1911 respectively) continue to operate essentially as family concerns, producing high quality dried and glace fruits. The Angas Park Fruit Company, located in Angaston, has become Australia's largest tree and vine fruit processor, of which the greater proportion of the products are exported to North America.

To the preceding local produce of fruits, grains and vegetables we must add three important additional 'ingredients' which go to make-up the modern Barossa culinary approach: the original intimate relationship of the inhabitants with their nurturing land; the acknowledgment of a European cultural heritage; and the long period of time that has passed since settlement which has permitted the various blending processes and influences to have their present-day effect.

It is usually through oral tradition that recipes are preserved and handed down, but cooks often also treasure a well-worn, hand-scrawled notebook containing such recipes as passed from grandmother to mother and daughter. In the Barossa, one of the few positive outcomes of World War One was the publication of *The Barossa Cookery Book* in 1917. Subtitled *Four Hundred Selected Recipes From A District Celebrated Throughout Australia For The Excellence Of Its Cookery – Every Recipe Of Proved Merit And Signed As Such By The Donors*, it demonstrated the nation-wide reputation that the Barossa had already achieved. It was published by the Soldiers' Memorial Hall Committee in Tanunda in order to realise the 'South Australian Soldiers' Fund' and the eventual building of the Soldiers' Memorial Town Hall. The first paperback quickly sold out prompting second and third printings, the present third edition of 1992 enlarged with an astonishing further 500 recipes.

These old-time favourite recipes donated by many Barossa housewives

whose family names reflect their Prussian origins and include Seppelt of Seppeltsfield, Ahrens of Vine Vale, Obst of Rowland Flat, Keil of Krondorf, and Schulz, Hoffmann, Wilksch, Heuzenroeder, and Zilm of Tanunda, to name a just few. Among the first edition's 400 original recipes for soups, casserole dishes, roasts, stews, pies, cakes, desserts, sauces, puddings, and drinks, a handful especially stand out as Barossan and include: jugged hare, Russian Kromesskys, waffles, Honig Kuchen, and Gluehwein. The rarity of original German names for recipes as well as the lack of any information relating to the Germanic origins of recipes or their associated customs, was undoubtedly a result of the hostility against anything German which the war engendered (see Chapter 1).

In effect, the 1917 edition closely represented the flavour of the regional cuisine which had developed in the Barossa over a period of 75 years. Infused as it was with strong British influences, this was, essentially, a down-to-earth country fare which retained its German ethnic sources yet expressed these within an Australian-British setting. The book also contains many Germanic culinary hints such as the preparation of noodles, metwurst, German sausage, the preservation of olives, pickling cabbage, quinces and other vegetables, and salting meat.

An interesting influence of the First World War on the cookery book was the quirky inclusion of a soldier's recipe from France for Trench Porridge – an unappetising mixture of Anzac wafers (wholemeal biscuits commonly known as 'jawbreakers'), raisins, milk and sugar, the author Private Victor Offe of the Machine Gun Corps advising that the wafers first be soaked overnight, preferably 'in shellhole water if procurable'!

A more recent factor which has had a significant influence on the perception and make-up of Barossan foodways over the past two decades particularly, has been the entrance of newcomers attracted by the landscape and heritage of the region. Among these are Maggie and Colin Beer who established a pheasant farm in 1974, later opening The Pheasant Farm Restaurant. They focussed on using the Barossa's abundant produce, sometimes combining it with ingredients and approaches derived from its Old World peasant heritage. This was suggested, for example, in the tendency to apply German traditional approaches to smoking meats, but substituting kangaroo and using eucalyptus woods and

leaves to produce an enhanced Australian flavour. As we have noted, just as the Prussian settlers would never waste any part of a butchered animal, Maggie Beer adopted this tradition and took to creatively using offal in her cooking and patés. Today, her Pheasant Farm Paté, verjuice made from grapes and quince paste inspired by Barossan tradition, are also produced by her export kitchen.

Other restaurants specialising in fine cuisine have sprung up since: in 1995, The Pheasant Farm restaurant was renamed and operated as The Wild Olive by chef Pierre Barelier. In 1999 it reverted back to Maggie Beer to become a gourmet food sampling centre. At the Pear Tree Cottage (closed late 1999) in Greenock (a township established in 1846 and settled mostly by British migrants), chef Mark McNamara and his wife Jo-ann developed their own version of a modern regional Barossa fare. Their reliance on fresh local produce combined with a number of traditional Barossa influences, conferred a regional edge to the dishes presented at the Pear Tree Cottage, as well as those of other Barossa restaurants. Another comtemprary dish with traditional elements included local *Lachsschinken* served with marinated vegetables (asparagus, cucumbers and artichoke), which are prepared by first cooking in brine 'before pickling for a spell'. In this manner, Germanic vernacular and sophisticated modern approaches are becoming increasingly melded together to define a contemporary regional cuisine.

Other restaurants located in the Barossa region where the dedicated convictions of owner-chefs have earned reputations for distinctive and, to an extent, regional-influenced cuisines, include Saltram Estate Bistro, Vintners, Landhaus Restaurant, The Lanzerac Cafe, Kaesler Wines Restaurant, The Park Restaurant, Crackers Restaurant, Cafe C, and the 1918 Bistro.

Besides extending the availability of the variety of cuisines available, the main influence of these restaurants and the various Barossa newcomers, has been to heighten local and national awareness of the Barossa's vernacular cuisine. In summarising the character of this cuisine we may describe it as a regional blend of the traditional and the innovative, notably combining a core of traditional east-central European cuisine with a dash of the Mediterranean cooking style, and principally designed to evoke the flavour of the land and its heritage. In the final analysis, for those seeking authenticity, it

is surely both 'Barossa Deutsche' home and community cooking, together with contemporary local restaurant and festival fare, which defines the cuisine identified with this region.

Festivals and Picnics

We have seen how life in the Barossa revolved about the church, family, community, and work. Within this setting, the celebrations and pleasures of life were not overlooked, and special occasions when traditional feasting was especially enjoyed included weddings and their anniversaries, christenings, confirmations, birthdays, and even featherstripping evenings which ended in coffee and slabs of the ubiquitous Streusel cake. Rooted in tradition, this penchant for joyous celebration which balanced the long hours of work in the vineyards and fields, has led to the establishment of a number of contempo-

The Barossa picnic, c. 1910. Note the live hare held by one of the picnicers on the left, front.

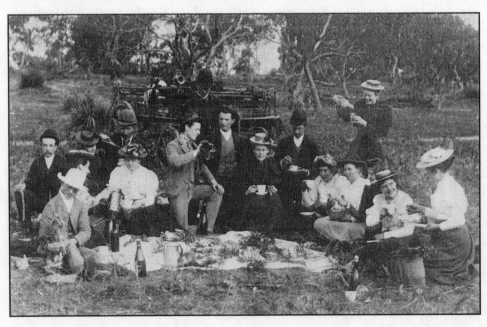

rary Barossa festivals dedicated to the celebration of gourmet food and the wines of the region – always in combination with music.

One of the longest-standing, traditional events has been *Essenfest* (literally 'eat' festival), which is held on the first weekend of March specifically as a festival of local food, wine and beer. As the shimmering heat of summer wanes and the leaves of the vine turns golden, the Barossa's autumn bounty of grapes, vegetables and fruits signals the coming of another festival. *Essenfest* is timed to coincide with the bringing in of the harvest of the Barossa, when its produce – which ranges from dill cucumbers, metwursts, breads, preserves and other foods – is displayed at the annual Tanunda Agricultural Show.

Beginning on Easter Monday every second year, the extended Barossa Vintage Festival takes over from the *Essenfest* in a week of frantic celebrations (see Chapter 7 for other aspects of this festival).

The all-important focus on traditional Barossan cooking, food and wine includes Orlando's Picnic at Jacob Creek, a popular event publicised as an occasion when the 'heritage of the Barossa comes alive!' Picnics have always been a favourite activity of the inhabitants of the Barossa – there are so many sylvan sites where one can throw down a blanket and partake of a feast in fresh air and delightful surrounds – so this event builds on that tradition, combining

Orlando's Heritage Picnic event held during the Barossa Vintage Festival at Jacob Creek. Traditional Barossan foods and games, and early costumes, add to the ambience.

a recreation of the early food recipes, such as wood-roasted suckling pig, as well as various games such as quoits, skittles and 'throw the weight', so beloved of the early settlers. Traditional costumes are worn by locals, and the added experience of being taken in horse-drawn wagons to the secluded, beautifully-treed picnic site on the banks of Jacob Creek, a stone's throw from the historic Menge cave home, add to the heritage ambience.

In the past three years, a two-day Harvest Market has also been held on the immaculately clipped lawns and gardens of the Yalumba Winery. Recreating the feel of the pre-industrial marketplace, some forty stalls provide produce and foods brought in from all corners of the Barossa by the growers and producers themselves. Produce includes a large variety of authentic Germanic smoked meats and small goods, fresh and dried fruits, fresh goat's cheese, egg noodles, pheasant pie, pot-roasted quinces, pickled dill cucumbers, olive oil, honey and cider vinegar, wines, numerous preserves and traditional cakes. Culinary experts give demonstrations of olive oil tasting, baking honey biscuits, decorative preserves, and traditional cooking such as *Rote Grütze*. With picnic baskets brimming with these delectable goods, guests choose a site on the gaily-decorated lawns where the food is consumed with relish. The Yalumba Harvest Market eminently expresses the spirit of the vintage festival in terms of its intimate scale, authenticity and the promotion of regionality and quality.

By way of contrast there are more formally-structured events where local foods and wines are also featured and consumed. The Barossa Shiraz Dinner at Richmond Grove Barossa Winery (held in 1995 and again in 1997), showcases and provides an opportunity to savour the Barossa's best Shiraz wines, accompanied by a gourmet meal created by renowned Australian chefs. Even more popular than the formality of the preceding black tie dinner, an Oom-Pah Nacht Traditional Dinner is also held at the Tanunda Oval.

Another festival event which expresses the specialist activity of the region is the Barossa Rare Wine Auction. Sponsored by Penfolds (Australia's largest winery), it is held in the 'Grand Marquee' at Nuriootpa Oval where an early morning start provides for a breakfast of eggs, traditional Barossa pancakes and champagne. First held in 1965, it now attracts national attention, especially given the array of rare wines brought out of the private cellars of the Barossa's

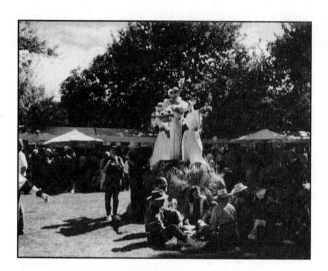

The Harvest Market held at Yalumba Winery during the Barossa Vintage Festival provides an opportunity to sample the region's abundant produce, wines and traditional foods, including Germanic smoked meats, egg noodles, pheasant pie, dill cucumbers, preserves and cakes.

numerous wineries and offered to the discerning wine lover. In 1997, some 220 lots of wines to the value of more than $100 000 went under the hammer, the money raised going to local charities. The centrepiece of the auction that year was an imperial-sized bottle of Penfolds Grange (1990 vintage) which raised $19 000 alone!

Classes on grape varieties, growing techniques, winemaking, wine comparisons and wine tasting are provided in the Winemaker's Masterclasses, a more recently added event, where the region's master winemakers instruct and discuss aspects of their art in a semi-formal fashion, with classes offered in each of the principal grape varieties.

Other, more vernacular-based events which bring food and wine together in a local community context include the Nuriootpa, Tanunda and Angaston Town Days when their thoroughfares become transformed into carnival malls with food, wine, arts and crafts, heritage stalls, music and maypole dancing. The latter town also has its co-operative, Angaston Cottage Industries, which brings together the jams, cooked foods and preserves of some 500 Barossa contributors – all housed in an early vernacular iron and timber building.

The Kellerfest and Weingarten, traditional dinners which are essentially direct descendants of the harvest festival custom of celebration, were inaugurated at the earliest Barossa vintage festivals. These continue to evolve in form and are held during each Vintage Festival, also under the decorated roof

of the huge tin shed, where Barossa cuisine and wine is accompanied by entertainment and, generally, a night of further revelry.

In 1997, the anniversary of fifty years of Barossa Vintage Festivals was celebrated. This was a bumper festival with numerous events, many similar to the preceding, some with slightly altered titles which perhaps reflected the ongoing tendency towards professionalism, sophistication and cultural authenticity that the steering committee has decreed. The Barossa Shiraz Dinner, for example, became the more upmarket Classic Wine Dinner, and included a sampling of rare museum wines especially drawn from cellar storages. The essentially community-based Festival Queen Finalist celebrations became transformed into the more somewhat formalised Crowning Spectacular and the Vintage Queen Crowning Ceremony. Held under the tall trees of Tanunda Oval, a day of parades and fairground amusements was followed by an evening concert, a spectacular night procession lit by lanterns, and the actual queen crowning ceremony, itself followed by a blazing finale of fireworks: if this doesn't ensure a bumper vintage harvest for the next year, nothing will!

Continuing the train of events in the commemorative fiftieth vintage festival year, the traditional Kellerfest became the Hofbrauhaus Dinner, a night of traditional Barossa-German fare and music styled 'in the spirit of the Oom-pah Nacht dinners' as presented in previous festivals. Held in the huge galvanised iron and timber Tanunda Show Hall, Hofbrauhaus Dinner brings over 500 people together in an unabashed celebration of yodelling, slap-dancing, food-parade-with-German-maids type of affair whose lederhosen edge is more inclined towards the clichéd tourist notion of German feasting and celebration than the authentic Silesian-derived character of the Barossa. Perhaps we may more kindly view the Barossa's Hofbrauhaus as another of those peculiarly Barossa-Australian vernacular expressions of old European traditions.

Among the new events held in 1997, which similarly underscore the food and wine heritage of the Barossa, was the Brunch On The Old Block held at St Hallett Wines' heritage vineyard: it contains among the world's oldest surviving shiraz vines. In this setting of aged, golden-leafed vines, Bob McLean, together with sixth-generation Old Block grower Graeme Fechner, entertained the guests with a discourse on the finer details of winemaking and viticulture, as the latter enjoyed a meal which included the regional specialty

of pheasant sausage. Twilight At Miamba was an evening dinner at Grant Burge Wines, also set in an historic vineyard, where, with glass in hand, guests mingled with grape pickers as they watched the 'unfolding of history' in an orchestrated floodlit spectacle whereby the romance of buckets, handpickers and horse-drawn carriages became replaced by the present-day method of mechanical night harvesting.

Yet another gourmet food and wine event, Lunch Over The Bridge Along The Para, was presented as an informal, 'al fresco' lunch. Located alongside the Para River, under the dappled shade of weeping willows, gums and market umbrellas, and accompanied by a scattering of scarecrows, guests enjoyed a four-course luncheon created from local produce by a team of Barossa chefs; its delectable ingredients included duck rillettes, peppercorn paté and galantine of corn-fed Dutton chicken with tiny dill pickles and sour dough rye bread; a second course of individual pies of local game and mushrooms; ashed Woodside goats cheese with Angas Park Fruits; and a dessert of grapes macerated in noble semillon with lavender sponge and rockmelon parfait.

The Barossa Classic Gourmet

While the Barossa Vintage Festival highlights the region's food and wines during the golden harvest season of autumn every second year, another major, and relatively newly-conceived, annual event which extends and combines the celebration of food, wine and music in the region is the Barossa Classic Gourmet Weekend. Realising the need to exploit the Barossa's cultural setting and products, this festival was initiated by the Barossa Winemakers Association in 1986, and since then, has been held over the last August weekend, every year for a decade, in late winter when the vines are bare and the pastures a vibrant green.

As its name indicates, the Barossa Classic Gourmet is a sophisticated festival designed to match contemporary regional cuisine with premium wines and 'appropriate' music. It has been so successful that, in 1996, the eleventh annual Barossa Classic Gourmet attracted some 15 000 visitors who had to make the daunting selection of which group of 27 wineries they would attend.

Each year, chefs from leading Adelaide and Barossa restaurants are teamed with wineries to prepare an eclectic range of entree-sized dishes. In a setting which varies from marquees set alongside vineyards or oak cask-lined cellars,

the dishes are accompanied by a glass or two of a specified premium wine made by the winery, while in the background selected live classical, jazz or folk music is played.

Included among the variety presented to the intrepid gourmet in recent past years were: Henschke Cellars teaming with the Red Ochre Grill restaurant (renowned for its innovative use of native flora and fauna) to serve Onkaparinga venison Osso Bucco, chipolata (small sausages) and rare medallion venison with Barossa native currant glaze, parsnip chips and puree; their wine choice was a rare pre-release 1994 Keyneton Estate, while 'One Short Quartet' provided music. Another combination included Saltram Wine Estates and the Pear Tree Cottage restaurant who served South Australian oysters with lime juice, coriander and chilli; these were followed by a 'tarlette' of prawns, leeks, roasted peppers, and salmon caviar and port wine paté; Barossa reserve 1995 Chardonnay accompanied this food. The 1998 success of the Gourmet Festival has been such that winemakers decided that the quality of the event was suffering from the large numbers of people. As a consequence, 1999 saw a new format whereby the last weekend of August was conducted on a much reduced scale, with the following four weekends extending the offering of food and wine on the basis of formal bookings.

As well as wine and food, music is similarly a strong integral tradition of the Barossa region (see Chapter 7). The inauguration of the Barossa Music Festival in 1990 also saw the beginning of a trend to integrate theme lunches, special meals, feasts, picnics, and evening meals with its programs of chamber and orchestral music, cabaret, choral music and opera, piano and cello, brass and jazz.

By the time of the fifth festival in 1995, a unique match of regional food, wine and music had been achieved. Leading Barossa chefs focussed on fresh local produce to create dishes which expressed, to some degree, the region's cultural, agricultural and community heritage. In 1996, the sixth festival had grown to include 34 'festival meals'. Lunches and feasts fused the region's Silesian-derived foods including various smoked wursts, breads and *kuchen*, with its premium wines, together with selections from other, compatible, food cultures, notably those of the Mediterranean and its fare of sundried tomatoes, olives, and capers.

Besides complementing the established musical tradition of the region, the Barossa Music Festival is also contributing its own influences to the region's culinary heritage. In 1993 the music program was combined with a church picnic which has been traditionally held every spring on the grounds of the Holy Cross Lutheran Church, Gruenberg near Moculta. Festival patrons enjoyed a midday concert of classical music followed by an afternoon of informal eating on the peppermint-gumtree wooded grounds alongside the church. The picnic is run by the local community with the men cooking huge roasts of mutton, while the women supply servings of potatoes, carrots and cabbage cooked in Dutch ovens in an open wood fire on the grounds.

Following the traditional noodle soup, it is the ubiquitous cabbage which especially links what is essentially an Australian main course with the German character of the valley: the cabbage is cooked according to early Silesian peasant recipes which differ from family to family. Margaret Zweck has supplied the following 1850s recipe for Barossa-Silesian peasant cabbage: boil shredded cabbage in salted water, strain then combine with cooked bacon and its fat, together with vinegar, pepper, butter; for a large pot of cabbage include half a cup of flour. Re-heat and the cabbage is ready to be served.

At the picnic, another link with the Barossa's past is provided by the traditional dessert of *Rote Grütze*, wine jelly or pudding made from fresh grape juice, sago and spices. Again, also based on a Barossa recipe handed down the generations, it is often modified slightly by the cook in charge. Linda Kroschel's traditional recipe for *Rote Grütze* uses three cups of red, fresh grape juice; half a cup of sago; half a cup of sugar; three-quarters of a teaspoon of cinnamon; one quarter of a teaspoon of cloves and half a cup of claret. These ingredients are combined then boiled down until the sago is clear. The pudding is ready for serving with cream after it has cooled.

Besides this and other picnics, special meals are now regularly scheduled to follow particular events during this festival, and have come to play an increasingly influential role. In 1995, for example, the performance of 'The Indian Queen' by Purcell, was followed by a 'Baroque Banquet' directed by Maggie Beer, and set in the candle-lit, redgum rustic Octavius Cellar at Yalumba Winery, where the guests were surrounded by stacked oak casks. In 1996, 'Alma', a locally-composed opera based on the story of Alma Mahler, wife of

the composer Gustav, combined a lunch and dinner feast, with a performance in The Glass Theatre of the Yalumba Winery in Angaston.

Yet other food events during the festival involve the Barossa's foremost chefs and included various individual lunches between concerts. These and the foregoing feasts or meals are essentially the outcome of modern Australian influences, sometimes combined with one or two cultural elements borrowed from the Barossa's Germanic food heritage.

Authentic Barossa Cuisine

Perhaps it is the preceding church picnic which especially illustrates the less self-conscious processes which have, and are still occurring, to produce what may be considered an authentic Barossa regional *vernacular* cuisine, in contrast to the paralleled development of a more 'contemporary' and 'sophisticated' Barossa cuisine. The traditional picnic fare emerged as the result of a core of basic Australian cooking, complemented by local ethnic influences which resulted in a simple though unique 'Barossa Deutsch' cuisine. Critically, it is the result of the influences of many local cooks over a long period of time – all in one place – bringing together a set of textures and flavours which retain the cultural essence of the region, more notably, its Germanic origins. There is also the all-important focus on local, fresh produce. In this way the sense of place, its vernacular quality, is expressed through the blending of two different, yet complementary, food customs.

It is instructional to look briefly at the parallel situation in North America, where the settlement of German migrants in the colony of Pennsylvania from the late seventeenth century differed from the Barossa's historical settlement insofar as in the former country Germans from a wider diversity of regions gathered together. In addition, this North American migration occurred some 150 years before the Barossa was settled. This meant that, not only were a greater variety of cooking customs brought together, but these also had a longer time over which to gradually change and develop into a truly American cuisine – one which was innovative and regional, yet retained its ethnic origins.

So long as self-conscious efforts to produce a regional vernacular cuisine do not become mannerist or too extreme then it may well be that we are witnessing a particularly active phase of that unique melding process which leads

to the creation of new forms – in this instance in cuisine. While the Barossa vernacular cuisine which is emerging of late is the only regional cuisine based on early pioneer traditions in Australia, it has yet to reach the point of definition that the Pennsylvania Deutsch cuisine achieved in North America a century ago. However, savouring the flavours of the Barossa region's cuisine certainly provides an engaging way of delving into history and of experiencing the cultural mores of the living Barossa.

Folk Arts & Crafts

Biedermeier to Barossa Style

*'Take up by the roots any real Saxon or Prussian peasant sitting room ...
transport it to the Barossa Valley: it will not look more genuine than
the room in which I now stood.'*
Friedrich Gerstaecker

Most of us are aware of the trend which identifies Spanish, Greek, and American decorative styles, but few are cognisant that there is an Australian let alone a Barossa, style. Yet, without delving very deeply, any visitor in the region can hardly fail to notice that it has a singular visual ambience, one which I term 'Barossa Style'. While this is most readily apparent in the Barossa's architecture, a perusal of its decorative and applied arts (sometimes referred to as the crafts), especially reveals a distinctive regional style.

How did this regional decorative and applied arts style come about? Who were the men and women who created it, and what are its identifying features? These were questions which occupied me for 10 years as I searched out and documented the arts and crafts of the Barossa's past and present.

We have seen how the early Prussian migrants moulded the cultural land-scape with its peculiar geographical patchwork through their evolving

agricultural and viticultural practices, which created the setting for its scatter of farmsteads, villages and townships. However, these people also used their skills to stamp their cultural signature on the totality of their material folk culture. During the nineteenth and early twentieth century, the differing expressions of this material culture – furniture, pottery, metalwork, architecture, stonework and textile arts – comprised a critical part of the Barossa community's creative and functional life.

Although these were crafts which were mostly practised by skilled artisans – that is, professional migrant craftsmen such as cabinetmakers, carpenters, coopers and blacksmiths – many of the Barossa's earlier generations of settlers who worked the land also had rudimentary skills, especially in woodworking and blacksmithing. Yet other craft practices transferred from the Prussian homeland to be practised in the region, were a continuation of the practical traditions of the German housewife, notably those of textile artistry.

In short, just as the migrant craftsmen and housewives of the past and their successors constructed much of the Barossa major features – the cultural land-scape of vineyards, villages, steepled churches and gabled homes – on a more intimate scale, they also created a distinctive interior landscape. Essentially austere, their interiors were nevertheless characterised by a symbolic decora-tive style, one of graceful exuberance and practicality which reflected the pious Old Lutheran values and peasant origins of these people.

Utilising local resources – felled gumtree and native pine, quarried stones, and clay dug from valley and hills – furniture-maker, carpenter, mason, black-smith, and potter alike applied traditional, time-honoured skills, to meet the practical and symbolic needs of their community. They erected buildings and constructed chairs, tables, dressers, wardrobes; they carved stone monuments, and forged iron implements for farm and kitchen; and they also fabricated earthenware storage and cooking pots. For much of the nineteenth and early twentieth century, before the juggernaut of industrialisation swept aside the need for their specialised handskills, these pioneer Prussian craftsmen and their wives, their sons and their successors, were responsible for much of the Barossa's material folk culture, determining the basis of its distinctive decora-tive arts style.

In the early decades of the Barossa's establishment, migrants who had such

craft skills were indispensable to the community, building its farmhouses, churches and schools, and supplying their interiors with furniture, as well as making essential tools for farm and kitchen. Indeed, they practised their traditional crafts with such precision in respect to their original, homeland models that, even as early as 1851, the keenly observant German traveller Friedrich Gerstaecker was to describe with evident astonishment the Barossa's villages, farms and household interiors as a microcosm of Prussian rural homeland: '… everything in the room was German: oven, chairs, tables, cupboards, footstool … Take up by the roots any real Saxon or Prussian peasant sitting room … transport it to the Barossa Valley: it will not look more genuine than the room in which I now stood.'

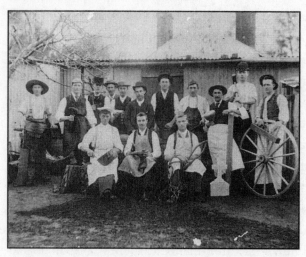

Craftsmen of the Barossa Valley, c. 1900. This photograph shows a line-up of a successive generation of German-born craftsmen holding various tools of trade, and includes blacksmiths, tinsmiths, cabinetmakers and carpenters, bootmakers, a painter, a wheelwright, and a monument mason.

Clearly, the cultural baggage which had accompanied these Lutheran migrants to Australia included a set of manual skills and stylistic blueprints which, at first, resulted in the faithful replication of familiar Old World forms within the strange setting of the new Australian homeland.

And it was in the Barossa, more so than anywhere else in Australia, that traditional Germanic decorative arts flourished. For it was in this region that conditions suitable for the successful transference and continuous practice of Prussian furniture-making and other craft practices were present for an extended period, in some instances with little change, from the early 1840s through to the 1930s. Within the dominant British setting and influences of the colony of South Australia, enclaves of close-knit German communities in the

Barossa supported the services of fellow craftsmen who recreated the familiar forms and styles of Old World furniture and other crafts.

As we shall see, it was also a consequence of the long-term practise of these crafts in the region which allowed the environmental and British cultural influences of the local setting, to gradually modify Prussian traditions into a vernacular, that is, Barossa style. For while the physical and cultural isolation of settlements in the Barossa, together with their close-knit communities and self-sufficient economy, acted essentially to preserve central-European decorative art and folk craft traditions, these conditions did not last indefinitely. Just as the original traditions in language, architecture and cuisine changed into vernacular, regional forms as influences were absorbed, from 1842 to the 1940s, a period covering some five generations, so too did Prussian art and craft traditions similarly blend with contemporary Australian and British-Victorian expressions to produce a distinctive Barossa vernacular style.

The Medieval and Neo-Classical Barossa

At their most basic, the folk arts and crafts of the Barossa region also often reveal either a distinct medieval or a neo-classical style. The reasons for this are based on the nature of the cultural heritage transferred to the Barossa by its earliest settlers, many of whom originated from the rural, south-east border region of Prussia. The medieval and the neo-classical have constantly provided models for ordering life in the Western world.

The peasant farmers and craftsmen who comprised the majority of the pioneers who founded the Barossa's earliest villages were a conservative people whose traditions and customs had changed little over the centuries. Their ancient Silesian and east Polish heritage is reflected in the furniture, pottery, textiles, architecture and other decorative art and folk crafts made by them and their offspring, from the mid to late nineteenth century.

Besides their stylistic influence on the interior setting, medieval and neo-classical cultural traditions also had an effect on the broader cultural landscape. For example, medieval influences can still be seen in the distinctive pattern of the *Hufendorf* or farmlet-village layout of Bethany; in the form of the belfries or steeples of some of its Lutheran churches; in the few surviving black kitchens; in the high-pitched roofs and walls of *Fachwerk* cottages; in the intimate layout

of Goat Square in Tanunda; and in the curious, bulbous-shaped earthenware jars made in the region by potter Hoffmann.

Neo-classical influences, on the other hand, may be seen in the vernacular versions of Biedermeier furniture produced by a number of Barossa master cabinetmakers, and notably in the *klismos* or sabre leg style of chairs; in the Greek temple-style pediment of wardrobes; or in the turned columns of chests of drawers. Neo-classical influences also dominate a number of private and public buildings in the valley, the most impressive example being the Seppelt mausoleum with its columns and pediment which mimic a Greek temple, as well as in the facades of a number of late-nineteenth-century buildings in Tanunda. A notable proportion of headstones or monuments also exhibit the neo-classical style. Indeed, the neo-classical was also once a strong stylistic feature in the interior of late-nineteenth-century decorative schemes of the region's Lutheran churches, a number of which once featured painted columns and Grecian motifs.

The Professional Cabinetmakers

Because large numbers of German cabinetmakers were attracted to and chose to work in the Barossa, formal furniture-making in particular became a prominent craft in the region. Prussian furniture styles flourished in the conditions of the physical isolation and cultural continuity of the Barossa Valley. So long as these cabinetmakers, and their successors, worked faithfully from their memory and experience of homeland traditions, and so long as the close-knit communities in which they worked remained isolated from the cultural and economic influences of the larger urban centres, the distinctive appearance of Barossa furniture was preserved.

Today, we may identify a 'golden age' of furniture-making in the Barossa Valley as having occurred during the period from the mid-1840s to the 1880s, a period when the styles of cupboards, tables, dressers and other items conferred closely, with little change, to homeland forms and styles. Traditional styles and vernacular forms, however, were made through to the First World War: although, amazingly, strands of the original Prussian traditions even survived well into the twentieth century. It would appear that Bernhard Freytag, who died in Tanunda in September 1962, just a year short of his century, was

the last of a direct line of Prussian-born migrant cabinetmakers who had come to South Australia in the nineteenth century. Freytag had persisted in practising the traditional Germanic cabinetmaker's approach and techniques in the Barossa well into the 1940s!

Most people are surprised to learn that as large a proportion as up to one-third of the German migrants who arrived in the colony of South Australia between 1838 and 1900 were artisans, that is tradesmen skilled in a range of Old World crafts. Although the earliest of these craftsmen migrated for reasons of religious persecution, many subsequent arrivals were among those who had been displaced from their homeland by the expansion of industrialisation: colonial South Australia was a place where their handskills were still highly valued.

The greater majority of these early craftsmen were skilled in the medium of wood: they were cabinetmakers, carpenters, wheelwrights or coopers. In terms of absolute numbers, at least 120 German professional cabinetmakers settled to work in the Barossa region over the nineteenth century, so it is not surprising that the greatest contribution to the Barossa's decorative arts heritage was the furniture created by them. At the time, those who specialised as carpenters were called *Zimmermann*, while those who worked as joiners or cabinetmakers were called *Tischler*.

With so many woodcraftsmen settling in one small region, it would be unlikely to expect that they would all be able to re-establish themselves in their original trade – the infrastructure and population to support such large numbers simply did not exist. Dependent on their personal initiative and means, each craftsman determined his fate. Hence, there were those who immediately abandoned their profession to become farmers; later, they sometimes managed to apply their skills to make furniture for family needs. Many others took up farming as their primary activity, but also kept their cabinetmaking skills active in order to generate a secondary income: these were the farmer-craftsmen of the Barossa. These farmer-craftsmen tilled the earth by day and planed wood, forged iron or kneaded clay by night.

Yet other migrant woodcraftsmen, especially those whose arrival in the Barossa coincided with the boom in building and settlement in the late 1840s and 1850s, set themselves up as professional cabinetmakers in its emerging villages and townships. This latter group made a living successfully working

full-time in their original trade for various periods, according to their choice of settlement, the more successful also passing on their skills to their sons.

Hence, throughout the nineteenth and early twentieth centuries, a craft-production economy thrived in the region, as furniture and other articles were created in the farms, villages and townships of the Barossa.

Biedermeier to Barossa Style

What kinds of furniture did these cabinetmakers make? Furniture styles were based on traditional town and country provincial styles acquired by the cabinetmaker during his apprenticeship in his Prussian homeland. Hence, while Barossa furniture as a whole has its own characteristic style which distinguishes it from the work of other migrant cabinetmakers in Australia, it is possible to identify the variations according to the region of origin of each maker. Even so, much Barossa furniture appears to have been based on a form derived from the central-European Biedermeier style.

Indeed, from early 1842 through to 1850, a group of at least eight cabinet-makers worked within the Barossa's more central German-founded villages, producing furniture which matched the then popular homeland style called 'Biedermeier'. Some German cabinetmakers even worked within this style in the Barossa in later decades, one at least as late as the 1890s! Indeed, it appears that in Australia, the Biedermeier style was introduced by German cabinet-makers first in the Barossa Valley – and it was in this region where it played out its last refrain.

The term 'Biedermeier' intrigues most people, especially as the late 1980s and 1990s have seen a considerable revival of interest in this genre. When German cabinetmakers began to arrive in the colony of South Australia in late 1838, the Biedermeier furniture style was already dying out in Prussia. It was a popular furniture style in the main cities and other urban centres in the period from the end of the Napoleonic era in 1814 through to the revolutions of 1848 and 1849. However, typical of city centres, fashions change rapidly and from the late 1830s, it was already in decline. However, Biedermeier was to survive for some years yet in a modified form in the more isolated towns and villages of east-central Europe.

Assisted by the conservatism of rural Old Lutheran communities and their

resistance to change, while Biedermeier passed out of favour elsewhere, it lingered on in rural villages into the late 1840s. Here, the 'high' Biedermeier furniture style became simplified by the peasant, village cabinetmakers who combined country elements from their own regional traditions of folk craft with those of the more formal Biedermeier town style. Mahogany and strongly-patterned veneers were replaced with Baltic pine and other cheaper timbers which rural communities could afford. The pine was stained or comb-painted to mimic the effects of expensive timbers or veneers; sometimes, painted folk motifs, or simplified low relief carving were added as decorative embellishments.

The result of this vernacular process was a countrified version of the 'city' Biedermeier which suited the austere nature and religious values of the rural Lutherans. As the early Barossa cabinetmakers had received their training and working experience in the period between the 1820s and 1840s, it was therefore mostly this provincial, or folk Biedermeier version which became transplanted to the region.

The name 'Biedermeier' itself was derived from the German 'bieder' meaning good, honest and unpretentious; whereas 'Meier' is one of the most common German surnames, comparable to the English 'Smith'. Biedermeier came to be used as a stylistic term descriptive of the applied art of the 1815 to 1830 period, evoking the middle-class virtues of domesticity, plainness and comfort.

Who were the actual makers and how did they work? In the Barossa Valley tradition of fine cabinetmaking two men, Wilhelm Schaedel and Karl Launer, stand out as significant masters. This is especially so as both worked within their own regional and distinctive homeland traditions, and both were active for many years. Working independently, one within a township, the other in the rural setting of a mixed village and farming community, these two craftsmen exemplify the two extremes of approach to the way their craft was practised in the Barossa. While Schaedel lived and worked within the township of Nuriootpa, Launer was less defined, moving between village and farm as either full-time cabinetmaker or working as a farmer-craftsman.

The Master Cabinetmaker's Tale

Karl Launer was among the more successful cabinetmakers who was especially stringent in preserving Prussian homeland furniture traditions. Unlike the

standard picture that is generally held of the early migrant Prussian, Launer was a complex person who does not conform to our generalisations of these people. The extraordinary tale of this gifted Silesian cabinetmaker encompasses personal squabbles, social disorder, religious upheaval, devastating drought, and bankruptcy.

Born in Silesia in 1820, Karl Launer, with his wife and two children, arrived in South Australia in 1848. Over a period of some forty years, he constructed wardrobes, chests of drawers, tables and chairs which conform to a pure Biedermeier style. We will see that Launer became the most significant exponent of the Biedermeier style in the Barossa, as well as throughout the whole of Australia.

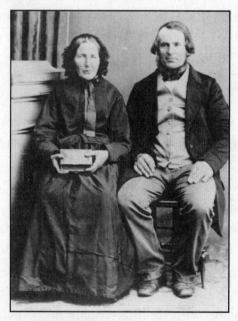

The master cabinetmaker Karl Launer with his wife Johanne Dorothea, c. 1870. Note the Silesian's Old Lutheran style fringe beard.

The following story emerges from my research based on oral tradition, material culture analysis and church records. I begin the tale of the master cabinetmaker Karl Launer, or *Tischlermeister* of Light Pass as he liked to be known, in 1871, at a pivotal point in his life, some 23 years after his arrival in the Barossa.

Launer stood patiently outside the small stone church, while inside he could hear the muffled voices of the elders debating various community

matters. His turn would come soon. It had been a hard life; beginning with the long trip from Silesia some 20 years earlier when he was still a young man of 28 and accompanied by his dear wife Dorothea and their two children. Sailing to this strange southern continent he was filled with the optimism of those leaving behind a tired country but heading for a new land of hope. On reaching the beautiful Barossa Valley, he had worked hard, building their *Fachwerk* home, tilling the earth and establishing himself and earning respect as the community's master cabinetmaker. It was a distinct advantage having a respectable trade for, as well as being able to farm, he could generate additional income between harvests by making and selling his furniture and carpentry skills.

Through this means he had become the proud owner of his property – within six years of taking a lease on it! And, like most of his fellow country-men he didn't mind having a leasehold agreement with the kind British benefactor of the Lutherans, George Fife Angas, then living on his vast property holdings in the Barossa at Salem Valley, not far from his own farm. After all, he could pay him back with wheat, and within a year, following those good crops on the virgin soil, Launer had been able to pay off his leasehold obligations, even sometimes with cash! Yes, those early years had held much promise.

Even the earlier family disputes and quarrels between him and his brother Gottlieb, no longer bothered him. And for that matter, nor did the doctrinal differences which had arisen between their religious leaders and which had proved irreconcilable. He recalled the annual church synod held at Langmeil in September of 1860, some seven months after Pastor Kavel's death in February, when matters came to a head and that upstart new pastor from the homeland, Staudenmayer, voiced his objections. Surely it was his doing that led to the division in the Light Pass congregation and the founding of their new church, alongside which he stood. Nevertheless, its construction had given him much work! Well its name should remind those of the congrega-tion who had refused to follow: *Zur Engen Pforte* (The Strait Gate) we rightly called it. This musing prompted Launer to turn his gaze across the road where, less than 300 metres away, stood the whitewashed *Fachwerk* Immanuel Lutheran Church, Light Pass's first, and once his own.

He could have accepted these doings as those of God's will if it had not been for the ensuing droughts in those years just past, and then the terrifying pestilences which devastated his and his neighbours' crops. Who could now afford to pay him for his sturdy wardrobes and tables? They were 'bad times' alright, as red rust ravaged their cornfields. Just like himself, farmers were left with large debts, with the labours of years swept clean away. It was then that the trickle of farmers and their families out of Light Pass and from other communities about the Barossa turned into an exodus. A large number of German families even left to embark upon on a great trek for land in New South Wales (see also Chapter 2). Perhaps he should have joined them!

Launer himself had sold much of the household furniture and other belongings in order to pay back loans. But he remained in debt, until that fateful day in March 1869, when he filed for insolvency. What an embarrassment! His farm was sold and the family left with nothing but the cabinet-maker's tools-in-trade. And there was precious little work to be gleaned about the valley, aside from the job of building a footbridge across the Para River which he had thankfully been given by the district council. It was then that he had heard the news of another sailing vessel, the *B. Aymar*, to be dispatched soon from Port Adelaide for California, that land of gold and promise. His older son Wilhelm had already quit South Australia for this place, to write urging his father and mother to follow.

But now Launer's reverie was interrupted as he heard the door open and he was ushered into the dim interior to face the assembly of stern-faced and bearded Lutheran elders, his peers and neighbours. After some discussion and questioning he told them: *'da derselbe Willens sei, nach Amerika auszuwandern'*, he was minded to emigrate to America.

There was no turning back, and Launer now set to raising funds by various means including selling his most prized possessions, the cabinetmaking tools which had accompanied him on his long journey from Silesia to Australia some 23 years past. The family now consisted of Karl himself, his wife Dorothea, and their remaining youngest children, 17-year-old Traugott and 14-year-old Caroline. Unfortunately, Caroline was not to accompany

her parents and brother to America. In the event she was left behind, for a time in the care of her married brother, Johann, then living in the nearby township of Stockwell: the outcome of her life was to be a short, lonely and pitiful one.

In early 1872, Karl Launer, his wife and son became emigrants once more, sailing across wide seas for California, North America. Very little is known of their fortunes during the following two years, but certainly, the family was, once more, reunited: Karl, Johanne and Traugott would have been overjoyed to see their Wilhelm, his wife Sophie and their children. The enlarged family now all resided in Castro Valley where Karl found employment as a cabinet-maker. Their lifestyle was to be in distinct contrast to that of the rural and peaceful setting of Light Pass, Australia.

Californian society had just emerged from a gold rush with a mixed popu-lation of Chinese, Europeans, Negroes and North American Indians, as well as eastern-American entrepreneurs and fortune hunters: there was much lawless-ness, gambling and drinking. It was in this setting, the antithesis of that of the ordered agrarian Barossa Valley Lutheran community, that Launer's family found itself. They managed to avoid much of the social unrest by living in the nearby township of Castro Valley, rather than within the city of San Francisco itself. Given Launer's Old Lutheran temperament and upbringing, he must have abhorred this society.

Folk tradition tells us that he was particularly alarmed by the guns that many carried about for pistol duels which were a common means of settling disputes, often in public. Over one hundred years later, his descendants would quote him as having said (on his return): 'If you didn't like any one, you shot him ... you had to carry a gun wherever you went'. It was for this reason that he eventually quit California and, for the third time in their lives, Launer and his wife once more become emigrants, returning to South Australia, while his two sons, Wilhelm and Traugott remained behind.

Karl and Dorothea's remaining years were spent in Stockwell, nearby their former Light Pass home, where his routine was one of a small town tradesman, supplying local Stockwell residents and outlying farmers with their furniture requirements, or providing his services as an undertaker, as well as using his spare time to work on special presentation pieces of furniture for his own family.

It was during this latter period in his life that Launer also earned a reputation as a maker of models of the Wartburg Castle. As the place where Martin Luther was held in protective custody in 1521, and where he translated the New Testament from the Greek and Latin texts into the German language, it is of special significance to the Lutherans. They were made, according to oral tradition, for presentation on the occasion of the wedding anniversary of each of his daughters. Each model, complete with castle, a landscape of trees and parading soldiers, was displayed within its own glazed cabinet, itself surmounted by Launer's carved tulip and scrolled pediment. One model even had a mechanical chain drive which caused the toy soldiers to parade around the castle at the sound of a bell: for a time, it stood under the verandah of his workshop, advertising his trade (it may be seen at the Museum of Barossa and German Heritage).

Karl Launer continued to make furniture up to less than a year before he died in 1894, aged 73 years old. He was buried in the Strait Gate Church cemetery at Light Pass, his tombstone bearing the brief epitaph *Tischlermeister*.

It is clear that Karl Launer's furniture is undoubtedly the most distinctive and among the finest crafted in the Barossa. It is characterised by strong

An elegant wardrobe by the master cabinetmaker Karl Launer, 1879. The Biedermeier style is evident in the classical lines of the pediment, architectural mouldings, and symmetry. The vernacular scroll and carved folk tulip were Launer's 'trademark'. Note the mother-of-pearl key surrounds and porcelain knobs. The Baltic pine retains its original finish of red stain and light varnish.

neo-classical proportions: chairs have sabre-legs; wardrobes have fielded panels, surmounted by stepped, classical pediments, sometimes with the addition of a carved tulip. Typically, a claret-red woodstain and light shellac varnishing finished the Baltic pine surfaces. Launer's earliest documented work is pure Silesian Biedermeier in style, but from the mid-1870s, following his return from America, his style became became modified through the addition of a carved tulip motif and scroll, transforming the work into a unique vernacular 'Barossa Biedermeier'.

Launer's furniture is now recognised as constituting one of the most compelling records of the Barossa Valley's and indeed, of Australia's furniture heritage. His work demonstrates the stability of the tradition he transferred to Australia, and shows how distinctive various cultural practices, specifically those of woodcraft, were in the German settlements of the Barossa.

While much of this Silesian's story is unique, it also gives us insight into the trials and tribulations of the migrant's life, of alienation and sorrow; it encompasses family within the Barossa Lutheran community and its church; and it involves the drama caused by natural calamities such as drought, as well as the more intimate scale of interpersonal conflict. In Launer's case we can understand as closely as might be possible, how much of a cornerstone traditions (in this case those of furniture-making) represented for him. In a life characterised by repeated journeying, family and community crises, Launer's craftsmanship remained a central anchor to his identity.

Nuriootpa's Furniture Clan

While Launer struggled to make a living in the rural community of Light Pass, the Schaedel 'clan' of cabinetmakers worked in the growing township of Nuriootpa (from 1858 to the mid-1930s) where they prospered.

Nuriootpa, after Tanunda, was the most prominent township in the Barossa. English settler William Coulthard arrived in 1850, building a two-roomed slab hut which became the area's first inn. By the time he had drawn up plans for the first town acre in 1854, a village (which was to become Nuriootpa) had already come into existence. Over the following decades, Nuriootpa was settled and developed by an almost equal mixture of both British and German migrants.

The surrounding wide plains, originally known as Angas Park, first

supported a dairy industry which was later replaced by an extensive wine industry. By 1885, Nuriootpa township had a population of about 400, and included a post office, bank, St Petri's Lutheran Church, steam mills, two inns, brewery, tannery, a variety of stores, and residences located along the main thoroughfare, Murray Street. It was on this main thoroughfare that the Schaedel family of cabinetmakers came to live and work for some 80 years.

The arrival of the Schaedel clan of three cabinetmakers occurred as three separate migrations. Twenty-two-year-old bachelor Carl Freidrich Wilhelm Schaedel was the first to arrive in South Australia in February 1856, followed in August of the same year, by the 38-year-old Carl Gottlieb Schaedel, possibly a brother to Wilhelm. One year after Wilhelm had arrived, his father Carl Friedrich Julius Schaedel arrived with his family. All three cabinetmakers hailed from a common district located in the Province of Brandenburg.

Wilhelm chose to settle in Nuriootpa where he proceeded to set up a workshop in the growing township. Wilhelm was one of those cabinetmakers who intended to work full-time at their trade – as was evident by the fact that his father's German woodworking bench and tools accompanied the family.

A wattle and daub cottage provided the Schaedel's first home and workshop, but by 1873, as the cabinetmaking business proved to have been very successful, a substantial house and workshop was built to accommodate the growing family (see Chapter 3). Situated centrally in Nuriootpa's main street, the two-storey house had a part-sunken basement as the workshop; fronting onto the main road, Wilhelm regularly displayed his furniture along the footpath. Passers-by could peer in and observe the cabinetmaker at work, or walk down the steps into the basement to inspect his handicraft or commission a wardrobe or dresser.

The Schaedel cabinetmaking clan extended over a period of some 80 years. During this period three generations of the family practised a tradition of cabinetmaking which had originated in their particular region of Prussia. Just like Karl Launer, the Schaedels had their own 'signature' style which immediately identified their work. They favoured a scrolled pediment often in combination with scalloped door panels. The combination resulted in a French provincial look which remained unchanged during the life of the workshop, from the late 1850s through to about 1915.

The lifestyle of the Schaedel family reflected their success and the British and German mix of the town. Two doors down from the stately Schaedel residence lived the Riedel family of bootmakers who had arrived in early 1864. The Riedel family home (now demolished) was an unusual building one storey in height, also with a part-sunken basement where shoe and boot-making was carried out; a facade of six substantial pillars supported mock battlements which enclosed a roof garden! The Schaedel and Riedel residences were not only unique in appearance, but also openly expressed the success of their owners.

There was a close relationship between the two families, strengthened in 1880 through the marriage of August Riedel's son, Heinrich Otto, to Wilhelm Schaedel's daughter Clara. In the late nineteenth century these two families contributed substantially to Nuriootpa's social life — as well as to the town's oral lore. During warm summer evenings, passers-by down Murray Street would see the Schaedel family sitting on their verandah, chatting among themselves and to friends; while alongside, the Riedel family sitting in the roof-top garden behind the low battlements, amid potted ferns and trailing vines, enjoyed the promenade. They also shared a love of music, and several of the children were skilled in playing the piano, organ and brass instruments.

The idiosyncratic Schaedel house also reflected the character of the family, especially that of the patriarchs Wilhelm and his wife Pauline. Wilhelm was a particularly formal person, very controlled in his daily routine of taking a cold plunge-bath on rising every morning, no matter what the weather was, prior to starting his work. At the end of the day, he would dress formally for the evening meal which was taken in the splendid dining room. There, the chimes of an elaborate and massive, long-case musical clock, imported from Germany, punctually announced the time for the evening meal. Afterwards, the family retired to the balcony where Wilhelm enjoyed a pipe or cigar while wearing a dark coat and his traditional embroidered smoking cap.

The Schaedels, Riedels and Coulthards, all occupying the largest of the houses along Murray street in Nuriootpa, naturally became closely affiliated. Coulthard House, built over a decade from the mid-1850s to 1860s, and located at the northern end of the street, was a large two-storey Georgian-Australian residence which similarly reflected the British origins and wealth of

its owner. Tragically, William Coulthard had come to an untimely end in 1858, dying of thirst when separated from his companions during an exploration of the outback.

It is not surprising therefore that, through their social connections, the Schaedels regularly received furniture commissions from many of the larger households and landowners of the Barossa Valley, including the Seppelt family of winemakers. Maria, Julius Schaedel's wife, visited the Seppelts regularly, and the christening of Wilhelm's third son 'Benno', after Joseph Seppelt's own son, further indicates the close ties between these families.

The constant growth and expansion at the Seppeltsfield Winery provided the Schaedel cabinetmakers with much work. They constructed cellars, workmen's quarters, and production rooms as well as making chairs, tables, dressers, built-in and free-standing storage cabinets for the interior furnishings.

Today, surviving examples of the Schaedel's work – characterised by their scrolled style – testify to these cabinetmakers' steadfastness to Prussian homeland furniture traditions for over half a century in the Barossa.

The success the Schaedels enjoyed may be attributed to the combination of their social connections, their exceptional craftsmanship, and their early establishment in the town. After some 55 years of making furniture in Nuriootpa, Wilhelm retired in 1910. The workshop was operated by his son Hugo until 1912, but was closed at the time of his departure from the Barossa Valley to work in various country townships until the Depression. The traditional Schaedel style itself ended with the death of the founder of the Nuriootpa workshop, Wilhelm Schaedel, in 1913.

'Glue-pot' Graetz

While the Schaedel's provided Nuriootpa with its furniture needs, it was Tanunda that grew to be recognised as the centre of cabinetmaking in the Barossa Valley. Skilled professional cabinetmakers settled to work there from its establishment in the late 1840s and included a number of Silesians the best known being Johannes Basedow, Julius Kunert, Carl Maywald, and Johann Schulz – all working within their provincial traditions.

Outside of the main centres of Tanunda and Nuriootpa, most of the Barossa villages had their own resident cabinetmaker, particularly so in the years from

the late 1840s to 1870s. But perhaps the most endearing, and one of the more significant, of the furniture-makers of the Barossa was Carl Ewald 'Gluepot' Graetz.

Graetz was one of the first generation of cabinetmakers to be born in the Barossa. Although his furniture had strong traditional elements, it also departed from the norm, expressing both his Germanic origins as well as the local conditions of the Barossa. Through his individual flair he combined traditional Germanic furniture-making, with an exuberant decorative style, creating a true Barossa vernacular style.

One of the more remote corners of the Barossa Valley is Keyneton (also called North Rhine), a district about 11 kilometres south-east of Angaston. Pioneer Rudoph Graetz chose to settle and farm there in 1855, and typical of the Lutheran pioneers, the Graetz's had a large family which included six sons. Over the years, the sons purchased their own land and established their own farms in a cluster about their father's original holding. The extended family farm settlements came to be known as 'Graetztown'. Life was straight-forward and revolved about family, farm work and church. After Sunday morning church service, a midday meal followed with the families assembling in each of the son's homes in rotating order. Later, the Graetz men would meet in the patriarchal home to discuss various matters ranging from farm-work to church, family and the weather.

Born in 1865, Ewald, the youngest son, grew up to become gregarious, romantic, a music lover – and a humorist. His extrovert personality came with a literary bent exercised by composing poetry or stories for special events such as weddings, birthdays and other family celebrations. His fame spread throughout the Barossa to the extent that, even in the 1990s, he was remembered in oral tradition as 'quite a character'. Ewald Graetz had a joyful outlook which influenced all aspects of his life – including his work as a cabinetmaker.

He opened his workshop in 1887, advertising his ability to make 'chests of drawers, wardrobes, glass cupboards, tables, butter machines, coffins, ... Good and solid work at moderate prices'. Following marriage, between 1895 and 1910, Ewald and his wife Elisabeth had a family of eight, the three boys training in their father's workshop.

Graetz 'liked his wine', a Barossa euphemism for excessive drinking. He

always kept a jar of wine concealed in his workshop 'for a quick nip'. As there were occasions when he was not as sober as he should have been, he always kept a pot of glue handy to fix poorly made joinery, so one anecdote describes, hence his nickname 'Gluepot'. Eventually, the bend in the road between Keyneton to Sedan, where his home and workshop was located, became known as 'Gluepot's Corner in Graetz Town'.

Another Barossa anecdote relates how, after a night of drinking at a local hotel bar, Graetz was placed into a cell to sober up where, during the night and to his consternation, he heard the croak of frogs in a nearby creek seemingly calling his name: 'Gluepot, Gluepot ... how the heck did they know my nickname,' he was said to have exclaimed!

Furniture produced by Barossa cabinetmakers of German origin was invariably recreated within the traditions of their regional homeland styles with little alteration. Graetz was exceptional in that he extended homeland traditions, developing his own style, one which is unique to the Barossa. As such he made one of the most distinctive contributions to the vernacular furniture tradition which emerged in the region. Unquestionably, he was also the most ornamental and original of the Barossa cabinetmakers.

Graetz's furniture combined traditional Germanic forms with an individualistic, even naive, approach to decoration – indeed, his was a flamboyant style. It fused his lively personality with influences derived from his German Lutheran upbringing and the Barossa landscape.

In the late 1880s through to about 1910, there was a fondness for the Gothic in the Barossa, reflected in the furnishings of Lutheran churches built or remodelled in this period. As many local cabinetmakers furnished these churches, including Graetz, it was inevitable that the style would influence their domestic work. This was especially so as, unlike many of the more conservative Barossa cabinetmakers trained in Prussia, Graetz was born in the region, and therefore would have felt less constrained by tradition; he was more interested in showmanship.

Graetz's lively decorative style – the contrasts produced through the combination of differing timbers, graining effects and painted colours, together with the addition of various accessories – was a daring approach which intensified the look of a piece.

Imported Baltic pine was the mainstay for much of the Barossa cabinet-maker's work, although Australian cedar from the eastern states was another favourite timber. As well as plain surface stains, stippled, combed finishes were a popular Barossa tradition, giving the distinctive forms a vibrant appearance: tragically, many pieces have been stripped of these original surfaces. Wooden pegs, and wedged, dovetailed joints were also standard German construction techniques. The Barossa cabinetmaker George Juers once remarked: '... in those days it was thought to be bad workmanship to construct a coffin with nails, instead, the wood joins were fitted together, as neatly as a pair of folded hands'.

By the 1920s, the distinctive Barossa style and tradition of furniture-making had been mostly superseded by the Edwardian style through imports of factory-made furniture, although a small handful of German cabinetmakers and their successors maintained homeland traditions on a very small scale as late as the early 1960s. Since the mid-1970s, as interest in Australiana and country furniture grew, examples of Barossa-made furniture became eagerly sought after by serious collectors. Today, given the increased awareness in the Barossa community of the inestimable heritage value of such items, it is not surprising that the frequency with which examples appear in the antique shops of the region or elsewhere, has diminished considerably.

Valley of Wardrobes

The wardrobe was the most desired, practical and favourite furniture form con-structed by its Germanic cabinetmakers in the Barossa region. Indeed, the Barossa became a veritable 'valley of wardrobes', as village cabinetmakers handcrafted, according to their client's commission, the all-important wardrobe for husband and wife – as well as special pieces for presentation to newly-married daughters.

Standing proud and tall, solid and self-assured, the wardrobe also expressed the patriarchal basis of their Lutheran community. Poised at the pediment of these wardrobes was the ubiquitous *Schnurrbart* – literally, the moustache. It is not a coincidence that the Barossa vernacular for the pediment took this masculine name, as the flourish of the moustache topped a very masculine construction – women were never cabinetmakers in this society!

Each cabinetmaker could identify his particular workshop style through

Over the nineteenth and early twentieth century, the Barossa's craftsmen produced a bounty of distinctive decorative arts and folk crafts: Wardrobe by Ewald Graetz, c. 1890. Graetz's work exemplifies Barossa vernacular; carved cottage folk chair of redgum by Wilhelm Zilm, 1895; a pair of earthenware jars by Samuel Hoffmann; a table runner decorated with the traditional European paired bird design c. 1855; a painted candle box, c. 1875; a Christmas tree made of redgum

the shape of the *Schnurrbart*. It appeared in many shapes: as complex neo-baroque scrolls, neo-classical temple-tops, Greek fan motifs, wavy neo-rococo, richly-carved Edwardian profiles, and even as carved folk tulips as favoured by Karl Launer. Graetz's elaborate wardrobes were topped by a trefoil pediment, also found on some early gravestones. One anonymous Barossa cabinetmaker even carved dolphins in semi-relief as part of the pediment, while yet another carved an open book, presumably representing the Bible! Aside from the pediment, Germanic-Barossa wardrobes mostly avoided additional decorative frills, so that their essentially austere styling exuded a solemnity in keeping with the conservatism of the community's Lutheran basis.

Aside from these stylistic allurements and curiosities, it is the evocative qualities of these wardrobes that especially command our attention and veneration. Even today, standing before a Barossa wardrobe is sufficient to convey to the observer an idea of the strength and longevity of the region's traditions, and of the symbolic qualities which suffused Barossan material culture and its inhabitants' everyday lives. Each and every wardrobe embodies generational memories, preserving within its dark, moth-balled interior, and its glowing patinated surface, the stories of family lives lived in this valley, of their ordered ways, of their piety, their hardworking ethos – and their enduring traditions.

The German Wagon

After the wardrobe, perhaps the next most common article constructed and used in the Barossa was the wagon. The reader may already have noticed that German wagons are mentioned frequently throughout the text. Indeed, the German wagon is as much a symbol of the Barossa as are its vineyards and Lutheran churches. Why is it always referred to specifically as a 'German' wagon?

The pioneers of the Barossa, those groups of Prussians who fled their homeland specifically because of religious persecution, were destitute on their arrival. Largely farming peasants and artisans from the smaller villages of eastern Prussia, most of their household belongings had been sold, if not impounded by the Prussian authorities, prior to their long journey to Australia. It is unlikely then that any of these early groups brought over templates or the parts of their distinctive farm wagons. Nevertheless, among these earliest of arrivals were a number of artisans-in-wood who were able to construct wagons based on the traditional homeland form.

German wagons made their first appearance in the village of Klemzig, the first settlement of Prussians in South Australia. Here, in 1839, as their fellow countrymen cleared the forest for crops, the community's carpenters, wheelwrights and joiners, set to constructing wagons, as well as the vital agricultural implements. As the land was cleared of its redgum and bluegum trees, they supplied a hard, endurable timber which was used for making wagons.

As such, the German wagon may well have been the first artefact crafted by Prussians in Australia.

The traditional horse-drawn German wagon was quite distinct from its British counterpart: it was typified by outward sloping sides (initially open lattice, but later of closed plank construction), and had larger spoked rear wheels than its smaller front wheels; it was also springless. It was usual for the wagon to be painted in blue and red, originally for symbolic purposes (see Chapter 2).

For the Klemzig settlers, the German wagon was not simply used for transporting farm produce to Adelaide, but it also played a key role in picking up later arrivals of Prussian migrants at Port Adelaide, and subsequently, re-locating them to the Barossa from early 1842. In later decades, migrants were

185

more often than not accompanied by some household furniture. The transport of the latter from Adelaide to the Barossa over the renowned nutcracker road, caused anxious moments for many a family: the Schaedels, that clan of cabinet-makers spoken of earlier, transported a huge musical long-case clock by wagon drawn by oxen to Nuriootpa; it survives to this day!

During the nineteenth and early twentieth century, church attendances by the Barossa's devout Lutheran families, regularly occurred with the assistance of the German wagon. Farm produce was transported in it, and turn-of-the-century photographs taken at the Barossa's wineries during the grape vintage, often show long lines of German wagons waiting to off-load their piles of hand-picked grapes. Hawkers, including Hoffmann the Barossa potter, also transported their goods using their German wagon.

Other uses for the wagon included its role in wedding ceremonies, the bride and groom arriving at the church in a procession of wagons decorated with the traditional garlands (see Chapter 2).

The construction of the traditional German wagon was maintained up to the outbreak of the First World War, providing work for some four generations of Barossa carpenters, wheelwrights and blacksmiths. Afterwards, they remained in general, though declining, use into the 1950s, when they became entirely superseded by motor trucks and cars.

Today, the German wagon may still be seen in processions during the Vintage Festival, or else visitors will come across preserved examples such as the very early form at the rear of historic Luhrs Cottage in Light Pass, in the Museum of Barossa and German Heritage in Tanunda, or else at Yalumba Winery where a traditionally-painted German wagon stands in a corner of the grounds for the benefit of tourists.

A sprinkling of individuals, fifth and sixth-generation descendants of Prussians, have kept their father's or grandfather's wagon in their farm shed as a nostalgic reminder of their family's background and the Barossa's Germanic heritage.

The Legend of Potter Hoffmann

We have seen that over one hundred migrant German cabinetmakers and carpenters made their home and workplace in the Barossa Valley during the

nineteenth century – yet only one potter, Samuel Hoffmann, worked there. His life in the region has been preserved in lore and legend, as well as in the examples of his pottery still in existence to this day.

Hoffmann, as surviving older descendants of his family recounted, would explore the hills in search of clays suitable for making his pots. Over the years, later generations shared the lore of the potter yet, despite extensive archival searches I could not uncover any written documents about this man – but then, who thought to record the experiences and tales of the ordinary folk?

In 1984, wishing to reconstruct the potter's story, I began by searching church records, directories and land titles which yielded some basic information. Johann Gotthilf Samuel Hoffmann and his wife Caroline hailed from the Prussian Province of Brandenburg, migrating to the colony in 1845 and, following a sojourn in Adelaide, settled in the Barossa at Rowland Flat in 1847. Rowland Flat grew into a self-sufficient agrarian settlement made up of a unique community of farmer-craftsmen including a mason, blacksmith, bootmaker, and cabinetmaker – all of whom combined their craft practice with agricultural activities. Similarly, Hoffmann supplemented his subsistence mixed-farm practice by making and selling pottery.

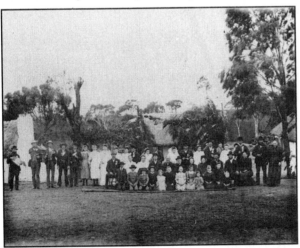

The Hoffmann family, relatives and friends, 1894, on the occasion of the marriage of the potter's granddaughter, at the site of the farm-pottery. Hoffmann is pictured sitting in the middle front of the wedding couple wearing a hat. In 1983, the author interviewed George Haese (visible as a young boy of six kneeling in the front row fourth from the left), then 95 years of age in 1983.

However, the most engaging information came from 17 direct descendants of his family and the potter's neighbours whom I located, many in their 80s and even 90s; they recalled snatches of this oral folk tradition which I came to refer to as 'the trek tradition'. It included intriguing snippets such as: 'The potter got

most of the clay for most of the pots about the farm … to make a shiny pot he walked past Kaiserstuhl towards Eden Valley, to Flaxman Valley before returning with a bag of clay which he carried back on his back …' And, 'Tepper Hoffmann got clay from somewhere near Bethany … and used it for pots which were supposed to be extra good'. 'Tepper' was a Barossa colloquial term derived from the German word *Töpfer* for 'potter'.

Eventually, I pieced together the evidence of this oral lore, together with that provided by the archaeology of his pottery site, a study of his surviving pots, and the secrets prised from the summit of Kaiserstuhl, reconstructing the following story about the potter's trek.

Potter Hoffmann was satisfied: his last kiln firing of wares had occurred a month earlier and the opening of his brick-domed kiln had revealed a cache of finely-fired pots. Their rotund bodies and gleaming orange through green-grey glazes and sturdy handles promised good sales. But he needed another batch of pots if he was to load his German wagon to capacity before venturing out with his son Friedrich on his annual journey about the Barossa. His last visit to the German villages of the valley had been a successful one, the *Hausfrau* always warmly welcoming the potter and his son, and keenly inspecting his latest batch of wares: they especially liked his two-handled jars as these were easy to carry, had a good capacity for storing their pickled cucumbers and, with their smooth inner glazed surfaces and wide openings, were easy to clean. Besides these important practical qualities, they also liked the swelling body form and its symmetrical profile – it reminded them of their far away Prussian homeland where they once used similar pots. Why buy those strange-looking straight sided jars made in Adelaide when they could buy these German-style pots which helped them to feel comfortable and which reminded them who they were? Besides, Hoffmann was a fellow Prussian just like most of them, coming as he and his wife did, from Bobersberg on the River Bober in the province of Brandenburg. Back there he had worked as a journeyman potter, but now he was a master potter with his own pottery and his own farm.

But enough of this reminiscing! He needed more of that white clay for his glazes and for making a batch of stoneware jars which were so prized above

the earthenware pots he usually made. Ah yes, it had been fortuitous meeting his fellow countryman, Professor Johannes Menge, some years ago now. Sad that he died over there in the Victorian Goldfields. It was Menge who helped the Prussians decide that this was to be their New Silesia. He was a strange one though, what with his habit of eating practically nothing but pancakes, though 'Mutter' Kleemann, over on the next farm but one, never seemed to mind the way he dropped in, just when dinner was laid on the table! Menge knew the land though. He knew of the white china clay that could be found just up there behind Kaiserstuhl. It's my secret now and it's time I went on one of my long walks to get another sackful.

Awakening to a cacophony of galahs and magpies, the potter and his wife and family arose to prepare for the day's activities. As his wife Caroline prepared a breakfast in the tiny pug and thatch kitchen-cottage, Hoffmann strolled down towards the creek to his gum-slab workshop. Unlike the routine of farm duties that usually occupied him, this was a special day. As the sun rose over the hills and Kaiserstuhl's dark peak to the east of his farm, it cast its warm hues, heralding a fine day. Tepper Hoffmann was pleased. He entered his rustic pottery workshop and cast his eye over the shelves, selecting two fine pots from his last seasonal firing. Wrapping these bulging pots carefully in a cloth, he placed these into a sack before strolling back to the cottage. After a prayer and breakfast, Caroline gave him a linen parcel which contained his lunch of dill cucumbers, bread and sour cheese. Packing this into the sack with its wrapped pots, Hoffmann now slung the bag over his shoulder and set off.

As the farmstead was situated towards the base of the steep track, the potter had to first negotiate the difficult climb up the escarpment that forms the western flanks of the hills below Kaiserstuhl. He continued up the steep Steingarten track, pausing for a rest at the top of the first hill where he took in the view of the scrub-covered peak of Kaiserstuhl, the scattered Rowland Flat farmsteads below with their wisps of rising chimney smoke and, to the north, the village of Bethany set amidst the neat vineyards and fields of the valley. He hiked over the hill's flank, finally reaching the elevated plateau of the eastern Barossa Ranges, a region of rolling hills, creeks and rocky

outcrops. Continuing through pastures grazed by sheep and intermingled with the woodland, amidst the thud of startled kangaroos, the laughing call of kookaburras, and flights of screeching multi-coloured parrots, Hoffmann trekked on for some hours. He eventually stopped to rest beneath an ancient gumtree, taking out the embroidered linen cloth and unwrapping its contents. After his lunch he continued on until finally, towards sunset, he reached the Seiboth farmstead located in the Flaxman Valley.

There he joined the Seiboth family for a meal and shared the latest news of coming marriages, births or confirmations. The next morning, following breakfast, and in gratitude for being able to rest in their cottage overnight, Tepper Hoffmann presented *Hausfrau* Seiboth with the pots he had carried in his sack. Over 130 years later, one of these pots survived as a witness to the potter's visit!

Departing, he now walked northwards, trekking over undulating pasture and fields for some 5 kilometres and, taking his bearing from the nearby Kaiserstuhl peak, he crossed the tea-tree lined Tanunda Creek into dense bushland. Somewhere in this locality was his secret spot, where he now set to scooping up sufficient white clay to half-fill his bag.

Finally, laden with the heavy clay, his bag slung over his shoulder, he set off on his return trek, now heading westwards up the side of Kaiserstuhl for a short distance, then down its steep slopes. Descending through Schlinke's Gully he negotiated around the walls of the abandoned flour mill and, following the Tanunda Creek, he emerged in the valley at Bethany itself, where its inhabitants were busy in the vineyards and fields. After making his greetings and a short rest, he headed south for the final stage of his trip through further vineyards, crossing Jacob Creek, and passing the Gramp winery and homestead, before finally reaching his own farmstead in the late afternoon.

It was a trek which consisted of about 20 kilometres over rough terrain which took the potter two days and a night, and from which he returned with a half-filled bag of a white kaolin clay which would be used to make the glazes for his next batch of pots.

That Johannes Menge the mineralogist and explorer (see Chapter 1) met

and knew the potter Hoffmann, is most likely as Menge's cave-hut abode at Jacob Creek was less than 3 kilometres from the potter's farm. Menge also had the habit of regularly calling on the Lutheran settlers about Rowland Flat, especially at meal-times; and he was known to have been a frequent visitor of the Kleemann family whose homestead was situated less than half a kilometre to the west of Hoffmann's farm and pottery.

It appears that Menge's intimate knowledge of the minerals and clays of the Barossa region was shared with potter Hoffmann, helping him to locate his secret, 'special' clay source. Menge himself often stated his wish to help his fellow countrymen, writing: 'I desire to give some directions to persons who frequent the hills, and ramble about what is called the bush, for seeking and finding out the minerals which might occur in their passages ...' Menge also wrote in the local press describing specific clays he had discovered about the peak of Kaiserstuhl, and which he even evaluated as suitable for use by potters! Given his gregarious and inquisitive nature, Menge would have surely been delighted to meet and talk with Hoffmann, a fellow Prussian – as well as the sole potter who settled in the Barossa. It is more likely than not that, after one of his meals at the Kleemann farm, Menge strolled across the adjoining field to Hoffmann's farm, where the potter had also built a kiln, to discuss the merits and whereabouts of various clays.

With his advancing years, making pots became difficult, not to mention uneconomic, for Hoffmann. Following his death in 1900 at the age of 78, the potter's secret passed into Barossa lore, to be relayed from father to son and mother to daughter, for some five generations. Today, anyone walking about the uncleared bush immediately east of the peak of Kaiserstuhl may discover pockets of white clay exposed by running water in the banks of creeks: which one of these was the potter's secret source?

Many of the informants I interviewed in the 1980s during the course of my research have since died. I especially remember George Haese who was 95 years old when I first met him in 1983, two years before he died; he had first-hand knowledge of the potter for he was born and brought up on the farm adjoining the potter's own. I still wonder at the fact that the generational distance between me and this early Prussian migrant was but one!

Today, with the frayed threads of the Hoffmann oral folk tradition as passed

on by word of mouth having almost faded away, only the potter's surviving jars with their quaint, bellied medieval bodies (complete with his impressed thumbprint at the based of each bulging handle) and the shards scattered in a windswept field, together with his simple gravestone in the Rowland Flat Cemetery, remain as tangible reminders of a life lived in clay in the distant past of the Barossa's history.

Hoffmann made at least 18 types of wares, either earthenware or stoneware, but mostly of the former. The variety of vessels he made has already been described, but briefly these consisted of storage jars, mixing bowls, milk pans, jugs, crocks, strainers, cake moulds, small containers and table dishes (a full description of the uses of Hoffmann's pots is to be found in Chapter 5). His pots were covered in a primitive earthenware glaze which was lead-based, and which ranged in colour from a dull brown, through to hues of orange-brown, yellow, greenish yellow, and red. Hoffmann's smaller output of stoneware pots had a brown, wood ash finish.

Hoffmann devoted his time to producing certain forms, especially a two-handled earthenware storage jar of a distinctive medieval belly shape. I refer to this form as his 'traditional jar'. His wood-fired kiln was a simple round, updraught structure with three firemouths, one of them large enough to allow access for the potter to place his wares. It resembled a domed beehive topped with a short chimney to increase the draught – a design based on traditional types in standard use in Prussia for centuries. Hoffmann used a pottery wheel to throw his wares, described as '… a wooden treadle machine fashioned out of a gum log …', the round section attached to an arrangement of wattle sticks as spokes.

During his active potting period, between the late 1840s and the late 1870s, once or twice yearly, Hoffmann would load a season's wares into his German wagon and, accompanied by his wife or son, cart them about the villages of the Barossa Valley including Bethany, Krondorf, Langmeil, Rosedale, Ebenezer and Light Pass. Given the primitive conditions of roads, travelling in a spring-less German wagon was rough going, so Hoffmann packed his wares in the wagon using straw to absorb the shock.

We may envisage the wagon approaching a lone farmhouse, the *Hausfrau* emerging from her kitchen to greet the potter. As Hoffmann unpacked his

wares from the straw, he passed the pots to the *Hausfrau* who handled them in order to judge for herself their various attributes. This was also a social encounter as the presence of Hoffmann's wife or son would have led to the sharing of news and local gossip.

In the earlier years, Hoffmann possibly also sold his wares in the central market place of Tanunda's Goat Square. *Der Ziegenmarkt*, as it was called, functioned as an active market place from the mid-1840s up to about the early 1850s, the German settlers bringing in farm produce and crafted goods in carts often pulled by goats. But the rapid growth of retail shops in Tanunda's main street rendered the medieval square obsolete; today it still exists as a popular tourist destination with its earlier glory recreated during the vintage festival.

An Old Lutheran, Hoffmann brought with him the skills and tradition of pottery as developed in his Prussian homeland over some hundreds of years. His jars were direct copies of an age-old tradition, transplanted and maintained for at least three decades in Australia. It can be a sobering experience to hold one of his jars, to run one's hands over the inside walls and feel the grooves where once the Barossa potter's hands impressed the clay, to see his fingerprints in the glaze, or to feel his impressed thumb-print at the base of handles: the humanity and history embodied by these pots is palpable.

Although Hoffmann had stopped making his pottery by 1885, examples of his bellied traditional jars remained in use for over one hundred years! For a time, their familiar, central-European forms were a powerful symbol for the Barossa community, a reminder of their Prussian origins. Later, their lingering presence prolonged the memory of Tepper Hoffmann's folk craft tradition and life in the Lutheran community. Today, his surviving pots are documents of fired clay, and are among the cultural icons of the Barossa.

The Textile Arts: for Home and Church

Turning the spotlight from the male-dominated crafts, the contribution made by the German housewife cannot be overlooked. Embroidery and the related textile arts were the preserve of women. Indeed, decorative needlework, which includes embroidery itself – as well as a variety of techniques such as knitting, crochet, lace and macrame – was an activity practised exclusively by the women folk. The needlework arts of embroidery, as well as those of basket-

making, weaving and spinning, contributed a wealth of useful and symbolic articles in the home and community church. Bonds of affection, as well as family and social affiliations, could be expressed through the communal activity of various textile skills. The customs and meanings associated with *Federschleissen* (featherstripping), early German weddings and their associated paraphernalia of black wedding dress and white veil, the tin-kettling ritual and the food customs associated with this important celebration, reveal the intimate links, now lost, between crafting and culture (see Chapter 2).

Federschleissen was a traditional German activity associated with the domestic setting, which especially reveals how textile practices could act as a sharing and bonding ritual. Literally translating as 'featherstripping', it was an activity widely practised in the Barossa Valley from the 1840s until the late 1930s. *Federschleissen* gatherings could also be considered as equivalent to the North American Pennsylvanian or Amish 'quilting bee', where a group of friends, neighbours and relatives gathered to work on a wedding quilt.

Barossa *Federschleissen* evenings were social gatherings of families when the women folk plucked goose feathers (although chicken or duck feathers were also sometimes substituted), or if this had already been done, cut out the hard ribs, an activity sometimes described as stripping quills of their down, feather by feather. The evenings were usually associated with a coming wedding, in which case the gathering usually included relatives and close friends of the betrothed couple. Sometimes as many as 20, but more usually at least 10 would gather to strip feathers, gossip, and often break out into harmony singing. With a large pile of feathers placed in front of each guest on the kitchen table, large quantities of German yeast cake and coffee were gradually consumed, the evening finishing with games and perhaps some 'sing song'.

A good evening's work was evaluated by filling a glass tumbler with stripped down, and packed densely enough for the pressure of its contents to cause it to tip over when set upside down on the table! This set up a competitive though friendly atmosphere as friends vied with one another to see who could fill their glass first. When enough feathers were available for the mattress, the down was stuffed into calico or cotton, and the mattress finished with a cover of printed textile.

The Barossa Germans used feather mattresses, that is eiderdown pillows and

a cover, in place of blankets on the base of the head. Sometimes a feather mattress was made as a cover for the top of a base mattress, itself filled with straw or 'cocky-chaff' (the husks of threshed wheat). Feather mattresses were more often made to be used under the bottom sheet as a means of keeping warm in winter and cool in summer.

As part of their routine domestic duties the Barossa *Hausfrau*, her daughter and the grandmother, practised a repertoire of textile skills which included embroidery, knitting, sewing, tatting, crochet and quilting. Included among the numerous items they made were bedspreads, mantle-shelf and table covers, linen samplers, cross-stitched or embroidered pillow cases, clothing, fancywork and other domestic articles of both practical and decorative nature.

Textiles could also have a symbolic function, especially within religious and ethical practices such as marriage. Lutheran values regarding family life could also be celebrated through framed decorative needlework wall mottoes unique to the Barossa (see later).

As well as being part of a wider social activity, needlework was linked to the Lutheran family lifestyle, acting to bond members of the close-knit Barossa community. In addition, the European tradition of the dowry centred about a collection of treasured textiles such as featherwork bedding, embroidered towels and mantle runners, lacework and whitework bed covers, all kept in a special chest or dowry box.

Whitework – embroidery using white threads on a white cloth – was particularly common in the Barossa, and was traditionally used to make pillow over-covers in white linen with the bride and groom's initials embroidered in white thread, often with the German lettering *Schlafe wohl*, meaning, 'sleep well'. Whiteworked cotton embroidered and quilted bed covers were a particularly essential item in the Barossa home. Because traditional whitework avoided coloured thread, it highlighted the fineness of the stitch and was therefore an indicator of skill. Perhaps the main reason for its popularity, in both the Barossa home and the church, was because this category of embroidery centred about the purity of white, in accord with the conservative nature of the Lutherans. As the best linen was reserved for religious coverings (which featured religious designs) for the church altar and pulpit, most of the whitework was of embroidered cotton thread on cotton cloth. Whitework was also

used to make and decorate women's garments such as field bonnets, petticoats, handkerchiefs and aprons.

Another specialty to be found in the textile arts of the Barossa's Lutheran settlements was the embroidering of patterns or lettering using red cotton on a white cloth. This red on white work was referred to as 'German red work'. Towels, tablecloths, handkerchiefs, mantle runners and pillow cases were often embellished with red-stitched lettering on white, the designs also frequently combining figurative work. Lettering included: 'He, who keeps you does not slumber'; 'Your own stove is worth more than gold, take care of it and value it'; 'Bestirring oneself brings great blessing'.

The tradition of the 'friendship' textile was maintained into the early years of the twentieth century. One Barossa linen table cloth was embroidered with red thread to commemorate a special social event, perhaps a birthday, the 29 Barossa Valley family names surrounding the initials of one Emma Lowke (1880–1954). Other documented examples of German red work include a runner embroidered with three crowns with a stylised floral border; a huckaback cloth with two peace doves holding the olive branch; a coverlet with the cross combined with symbolic ivy leaves; and a tea towel with the traditional, central-European folk design of symmetrical paired birds and central floral motif.

Yet other Barossa needlework included coarser counter-stitched embroidery used to embellish mantle covers, pillowcases and huckabuck towels, as well as floral designs embroidered in coloured silk on housewifes' black aprons, and on their husband's smoking caps.

Although patchwork quilting was also practised, together with the making of hooked bush rugs and waggas, these activities were traditions introduced from the wider Australian social setting and were not common until the 1930s.

Textile work also created the clothing requirements for the special events which marked the various life celebrations of the Barossa Lutherans: birth, baptism, confirmation, marriage and death. The ceremony of baptism required Christening bonnets and other clothes; confirmation (between the ages of twelve and fifteen) necessitated a confirmation dress; while the wedding was an event which perhaps required the most elaborate clothes: the bride's wedding dress and a vest for the groom. Even in death, special textiles were called for, from the lining of coffins to clothes for mourning and the funeral rites – such

as the widow's mourning collar of black silk, and mourning cape of beads and black lace (see Chapter 2).

Framed decorative needlework wall mottoes, mostly based on imported German patterns, were typical in the Barossa-Lutheran home. These were either prayer tracts or celebration records of green, silver or gold wedding anniversaries. The latter embroideries were framed as a record of specific milestones in married life: the Green Wedding marked the day of the marriage; 25 years for the Silver; 50 years for the Golden Wedding anniversary; and the rare 60 years for the Diamond anniversary. The embroidered mottoes were usually in German script lettering and included: 'God's Grace to your green wedding; Go joyfully towards the silver one!'. These embroideries were not original designs; instead, the housewife purchased do-it-yourself embroidery kits from the local store, imported from Germany. They were in use from the 1880s through to the 1940s. Embroidery kits of German prayer tracts could also be purchased and assembled, and sometimes included caesin-based plastic figures of angels.

The dedicated Lutheran housewife also created all the necessary ecclesiastical needlework, using the best linen and whitework coverings for church altar and pulpit. Embroidered designs commonly featured religious symbolism including the cross, fish (symbol of Christ), the monogram of the letters IHS (equivalent to Jesus), and vine leaves and grapes (symbolising the relationship of God and His people).

Textile traditions remained quite strong in the Barossa, and well into the 1930s, young women were active in needlework, producing much 'fancy-working' to stock the 'hope chest'. While a lot of textile work was copied from the traditional patterns of needlework examples produced by mother and grandmother and reproduced faithfully, there was sometimes an opportunity for the expression of individual imagination. Embroidery remains a popular leisure-time activity in the region and, to this day, community work is still the source of contemporary church wall hangings.

A popular phrase which epitomised the time-honoured pursuits of the Barossa housewife was *Kinder, Küche und Kirche* (children, kitchen and church). This was the role of the ideal Lutheran wife to devote her time to being a mother, keeping the home in order, preparing daily meals, and helping with

Barossa traditional embroidered wedding anniversary record of cotton and metallic thread on paper base, with gold-foil wreath, c. 1910. 'For the Golden Wedding Greetings to the Golden Couple, praise the Lord who was with you'.

farm chores. But she was also expected to be experienced in the textile arts: their practice not only made the Barossa home hospitable and comfortable, but were also a means of producing personalized tokens of friendship, especially when presented at birthdays or other occasions. Just as the traditional style of furniture made by German cabinetmakers gave the Barossa home a familiar ethnic ambience, so too did the housewife's textilework complement and enrich domestic and church interiors.

Barossa Folk Artworks

From the 1880s, the improvement of the economic and social setting of the Barossa gave the housewife time to pursue the popular handicrafts of the time. Magazines were usually the source of these crafts which included the use of hair, wax or paper to create flower pictures, as well as splatter-work, pokerwork, and the making of fancy frames. While these were popular around Australia, those made in the Barossa are distinctive in that they were a blend of Germanic decorative folk influences – yet another area of Barossa vernacular expression. Craft hobbies such as these gave the housewife a break from the routine of domestic work, as well as a chance to express her creativity, to cheer the home, and memorialise family events.

Both husband and wife could indulge in woodcraft activities to produce articles for gifts, a time-honoured folk tradition. The former was usually adept in chip-carving, whittling, marquetry inlay, fretwork, spatterwork, and pokerwork. As chip-carving originated in Germany it is not surprising that this was particularly popular in the Barossa; the technique was used to decorate tables, cupboards, trinket boxes, and frames. While this hobby was popular around the rural districts of Australia, the Barossa's Germanic community imbued their works with distinctive cultural characteristics expressive of its ethnic origins. Chip-carved patterns of sun-bursts, swirls and stars which emulate traditional central-European folk motifs, the 'tree of life' and roundel motifs were often used.

Fancy frames were especially popular in the Barossa as these were in high demand for the display of family photographs, mementoes, church certificates such as confirmations and wedding anniversaries, and embroidered religious tracts. The frames could be chip-carved, figuratively carved or pressed leather frames. Chip-carving, sometimes now called 'tramp art', was the most common means of making a frame and consisted of layering and gluing together thin sheets of cedar (usually recycled from imported cigar boxes), then carving the edges to create decorative, saw-tooth and stepped effects. Especially intricate effects could be obtained by carving many small pieces of wood into points which were then interlocked to produce frames in the form of a cross or 'crown of thorns' pattern.

The making of leatherwork frames was another popular activity in late-nineteenth-century Barossa. Leather was cut and press-moulded into leaf shapes which were then attached to a wooden frame: oak leaves were often used as these symbolised the strength of faith and virtue, and of the endurance of the Christian against adversity. A variety of other materials were also used to make fancy frames, including pine-cone scales, or even slices of old cork stoppers, attached in decorative patterns on a wooden frame.

As fretwork was taught in Lutheran primary schools throughout the Barossa, fretwork crosses entwined with ivy foliage and set against a framed velvet background, became a popular decorative and religious object in Lutheran homes. The ivy-leaf symbolised eternal life, attachment and life-long affection.

Figurative wood carving was also practised by the Barossa Germans, with cabinetmakers often adept at embellishing their furniture with carvings of

dolphins, tulips, and other motifs. They also carved church furniture, usually in a neo-Gothic style, with religious motifs such as the cross, the Paschal Lamb, and the grape vine.

In the Barossa, the traditional German plank chair acted as the model for a type of cottage chair specific to the region: usually constructed from redgum timber, the vernacular forest chair had a slab seat and splayed legs, but instead of the traditional plank back-rest it was fitted with an open geometric back-rest which included a pair of spindles. One Barossa family in particular, the Zilms, was responsible for perpetuating the tradition of this stick chair for some 50 years, incidentally creating a unique cultural form.

The Zilm family first began their chair-making in the Barossa at Nain in 1853, and continued to do so in Booleroo (in the far north), from 1872 to 1896. In their farm workshop, the primitive chair became a more elaborate carver chair: some examples had plain arms, others carved 'knuckle' arms, and some with fully-carved, outstretched, human-shaped arm ends!

The making of these chairs by the Zilms was initially a traditional folk bushcraft activity brought about by the necessity of the early pioneering conditions. What made them extraordinary was the addition of a playful imagination, one which combined practical considerations with a sense of humour. For the contemporary observer, the Zilm chairs are not simply a folk fusion of art and craft, but the outcome of the interaction of a number of forces: of culture, landscape, utility and art. They are a poignant reminder of the trials and tribulations of this German family.

Other figurative works were often carved in wood by various Barossa individuals, and included naively-carved figures inspired by the Australian setting, namely the kookaburra and kangaroo. Also, in later years, inspired by the arts and crafts movement, naturalistic and Art Nouveau carvings of gum nuts and leaves were executed on furniture or were created as decorative panels.

Among the toys and decorative garden objects which were made from the early 1920s were wind-driven whirligigs, kaleidoscopes, and rocking horses.

Tinsheet cut-outs were another type of folk art which also assumed distinctive vernacular forms in the Barossa. Old kerosene tins or flattened corrugated iron sheets were cut and painted to form silhouette forms of predators, such as hawks or cats, to keep birds away from fruit trees. Tin cut-outs of cat

heads with marble eyes were hung in trees so that, as the breeze moved the shape, the glass eyes became very effective deterrents against birds. Weather vanes, cockatoos, roosters, crows, galahs and magpies were also produced as verandah ornaments from discarded tin or sheet iron. They were often painted to give an additional folk art touch.

Foil art was a unique Barossa folk art introduced by Hugo Ahrens who claimed to be its inventor in the late 1930s. His technique recycled discarded foil obtained from sweet wrappings, together with black paint, and glass: his pictures emulated embroidery insofar as he often created decorative script of humorous catechisms or homilies such as: 'Your temper belongs to you – don't lose it'; 'In God we trust, but others pay cash'. Following an accident in 1937 which forced his early retirement, Ahrens henceforth used his time to perfect his foil pictures, working in his an old shed labelled on the door 'The Laboratory'. A denizen of Tanunda, Ahrens lived to the ripe old age of 88. A favourite commemoration or gift item made on commission, Ahrens's foil art became a familiar decorative item in the Barossa home.

Illuminated or decorative script, was also a part of early Barossa Lutheran material cultural tradition. Birth, baptism and confirmation certificates, wedding anniversaries, birthdays and other family records, were either of handscripted calligraphy or available as printed forms which were usually personalised with various embellishments. Presentations were often made by the husband to the wife, parents to their children or by family members to an anniversary couple. The calligraphy was sometimes illuminated with printed cut-outs of angels, flowers or decorative motifs, or in a very few documented instances, with hand-drawn patterns or illustrations. These calligraphic creations or certificates were carefully preserved and assembled in creative ways to be framed and hung as part of the furnishings of the Barossa home.

Although not a leisure activity, the Barossa was home to many skilled stone carvers or masons: monuments and gravestones embody their art which is dealt with briefly here. From settlement through to the late nineteenth century, Barossa gravestone forms show a stylistic progression from wooden and cast-iron markers through to slate, sandstone and imported marble; in some rare instances cast iron was also used. Wooden crosses were the earliest and were used to mark burial sites in Hoffnungsthal, the flooded German village

(see Chapter 2). The surfaces of these memorials were carved with decorative lettering together with figurative or abstract images.

Slate was the first stone used for gravestones in the Barossa. Unfortunately, slate does not weather as well as marble, so many of these early markers have disappeared or have eroded. Symbols on these slate gravestones included folk motifs such as the flowers-in-vase, the eight-pointed star, and oak leaves. A particularly common motif to be found on Barossa headstones is the anchor, often combined with the cross and heart (symbolising faith, hope and charity); on its own, the anchor symbolised the finding of a safe refuge – the aim of the early Prussian refugees who sought a new home. However, the anchor also symbolises the spiritual home, the destination of the soul in Heaven. Early German custom also led to the practice of engraving the back as well as front of headstones with memorial or religious script. Marble headstones and more ornate Victorian neo-classical or eclectic styles, became prevalent from the 1870s; the marble was quarried from the hills about Angaston, although imported Italian marble was also commonly used.

Other folk craft activities which are also expressive of the customs of Barossa Valley Lutheran family and community life, include the decorative work of blacksmiths, painted church decoration and even organ-making (see Chapter 7).

The Essence of Traditional Craft

The village craftsman's works once comprised most of the every-day items which made up the Barossa home where they were constantly used: Hoffmann's pots were handled by the housewife and other family members; Launer's wardrobes, chests, and other furniture had a strong visible and tactile presence in the Barossa-Lutheran home setting. Imagine the distinctive ambience created by bellied jars placed on the shelves of red-stained Biedermeier dressers, and consider how the visual power of these central-European forms evoked a sense of 'Prussian-ness'. Imagine too, around the walls, framed embroideries of Biblical texts or other religious images in Gothic German, ever present and constantly proclaiming their messages. Assembled together, they combined to create a cultural character, one which reinforced a sense of shared identity, as well as maintaining links with the homeland.

The shared values and attitudes held by the Barossa-Lutheran community included those of hard work, piety, and honesty – best expressed by leading an ordered life. The order and discipline characteristic of the pioneer and later generations of Lutherans has already been noted, including the thoughtful manner in which they founded their settlements, and their strong kinship and market networks. Similarly, time-honoured folk crafting traditions not only propagated familiar cultural forms such as buildings, textiles, pots or furniture, but through their replication, they were also symbolic of the central-European culture in which they were created and used. Key features of the decorative style of early Barossa material folk culture were therefore closely linked to communally-held Lutheran values. We see this in their ordered simplicity and practicality and, generally, in the harmonious balance of various components – qualities especially notable in Barossa furniture.

Tin wind vane, c. 1920. Tin folk art work included cat and hawk profiles once commonly used to scare birds away from grape vines.

Through their joyous commitment to their faith, the Barossa-German settlers imbued their folk arts and crafts with a quality of functional eloquence, avoiding superfluous decoration. Surviving folk arts and crafts express these qualities and, therefore, the essence of Barossa Germanic material culture.

Private Collections and Museums

Over the past two decades, a trade in Barossa artefacts, especially in locally-made early furniture, has thrived, unfortunately leading to many once-prized heirlooms being sold interstate. Tragically, in most cases, the provenance and

social history of these heritage items has been lost. While such activity has acted to highlight the allure of the unique craftsmanship of the Barossa-Germanic cabinetmaker, it has, thankfully, lately slowed down. The predominant reason may be attributed to the growing awareness by Barossa inhabitants of the cultural value of such artefacts.

Meanwhile, visitors are hard-pressed to view this vital aspect of the Barossa's heritage, although some idea of the material folk culture of the region may be gained from a visit to the Museum of Barossa and German Heritage in Tanunda. This is operated by a group of dedicated local historians (The Barossa Archives and Historical Trust), who are currently involved in upgrading the museum and its interpretive displays. Unfortunately, a public collection which focuses on a representative display of the rich diversity of the decorative arts of Barossa has yet to be assembled.

Yet the Barossa region has a surprising assembly of private collections, some straightforward and some quirky, which span various aspects of its heritage and which, in themselves, form a collective artefact of the region, one which is itself, quintessentially Barossan.

Consider the idiosyncratic Kev Rohrlach Collection. Located midway between Tanunda and Nuriootpa, this large purpose-built, private museum (called The Kev Rohrlach Technology and Heritage Centre), has mixed displays of rocket missiles, horse-drawn carriages, military machines, a mineralogical collection, veteran cars and clothes, pioneer artefacts, and a miscellany of curios. Rather than attempting to be representative of the region's material folk culture, this museum reflects the personal interests and inclinations of its Barossa born and bred owner.

The South Australian Museum of Mechanical Music in Lyndoch brings together an unusual collection. Although the large display of music boxes, phonographs, singing birds, player organs and other mechanically-operated devices comes from around Australia, just over half has originated from the Barossa. This is not surprising given that these were particularly popular in the region from the mid-nineteenth to early twentieth century, and given its Germanic musical heritage. Indeed, the devices are either German or Swiss made! A particularly Barossa-German exhibit which was once relatively common in the region, is an example of a mechanical music box surmounted

by a Christmas tree; a key wind-up operates a punched metal disc which plays Christmas carols, as the decorated green-dyed goose-feather tree slowly revolves!

On the flat eastern boundary of the Barossa, in the Cambrai–Sedan district, John Ward-Lohmeyer (who lives in a renovated, old Lutheran church) has created an extraordinary outdoor museum dedicated to the preservation and reconstruction of pioneer buildings, especially of the district's original wattle and daub dwellings. The display of Germanic and British buildings which are scattered in a re-planted bushland setting, includes a 1920s general store with its original display furniture and other artefacts of daily life in the area.

The Barossa Wine and Visitor Centre in Tanunda has already been mentioned, but its interactive exhibition 'From Vine to Wine', gives the visitor a chance to readily access the region's viticultural and winemaking story. Here, the unusual 'history wheel drums' which display vignettes of the most important events in world, Australian and Barossa history, may be 'spun' by the visitor; an audio-visual display presents a cross-section of the Barossa's festivals, scenery, townscapes and people; a 'working' model of a winery explains the process of winemaking; while video-clips of Barossa winemakers narrate their philosophy.

The Barossa region features a number of private and public museums which range from authentic heritage through to idiosynchratic, story-telling, displays as this folksy sign indicates.

Those interested in 'authentic' heritage displays will appreciate the Wine Heritage Museum at Wolf Blass Wines just outside Nuriootpa. It's easy to see why the museum, located in part of an old wine cellar, was the 1993 South Australian Tourism Award winner for Heritage Tourism. Visitors walk along a long circular path which takes them past professionally-set-out tableaux and room displays depicting aspects of the history of winemaking in the Barossa. Old tools, wine presses and other artefacts of the region's viticultural and winemaking history are sensitively displayed; one room is set out as a nineteenth-century Barossan dining room; another is an early barrel-making or cooperage workshop; finally, a spectacular diorama recreates the scenic setting of the Barossa's vineyards.

The era of the traditional craftsman is similarly vividly evoked in Angaston where the old Doddridge Blacksmith Shop has carefully been preserved. Fronting onto the main street, the galvanised-iron building has survived depression and the advance of technology to retain its faded original sign, bellows and forge, as well as most of the specialised tools once used by three generations of the family since 1873. Today, it is a living museum where displays and demonstrations of blacksmithing may be seen in the context of their generational accumulation; entering the workshop can be a transforming experience, so authentic is the display!

The Barossa penchant for story-telling is embodied in the curious and quirky Story Book Cottage and Whacky Wood at the southern entry to Tanunda. The decorated street pole with its tin-man wood cutter indicates the folksy ambience of this attraction established in 1979. Inside the Story Book Cottage visitors view an eclectic and random display of 55 tableaux or settings which illustrate nursery rhymes or historical events. Among the living trees of the Whacky Wood, bush picnic games and other displays entertain the visitor.

Contemporary Barossa Crafts

A new generation of artists and craftspeople is now working in the Barossa region, some introducing new skills, a few attempting to re-establish the traditional crafts of the past. Because of the demise of the historic Barossa's agricultural, village-crafts economy, only a small number of full-time professional craftspeople can now find full-time work in this region. The constant

growth of tourism promises to support more of these people, but compare the dozen or so professional craftspeople of today to the 400 or so craftsmen who were once an integral part of the Barossa's community.

Currently working full-time in the Barossa region are three furniture-makers, an art blacksmith, an organ-maker, a wood carver, a wood turner, and a handful of potters. There are also a number of artists and sculptors. However, there is little connection between these modern-day practitioners, both in terms of their technical and aesthetic approaches or styles, and the migrant German craftsmen who brought Prussian traditions to the region. Nevertheless, few of these professional crafts practitioners are immune to the Barossa's rich heritage and imposing landscape; like the folk of the past, they are expressing its qualities or telling its stories and even, perhaps, establishing their own traditions.

Harry Hennig, an art blacksmith, is especially keen to retain the element of authenticity in his work. Blacksmithing was once an essential activity in the Barossa, with all villages, and even most farms, having their own forge or resident blacksmith. The decline of the village blacksmith followed the advent of the motor vehicle and the accompanying demise of horse-drawn vehicles. A more recent German migrant, Hennig has been operating a traditional black-smith's coke and bellows forge as 'Hennig Forge' in the Barossa since 1986. His decorative iron-work includes gates, furniture and candelabra, items of practical use and all hand-made.

In the medium of wood, fifth-generation Barossa-born, resident David Nitschke is one of a group of a wood carvers who work in the region, maintaining a link between this medium and its past. Nitschke is especially skilled at figurative wood carving using native timbers; in 1993 he carved a lectern in native blackwood which features an eagle with outstretched wings, for St John's Lutheran Church in Tanunda (see Chapter 3).

Other wood craftsmen who work in the Barossa region include Norman Peterson who lives on its most easterly boundary at Cambrai where he specialises in working with redgum timber. The redgum tree has been encountered on a number of occasions in this book, but a diversion will serve to illustrate its significance and the 'redgum culture' it engendered.

Redgum trees are to be found along the watercourses of the Barossa region: Aboriginal people utilised it to make bark canoes and shields, or simply

sheltered in its hollowed trunks. Such specimens similarly provided shelter for European pioneers, as the story of the Herbig Tree at Springton demonstrates (see Chapter 3). Others used the durable timber for building their *Fachwerk* homes, and to make implements and German wagons. Prussian cabinetmakers also applied their age-old European furniture practices to create Australian vernacular expressions in redgum timber. These historical and cultural associations engendered by redgum's Aboriginal significance, pioneer roots, and its intimate links with the landscape, have especially drawn Norman Peterson.

Turner, carver and sculptor, he has coaxed its store of memory and created beauty from old fence posts or stumps of trees felled last century. The aged timber has a weathered grey skin which covers a blood-red interior and fine fiddleback grain – qualities exposed in his turned vessels. The cultural landscape has a marked influence on the forms Peterson creates: the layered beds of creek banks have suggested the application of bands of grooves, while barbed wire unravelled from old fence posts is sometimes coiled about his vessels to further endow these pieces with a sense of place and history.

Past and Present Barossa Artists and Sculptors

We have seen how the Barossa was visited by a number of professional artists who recorded its landscape in its earliest years during the process of its cultural transformation by Prussian and British settlers.

The most prominent and earliest of these was the distinguished artist George French Angas, whose drawings and paintings of early German settlements and landscapes were published as coloured lithographs in the splendid book *South Australia Illustrated*. The glimpses he provided for us of the Barossa of the 1840s are unique and unsurpassed (see Chapters 1 and 5).

Another artist who has remained unidentified, although he is thought to be of German origin, travelled about the valley painting a series of at least four watercolours. These illustrated various Barossa scenes, dwellings and public buildings of the 1850s. This anonymous artist's view of the Light Pass Lutheran Church and its manse and schoolhouse, for example, is today a particularly fascinating and detailed historical record, capturing the *Fachwerk* architectural style and setting of a group of church buildings erected by the members of this commune. Aside from his attention to detail, one of the painter's characteristic

trademarks was to paint human figures always facing into the picture, away from the viewer (see Chapter 3).

We also have sketches and oil paintings of the Barossa region executed by the German migrant Eugene von Guérard, considered today to be Australia's most important nineteenth-century artist. His sketches of the flooded village of Hoffnungsthal at Lyndoch, for example, and those of the remains of Schlinke's massive two storeyed mill (then still sporting its huge wooden water wheel) in Tanunda Creek, are especially evocative views of the past (Chapters 2 and 5).

Another Barossa artist was the German migrant Johann Gottlieb Otto Tepper. Farmer, then school teacher at Neu Mecklenburg, near Tanunda, Tepper was interested in botany, as well as being an accomplished painter. Like von Guérard, he also sketched the crumbling bluestone walls of Schlinke's mill, some twenty years after von Guérard's recording of the scene, in the 1870s.

Aside from these professional artists, there were those who were not formally trained and whom we may refer to as folk artists. These mostly amateur and anonymous painters applied their native skills to decorate a range of everyday articles, from the farm wagon to the wardrobe and even the kitchen door. Wheelwrights, blacksmiths, carpenters and cabinetmakers who worked in village manufacturing workshops were also sometimes capable of painting coaches and signs. The Barossa seems to have had its fair share of these talented tradesmen, and surviving late nineteenth-century wagons and farm machinery still sometimes display their painted flourishes.

Early interior church decoration was also executed by such talented artists in the community. Immanuel Lutheran Church in Light Pass, built in 1850, had a ceiling of muslin painted with an impressionistic starry sky; Holy Cross, Gruenberg was decorated with a tracery of vines and Biblical text around the walls. Church painting was a specialty of Julius Henschke, Tanunda's monument mason and sculptor for many years from the 1880s, his artistic work now visible on the headstones of the region's cemeteries.

Other paintings by various unidentified inhabitants of the Barossa fall between folk and naive painting: most are scenes of nostalgic subjects such as early settler's cottages, and were painted on tin sheets or even earthenware pots.

Folk painted furniture is not common to the conservative Barossa Lutherans, unlike its popularity among the Pennsylvania Germans in North America.

There are some exceptions, especially of the chest or blanket box which accompanied most migrants to Australia: the front panel of these chests, on which was often painted the name and date of the owner's departure from Europe, was usually also embellished with decorative traditional tulip or other floral patterns. A small number of these large boxes still retain their original painted surface; some appear to have been painted after the arrival of the individual or family, possibly to enhance their new use in the home.

More significant than the blanket box, Baltic pine furniture made by Barossa-German cabinetmakers was invariably finished with graining and other decorative effects. Furniture made by local farmers was also sometimes painted, a unique example being the set of slab and stick chairs made by the Zilm family, as described earlier, and painted with remarkable folk designs which merged traditional Germanic motifs with Aboriginal-derived symbols: hearts and dot patterns!

Today, artists continue to be drawn to the Barossa's inspiring landscape, heritage and its community; the following describes a little about some of them, their approaches, styles, and particular focus. Artist Rod Schubert is a fifth-generation Barossan who has been a full-time painter since 1970. His work is in the contemporary idiom with a mixed-media approach combining monotypes with acrylics and other materials. Although he has painted the diverse bird life of the valley, it is not so much the direct representation of the Barossa's landscapes or cultural imagery that he aims for, as capturing his impressions of the ever mutating colours and textures of its elements, such as its golden autumnal vines and red earth. Schubert has also designed wine labels for winemakers in the region, capturing their identity in striking images: consider Peter Lehmann's gambler's card label series, or the Old Block Shiraz label for St Hallett.

Una Grimshaw is an English-born migrant who has lived in the Barossa since 1974. A graduate of the Guilford College of the Arts, as well as the Royal College of the Arts (London), Grimshaw has been deeply influenced by the character of the valley, its landscapes and its people, using oils, pastels and watercolours. Her perspective of the region's landscapes is especially singular, interpreting these as an outcome of 'this community of remarkable women', referring to these intense works as 'womenscapes'. Among Grimshaw's principal

works are the extensive and remarkable series of historic murals painted in 1976 on the exterior of the large wine tanks located inside the Chateau Dorrien Winery and Tourist Centre (see Chapter 4). Grimshaw did numerous studies of local inhabitants and it is the faces of the descendants of the Barossa's pioneers, which she has depicted in the narrative images of Lutherans journeying into the valley and their subsequent lives and work there.

Thurza Davey has lived in the Barossa since 1979, the year she began to capture its community life and landscapes in her meticulous watercolours and fine egg tempura works. A 1949 graduate of the Girls Central Art School (South Australian School of Arts) in Adelaide, Davey spent some fifteen years creating a large series of paintings of the Barossa which she eventually published in 1991, with an accompanying brief outline of its history and her artistic impressions, in a book entitled *Barossa and Beyond*. She spends much time in the field, especially on Barossa farms 'painting every aspect of daily life'. Her artistic style is inspired by that of the famous North American folk painter of the early twentieth century, Andrew Wyeth.

Malcolm Bartsch was born and brought up in the Barossa and later studied architectural graphics and architecture in Adelaide. In the 1970s he designed a series of postcards and prints illustrating the historic buildings of the Barossa. As an artist-in-residence in Umbria, Italy in the 1980s, he returned with an eye for the regional character of the Barossa, and has since painted its landscapes. His style ranges from a conservative, naturalistic representation through to the abstract, with traditional settlers' cottages, farm buildings, roadside flowers, the vine and the broader Barossa landscape as his subjects.

Sabine Deisen from Bremen, Germany, has lived in Tanunda in the Barossa since 1970 and has been a painter there since 1985. Self-taught in the medium of oils and acrylics, she considers that if she 'hadn't moved to the Barossa she would not have become a painter', so inspired was she by its scenery, churches, townscapes, people and its 'alfresco' lifestyle, as she puts it. It is these elements that she depicts in her paintings in an impressionistic style which is lively and spontaneous with movement and intense colour.

The sculptor Paul Trappe shuttles regularly between the Barossa and his other home in Germany. Trappe, a modernist stone sculptor whose art works are to be found in Germany and North America, has literally made his own

mark on the Barossa landscape: a major stone sculpture, *Brunnenplastic*, forms the centre-piece of Tanunda's Benno Keil Memorial Gardens, while another is located in Mengler Hill's Sculpture Park. One of Trappe's workshops is located in a private bushland plot near Kaiserstuhl's peak, where huge blocks of granite and marble are scattered about awaiting his creative hands.

Mention must be made of the renowned and eccentric Victorian sculptor William Ricketts (c.1899–1993). Invited to work in Nuriootpa for a spell when passing through the Barossa Valley on his return from a trip to Alice Springs in 1947, he created three major figurative sculptures in fired clay. Based on Aboriginal mythology and beliefs, Ricketts' sculptures were placed in the local park, the Coulthard Arboretum, one of them being built into the bank of the North Para River. Unfortunately, a subsequent flood destroyed all but one, the 'Spirit of the Old Gum Tree', which was typical of his extraordinary work and which depicts Aboriginal figures emerging from tree trunks.

Artists have also left their mark on the landscape of the Barossa: Sculpture Park located on the brow of Mengler Hill Lookout, was the result of an International Sculpture Symposium (organised by Gerlinde Trappe) in 1988. Large blocks of black granite, white marble and other stone were scattered about the uppermost-slope of the hill then carved according to each artist's aesthetic approach (including one work, 'Alienation', by Paul Trappe): the result is a miscellany of figurative through to abstract sculptures. As a collection it lacks coherence given the eclectic variety of stone types, textures and colours. The choice of location for these sculptures in the foreground of the most commanding view of the valley is an unusual one, especially as the medley of forms seems at odds with the sweeping panorama of vineyards, townships and encircling hills. Yet, in its own way, Sculpture Park contributes to the Barossa's evolving cultural landscape.

I have never ceased to wonder at the richness of the Barossa's art and craft traditions – those brought over by the migrant Prussian craftsmen, and those which emerged from their interaction with the British settlers and the Australian environment. People in the region today have this diverse set of traditions to draw from and to be inspired by, creating new, imaginative art and craftworks which say something about themselves, or which interpret the stories and qualities of this unique place.

Music & Festivals

The Songs of Zion; Bacchus in the Barossa

'a joyful hymn of praise ...'

Perhaps the first German voice to be raised in song in the Barossa Valley was that of our now familiar mineralogist and explorer Johannes Menge (see Chapters 2 and 3). The colonial author Cawthorne describes one of his many endearing and curious habits: 'By the peep of day he might be seen perched upon some high rock, then, echoing in the valley below, would be heard a rich and musical voice singing one of the celebrated hymns of Luther'.

Menge's fondness for music and singing was a characteristic shared by the German settlers of the Barossa who bestowed to the region a strong musical heritage. Rooted in the Barossa Lutherans' religious beliefs and rituals of devotion, this heritage embraces church choirs, a number of Liedertafel, brass bands, *Saengerfest* (singing festival), and more recently, the international Barossa Music Festival.

The Barossa Lutherans' love of music was evident from the time of the

departure of the first group of religious refugees from their homeland, in the northern spring of 1838. Boarding two barges on the River Oder, the migrants sang 'a joyful hymn of praise ...' repeating their songs as they passed through villages and towns on their river journey to Hamburg, and drawing many curious onlookers. Similarly, at the time of a later departure of migrants led by Pastor Fritzsche, they also set off 'amid loud prayers and hymns ...'

Hymnal and other sacred singing continued as a part of the Lutheran service in Barossa churches, its integral harmony regularly commented on by contemporary observers. From this congregational singing the church choir emerged, with most of the valley churches having their own choir: one of the longest surviving is the Langmeil Church Choir formed in 1880. Christmas was a time to celebrate the birth of Christ with the joyous singing of carols – always in German in the earlier years; these included the all-time favourites: *Alle Jahre wieder, O du fröhliche, o du selige,* and *Stille Nacht, heilige Nacht.*

This love of music, especially song, also led to the formation of a number of Liedertafel (literally, 'song table') groups in the Barossa, of which the all-male Tanunda Liedertafel established in 1861 is the oldest continual survivor of the tradition. *Kaffee Abend* (coffee night), is an informal evening of feasting and music, the latter provided by the Tanunda Liedertafel, together with the additional entertainment of the delightful Barossa tradition of joke-telling by one or two of the town favourites (see also weddings, Chapter 2).

Brass ensembles accompanied church choir singing until organs were

One of the many brass bands which were once existed in each of the villages and towns of the Barossa. This one is from the Dutton area, c. 1920. *Melodie Nacht* is an annual two-night event held on the last weekend of May each year, during which popular German melodies are played by the Tanunda Town Band.

installed, and from the late 1850s most of the towns and larger village communities of the Barossa could boast of at least one brass band. Indeed, at least 16 bands were active in the region by the late nineteenth century. They entertained widely, on religious and secular occasions, or at picnics, wedding feasts and family celebrations.

The establishment of the Barossa and Light Band Committee in 1911, led to the Tanunda Band Competition, an annual event which attracts bands from throughout Australia which perform in the public halls and streets of the town. Traditionally, four hours of spectacular marches are also performed in the main street and at the Tanunda Oval; in the evening, the seven-hour Finale is played by the bands when the winner is finally announced to play triumphantly once more. In 1996, the Tanunda Band Contest was programmed as a part of the Barossa International Music Festival, together with another dozen or so community-style events such as the Spring Academy concerts.

Melodie Nacht is an annual two-night event held on the last weekend of May during which popular German melodies are played – also by the Tanunda Town Band. The liveliness and character of events such as these is evoked by an eyewitness account of 1909, which describes the nature of the music played on New Year's Eve in Murray Street, Tanunda: 'At the stroke of midnight the Brass Band had played "Now thank we all our God", and afterwards "God Save the King", followed by the "Watch on the Rhine"'. This traditional informal evening of music has been maintained to this day, with the welcome *Gluhwein* (hot toddy) always served at interval!

German families of the Barossa were often praised and even renowned for their musical talents. In the Zilm family living in Nain for example (the very same family that made the anthropomorphic chairs), all of the boys could play instruments: Carl was a self-taught organist, while Christian, Jack, and especially Paul, were variously proficient at playing the button-accordian, flute, piano, tin whistle, cornet and saxophone. Later, these three brothers established a brass band in the mid-north township of Booleroo which regularly played during celebratory events, as well as over the period immediately after harvest. During the 1880s and 1890s, family oral tradition tells of the five Zilm brothers, Christian, Jack, Wilhelm, Albert and Paul, who worked as shearers, and who would travel by bicycle to sheep stations in the north,

The Shulz brothers, c. 1920s, Eden Valley. Note the nineteenth-century German Zither on the table, a plucked musical instrument of many strings stretched over a resonating box.

taking their favourite instruments which they played in the evenings. One story relates their fondness (and verve) of playing their musical instruments as a band during their shearing excursions, especially during their entrance into and departure out of towns, causing quite a stir!

Associations such as the Lutheran Church Young People's Society (or Young Men's Society) also organised regular social evenings held in member's homes, often for singing sessions around the piano. This tradition extended well into the twentieth century: Ruby Fechner recalls 'all of the families would regularly gather around the organ or piano for a sing song'. Almost any event could warrant a 'sing song', including the evening after the hard work of pig slaughtering or featherpicking, when the wine or beer, coffee and cake was brought out and one of the men would tune and play his violin or some other instrument.

Organ-Makers and the 'Lost Krüger Organ'

Organ-making, a specialist and traditional craft, has catered to the musical needs of the Barossa's religious community since its establishment in its founding decade.

The first specialist craftsman to make organs in the Barossa Valley was Johann Carl August Krüger, originally an organ builder and organist in Brandenburg, Prussia. Religious reasons saw the family migrate to Australia who, on arriving in 1848, settled in the village of Hoffnungsthal (see Chapter 2). Krüger

immediately set to making organs, completing two before leaving the Barossa for Hamilton, Victoria, in 1855.

Despite the primitive conditions, Krüger made his own pipes, both the wooden and the metal ones, using native pine for the former and scraps of tin and plumbers' metal for the latter. After melting these down and adding the appropriate proportions of lead, the tin and lead alloy was cast into thin sheets with the use of a specially-made, traditional wooden casting bench.

Krüger made the first organ in 1849 for Hoffnungsthal's small pioneer church. The second organ, made in about 1850, was installed in Bethany's Lutheran Church, in which case both of the pioneer Pastors Kavel and Fritzsche would have heard its notes. In 1883, although the original church was demolished, Krüger's second organ was re-installed in the newly-built church where it remained in use until 1929. It was then transferred to St Thomas's Lutheran Church in Stockwell, where it remains in use to this day, still intact within its red-oxide stained casing which had been constructed in the Biedermeier style.

A curious anecdote regarding the German organs of the Barossa Valley is that of the 'lost Krüger organ'. It refers to the first instrument made by Krüger in Australia which was installed in 1849 in Hoffnungsthal's church. Some years after the flooding of the village, it was eventually transferred to the St Jakobi Lutheran Church in nearby Lyndoch in 1867, where it remained until its dismantling in 1929. From that year, the organ was 'lost' for almost 60 years. In 1985, a chance sighting of 49 unusual 'primitive' wooden pipes by Roger Jones during a visit to a fellow organ-maker in Adelaide, led to closer inspection revealing that all were hand-inscribed in pencil with Krüger's positioning codes! These pipes have since been incorporated into a restored English theatre organ so that, once more, Krüger's wooden pipes sound the air, over 140 years since they accompanied the singing of hymns by German pioneers in Hoffnungsthal!

The Krüger family was also among those pioneers who founded the German settlement of Hochkirch, now known as Tarrington, in Victoria. When Krüger later left the Barossa to join his son's family there, he turned to farming, but not before he made one more organ, his third, in 1863 in Tabor (also near Hamilton). Ever resourceful, he used foil from re-cycled tea-chest linings to make his metal pipes. The organ was first installed in Tabor's pioneer wattle and

daub church, to be later re-installed in the subsequent rebuilding of the church where it remained in use until 1928. In 1992 it was donated by Krüger's descendants to the Barossa Archives and Historical Trust. Roger Jones tackled the task of restoring it to playing order (it has hand or foot-operated bellows), prior to its installation in late 1997 in Tanunda's Museum of Barossa and German Heritage.

The other nineteenth-century Barossa organ-maker was Daniel Heinrich Lemke, a Wend who, in common with others of his time, fled Prussia to escape social unrest. He settled in the Barossa at Moculta in 1855 where he became the local school teacher until 1878. It was in this period, during his spare time, that Lemke would supplement his income by building organs. In his later years, Lemke left the valley to work as a farmer at Sandleton.

Lemke similarly used local native cypress pine wood to make his square pipes which were pinned and glued together. His compact organs, about the size of a bedroom wardrobe, were encased in cedar. Although it is claimed that Lemke made 13 pipe organs between 1860 and 1885, this is most likely to be exaggeration born of folklore and, to date, only four are known to exist. These are to be found in the Lutheran Churches of Immanuel, Point Pass; St John's, Ebenezer; Holy Cross, Gruenberg; and Immanuel, Light Pass. Lemke died in 1897 aged 55, to be buried in the now disused cemetery at Sandleton, located on the lonely windswept plains to the east of the Barossa Ranges.

Traditionally, German organ builders preferred to see their organs placed at

One of Daniel Lemke's (1832–1897), Barossa-built organs, c. 1864. Located at the Holy Cross Church, Gruenberg, Moculta, it contains seventy-four handmade pine pipes together with ninety-eight metal ones and, except for the addition of an electric blower in 1966, it is unaltered and produces a late baroque sound. Note the painted Biblical texts.

the back of the church in the gallery with the pipes open on all sides to allow the full effect of their symphonic sound to be heard. Both Krüger's and Lemke's organs are said to embody the golden age of organ-making of eighteenth-century Europe, and are themselves based on the renowned Gottfried Silbermann organs of the era. As such they produce what is often described as a romantic resonance, one of unique tonal clarity and depth enhanced by their original settings.

These organs are not mere historic artefacts but are vital and key links in the life of the Barossa community: John Stiller, the son of a Lutheran pastor, has studied and majored in organ performances, and often gives recitals during the Barossa Music Festival, playing the historic Lemke and Krüger organs. In 1985, 100 years after the last organ made by Lemke, Adelaide organ-maker Roger Jones relocated his workshop to the region – hence reviving the Barossan tradition of hand-crafted organ-making which he maintains to this day.

Music and Festivals

The reader will have noticed that festivals are an indivisible part of the life of the Barossa community and that, over the years, new festivals have become established to complement earlier, traditional events which themselves are forever evolving and changing. Aside from the days of traditional celebration associated with the Christian calendar, there are at least seven additional festivals now held each year in the Barossa. The three prominent food-oriented festivals in which music has come to form an increasing role over the past years to varying degrees, have already been mentioned in Chapter 5.

Of the new traditions in the Barossa, the Tanunda Town Band, besides its aforementioned 85-year-old Tanunda Band Competition and the 140-years Liedertafel, has initiated a *Melodie Nacht* as a festival of music performed over two evenings: the musical offering focuses on popular German melodies described as *Hofbrauhaus*.

However, it was the inauguration of the Barossa Music Festival in October 1990, which has especially extended the region's heritage of classical music, dance, wine and food beyond its community setting into one which draws both a national and international audience. The festival was established by John Russell and the late Adelaide violinist Brenton Langbein, to realise a vision of

diverse classical and other music played in the historic wineries and churches of the Barossa. John Russell creates each year's program following his philosophy to have a 'fresh new approach' for each festival. One constant, aside from place, is the the festival's strong community underpinning which maintains a vital integrity and authentic cultural base.

The festival occurs during the spring of the Barossa countryside, just as the vines are vigorously sprouting bright green shoots, and the rolling hills and fields take on a bold daub of purple as the wild Salvation Jane blooms. The harmony of nature, always so palpable in this region, suffuses the atmosphere and invigorates the diverse and imaginative musical offering.

In the first six festivals traditionally set off with an opening concert in the elevated setting of the Mountadam winery, the musicians playing from an improvised stage to an audience flanked by stacked wooden barrels of wine (performed in 1995 by Die Kammermusiker Zurich). Outside, marquees open out to frame the grand vista of the Eden Valley, its rolling hills, vineyards and stately gumtrees. The inaugural 1990 festival presented 22 concerts. It gradually expanded and, in 1995, the program comprised 108 events spread over sixteen days, covering a diverse range of music and dance including: concert performances, operas, piano works, organ promenades, lieder, jazz, brass music, chamber singing, and even a performance by an Indonesian gamelan and dance ensemble.

In 1996, the Barossa Music Festival became a fifteen-day event with 112 events of which 65 were formal concerts or other musical performances which included the works of Bach, Handel, Mozart and Beethoven. World-renowned ensembles which performed included Die Kammermusiker Zurich from Switzerland, Manchester Camerata from England, The Peterson String Quartet from Europe, and The Trio of London – as well as a number of overseas-based Australians such as the virtuoso violinist Jane Peters, and pianist Peter Waters. Music ranged from the baroque to chamber and orchestral music, cabaret, choral music and opera, with the variation of the violin, piano, cello, woodwind, brass – and jazz.

In 1997, two concerts opened a festival of 85 events over sixteen days; its highlights included five orchestras, three dance companies (two international and one national), as well as many artists drawn from four continents – Asia,

Australian Harpist Susan Handel at the 1995 Barossa Music Festival. Each year, this festival presents a diverse program of musical performances in the region's historic churches and wineries, complementing and extending the long-established musical traditions of the Barossa.

Europe, America, and Australia. Collaboration between artists and groups was one of its strong themes: for example, the Chinese National Music Orchestra of Shandong played with the Danish Folketeatret; and the Adelaide Symphony Orchestra teamed with Schnyder Taylor Drew Jazz Trio. The festival also featured a major Danish involvement with four leading arts companies from Denmark, including the New Danish Theatre and the Danish Radio Jazz Orchestra.

The Barossa Music Festival's rich offering of sounds is always accompanied by a feast of local foods combined with an experience of the unique settings the region provides (detailed in Chapter 5). The latter is an especially critical aspect of the festival: its sensorial offering is heightened through its intimate integration with various elements of the cultural heritage and landscape of the Barossa. Concerts and other events are performed all over the valley floor and in some elevated sites in the ranges, in a large variety of venues. These range from the historic Lutheran churches of the Barossa, with Langmeil in Tanunda, Herberge Christi at Bethany, and Gruenberg at Moculta as three of the most frequented favourites out of some eight that are often used.

After the reflective and spiritual mood of the churches, the unique ambience created by the region's considerable variety of historic and contemporary

winery buildings, provides an important additional series of venues for festival events. These include the vernacular feel of massive corrugated iron storage sheds with exposed redgum beams, or bluestone cellars lined with oak kegs, barrels or hogsheads – their unique astringent wine and woody-oak odour generates an atmosphere which readily lends itself to adaptation for musical performances.

Wineries which have been transformed into theatres through the judicial arrangement of existing elements, and which provide sensual, unique spaces include the Orangery and Vickery Shed at Richmond Grove, Mountadam Vineyard in the Eden Valley, and Peter Lehmann's Cellar Door; all three acting as regular focal points for performances. In addition, at the Yalumba Winery in Angaston, the Cask Hall and Signature Cellar have also consistently been used to great effect. In 1996, hundreds of crates full of empty champagne bottles were arranged to frame the auditorium and stage to create the Yalumba 'Glass Theatre'; the light filtering through the bottles generated a luminous effect which complemented the emotive theme of the opera *Alma, the Tempestuous Garden*.

The Barossa Vintage Festival – Gemütlichkeit!

Other major festivals present a mixed program of music, performance, food, parades and other events. This is especially the case for the Barossa Vintage Festival.

I have already described how, every second year, the Barossa Vintage Festival takes over from the annual, though humble, *Essenfest* as a community-driven week of celebrations beginning on Easter Monday (see Chapter 5). The biennial Barossa Vintage Festival is essentially a contemporary expression of the traditional German *Erntedankfest*, that is, the harvest thanksgiving, which signalled the completion of the grape harvest. *Erntedankfest* itself has long been celebrated in the churches of the Barossa as a significant community occasion with the members of each congregation bringing in examples of the best produce (later donated to charity) from their farms and gardens.

Originating centuries ago and derived from ancient Old World rituals, *Erntedankfest* continues to be celebrated by Lutherans in the Barossa region. Deuteronomy 16:15 instructs: 'For seven days celebrate the feast of the Lord

your God at the place the Lord will choose. For the Lord your God will bless you in all your harvest and in all the work of your hands, and your joy will be complete.' Harvest thanksgiving includes the decoration of the church interior with wreaths, and even sometimes farm implements, and of course a service conducted with the congregation singing special thanksgiving songs and hymns (see Chapters 2 & 6).

This elaborate display of *Erntedankfest*, harvest thanksgiving, dates from the 1920s in Langmeil Lutheran Church, Tanunda. Note the anchor made of bread hanging in the centre, the traditional symbol for the spiritual refuge.

The historical origins of the contemporary Barossa Vintage Festival may be traced to this time-honoured, community-based harvest festival, which became the basis of individual celebrations held by various wineries about the Barossa. In 1947, following the end of the Second World War, motivated in part by a desire to sooth memories of hostilities and the loss of sons and fathers, and in part by the economic need to develop the region's attractions for tourism, the various harvest and wine festivities were combined into one major period of events, somewhat daringly called the 'Festival of Bacchus'. Not surprisingly, the pagan connotations – not imagined but real in terms of the ancient derivation of this festival – were disapproved of by the Lutheran Church, leading to its renaming from 1949, as the more modest, 'Barossa Vintage Festival'.

The idea of staging a large wine harvest festival as a tourist event is credited to Bill Seppelt. Following a tour of France where he had been especially impressed with the national wine festival at Colmar, he had returned to the Barossa in 1936 determined to spark off a similar festival. He set to enlisting the support of a handful of other distinguished Barossa locals associated with

the wine industry, but the onset of the war in 1939 delayed the implementation of their plans. The end of the war was a time for celebration, so the festival was inaugurated with a Vintage Ball in Nuriootpa, the funds raised being donated to the local branch of the Returned Servicemen's League. Additional activities included 'street dancing', speed car racing, a procession of floats, and a vintage carnival.

In 1948, Joan Hoffmann was crowned as the first 'Daughter of Bacchus', the progenitor of the festival's Vintage Queen, a tradition replaced in 1999 by a non-gender 'Young Amassadors' role. With each succeeding year, other events were staged during the vintage harvest, expanding the festival and drawing in a more diverse and larger audience: the 1949 and 1950 festivals included the Australian Grand Prix at Nuriootpa, while Angaston hosted the 'biggest rodeo ever held in the nation'!

Prior to the recognition of the cultural significance of the festival and the need to be ever mindful of this element, the vintage festivals of the 1960s and early 1970s tended to become vulgarised. Indeed, a Bavarian flavour was deliberately imparted to the activities in the mistaken belief that this would attract more tourists! Lederhosen and its associated cultural paraphernalia has never been a part of the Barossa's history: its east-Prussian Lutheran founders were relatively austere, yet joyous, in the expressions of their folk culture. Thankfully, the wider recognition of the unique character and attraction of the Barossa's authentic cultural heritage, led to more thoughtful planning in subsequent and contemporary vintage festivals.

It may have been the latter trend which led to the instigation of a quite idiosyncratic group, the Barons of the Barossa, in 1975. This 'wine brotherhood' was based on the ancient, traditional wine groups of France; it was instituted by members of the Barossa wine industry as a means of promoting the industry and to 'preserve the traditions of the Barossa'. Each year, new members, dressed in extravagant and colourful robes and hats, are inducted in a public ceremony among the vines. Perhaps time will introduce and meld elements which tie this event more closely to the region's heritage.

In the 1990s, the growing importance of cultural tourism to the economy of the region and state as a whole, led to a gradual shift in the organisation of the Barossa Vintage Festival away from its community base. It is now steered

through a 'Festival Committee', which is assisted by the Barossa Wine and Tourism Association and, to a lesser extent, by the state government through the South Australian Commission and Australian Major Events committee. Although 'Event Conveners', drawn from Barossa winemakers and other local residents, have a say in its planning, the integrity of the festival surely depends on the degree of community involvement.

Aligned with this planning approach, the festival now has its marketing and publicity handled by a Adelaide firm which seeks and obtains high-profile sponsors (over thirty-five in 1999). New events are constantly added to the traditional forms which are themselves constantly modified, while the trend towards more authentic cultural activities based on the region's historic origins and local setting, is generally being maintained. And while more events with a sophisticated, cultural quality have been introduced in the past two festivals in particular, the emphasis strives to remain one of a unique mixture of popular community culture and a hearty exuberance in the celebrations of food and wine – all in the context of a vintage harvest.

Today, the Barossa Vintage Festival (held every second year since 1965 to avoid 'clashes' with the Adelaide Festival) has expanded to an enormous size, with a core of close to a dozen principal events, supported by various corporate sponsors, as well as the numerous community-originated activities. Every Barossa Vintage Festival has grown larger and been promoted more widely as a major tourist attraction, featuring newly created events as well as others developed from traditional activities. Indeed, the Barossa Vintage Festival could be described as a monster of a festival, and is certainly the biggest of its type in the southern hemisphere, the most recent one in 1999 including over 200 attractions and some 100 events in the programme, and attracting approximately 100 000 people! Despite this fullness, the festival's aim strives to remain simple: to celebrate and give thanks for a successful vintage in a spirit of fun.

While in its earlier years, festival events included roughriding championships, motor racing, visiting wine queens from Germany and the USA, and the traditional and very popular dinners of Weingarten and Kellerfest, it was not until some years later that a broader heritage consciousness emerged. The latter events supplemented with those which were more authentically linked to the region's cultural character, such as visits or tours of the Barossa's historic

churches and recitals on their old pipe organs. Performances of amateur theatre and local brass band music, as well as *Freudennacht* (joy night) are other means of celebration in the delightful Barossa-Deutsch style.

More recently, the festival has developed an even stronger focus in its celebrations of food and wine which are combined with many other activities as diverse as arts and crafts fairs, parades, music, cultural heritage and art exhibitions, music, dancing, not to mention competitions of the grape-picking and treading and barrel-rolling kind!

A following perusal of the 25 or so principal events which made up the most recent two festival programmes reveals this typically Barossa mix of the traditional and the contemporary. The festival is launched with an official opening ceremony (held at the Lyndoch Oval) during the quintessential Barossa *Gemütlichkeit* — literally, 'lets get together and have fun'.

Enlivened by the region's brass bands, the Grand Parade is one of the longest of its type in the southern hemisphere with over 100 floats created by the region's business, heritage and other community groups, all illustrating aspects which make up the character of the Barossa. Thousands of spectators line the seven kilometre Barossa Way route from Tanunda to Nuriootpa to watch the spectacle.

Events which bring food and wine together in a local context include a series of 'Town Days' which are held in Angaston, Nuriootpa and Tanunda. The main streets of these Barossan towns are closed to traffic, transforming their thoroughfares into carnival malls with food, wine, arts and crafts, heritage stalls, music and maypole dancing. In Tanunda, at the historic Goat Square with its trunk-twisted carob trees, quaint Germanic high-pitched cottages and the spires of St John's and Langmeil Lutheran churches rising in the near background, the original mid-nineteenth-century function of the square is evoked during *Der Ziegenmarkt* 'event'. This is an especially delightful time with live animal auctions (put on with a strong dash of quirky Barossan humour), and other quaint and traditional activities such as feather-picking, horse shoeing, sheaf tossing and stooking, all enacted or demonstrated, as residents in traditional dress intermingle with visitors. Delicious breakfasts including waffles or German sausage are provided, as are other traditional Barossa foods such as *Deutscher Kuchen* and *Rote Grütze* (see Chapter 5). I personally find the

In 1999, the 52-year tradition of the Barossa Vintage Queen ended, to be replaced by a 'Young Ambassadors' event open to both genders. Pictured is the final, 1997 Vintage Queen ceremony.

ambience of Tanunda Town Day, especially that of Goat Square, to be one of the most fulfilling in terms of its authenticity and unselfconscious community involvement.

In Angaston similar entertainment follows a champagne breakfast, and is also accompanied by displays of vintage machines, church choir performances, working blacksmiths and heritage tours of the town's splendid buildings and special locales. In Nuriootpa, the main street is lined with gourmet food stalls, while the crowd may enjoy wine tastings and musical entertainment, watch The Classic Barossa Motorcade of vintage vehicles, then complete the day's celebrations with even more liberated revelry at the Grape Stompers Ball!

Various sporting or competitive activities are also held during the festival, and include the Australian Barrel Wheeling Championships, sponsored by A.P. John & Sons Cooperage; and the Jacob Creek To Steingarten Challenge, a major athletic carnival which culminates in a gruelling ten kilometre 'dash' uphill from the historic Jacob's Creek Vineyard up to Steingarten, high in the Barossa Range at the top of Rowland Flat. Thanks to the French, pétanque is closely associated with wine-growing regions the world over, so it was apt to see its introduction in the Barossa in the 1995 festival! Referred to as Pernod Pétanque Challenge, and played in various locations, it seems especially appropriate set alongside the golden vineyards surrounding Chateau Dorrien's six pistes, where teams of three players use two boules each, ending with a Grand Final 'knock-out' competition.

227

Perhaps the idea of pétanque in the Barossa may seem even less unusual when it is revealed that the ball game of kegel or skittles, has been played in Tanunda since 1858. This still occurs in the original, specially-built, nine-pin kegel alley or *Kegelbahn*, located in the Tanunda showgrounds and Park, the only one of its kind in the southern hemisphere.

Heritage is also the emphasis in the 'From Vine to Wine' tour through Seppeltsfield's splendid gardens and buildings which included cooperage and winemaking demonstrations. The Tanunda Liedertafel Choir performs at Chateau Yaldara, while Afternoon Tea Dances are held in the historic architectural and garden setting of Collingrove Homestead.

In 1997, fifty years of Barossa Vintage Festivals were celebrated with a programme of numerous events, many similar to the preceding. These ranged from the Classic Wine Dinner, the Crowning Spectacular, the Vintage Queen Crowning Ceremony, the Hofbrauhaus Dinner, the Jacob Creek Heritage Picnic, and the Rare Wine Auction (described in detail in Chapter 5). New events designed to highlight the fifty-year achievement included: The '47 Ball, a commemoration of the first ball held on the occasion of the inaugural Vintage Festival on 22 April 1947; Brunch On The Old Block, and Twilight At Miamba: the latter two highlighted heritage by combining food, wine and history. During the Barossa Fair, the Tanunda Oval is transformed into a 'series of villages' featuring local foods and wine, grape treading and spitting finals, with a fireworks display to close the fair. Harvest queen sculptures are also put on display; in 1997 and 1999, some 1 000 scarecrows decorated many fields and roadsides about the valley during the week's festivities. Traditionally seen as 'guardians of abundance', these straw-based figures, together with the custom of the (final 1997) Festival Queen, have their origins in ancient, pre-Christian rituals – now appropriated for essentially decorative purposes.

The festival of 1999 was dedicated to the 150th anniversary of commercial winemaking in the Barossa. Hence some emphasis on wine with the new attractions of Hand Made Wines – Secrets of the Barossa, and Wine, Women and Song. There was also a repeat of a number of favourites such as Classics in the Quarry with the Cologne New Philharmonic Chamber Orchestra from Germany performing Vivaldi, Bach, Tchaikovsky and Mozart. On this evening, the sounds of classical instruments resonated off stark stone walls in

a unique elevated site. Within this floodlit quarry at Bethany Wines patrons sipped premium wines as the sun set over the Barossa's birthplace and the gentle hills of Greenock in the distant north-west.

Aside from this 'core' programme, community groups and wineries also put on various individual food and wine harvest breakfasts, lunches or dinners, as well as heritage displays and other events. These included Bradtke's Woolshed centenary (1897–1997) celebration of Germanic craftsmanship; various guided historical walks about Bethany and other sites; and Roger Jones's demonstration of organ pipe-making in the traditional manner, to name a few.

The visual arts are not neglected and a number of exhibitions are held during the vintage celebrations. Among these in 1997 was the inaugural Visy Board Art Prize, touted as Australia's richest regional prize for contemporary visual art works – $30 000 including 1 000 bottles of Barossa shiraz! (Visy Board is an Australian carton manufacturer.) By invitation only, the artists included Imants Tillers, Aldo Iacobelli, Zhong Chen and others of national promi-nence. While the displayed works were of the highest contemporary standards, they had absolutely no visual or other links to the festival or the Barossa region's characteristics. As a result this elitist show was perceived to be at odds with the vintage festival's regional and community base.

On the other hand, The Festival Art Exhibition was open to works related to a harvest theme, while yet other exhibitions featured Barossa artists such as Rod Schubert's regular display of new works, as well as those of Malcolm Bartsch (see Chapter 6). Numerous craft shows are also open during each vintage festival: in 1997, wood carver David Nitschke and forged iron artist Harry Hennig showed together in the Exhibition of the Two Meisters; while exhibitions of embroidery, chinapainting, basketweaving, and quilts were also held. It would be more engaging and worthwhile to see more of these exhibi-tions which draw from the wealth of folk arts and crafts brought to the region by the Prussian migrants, or else inspired in some way by the Barossa's cultural landscape.

There are also dozens of other smaller, community-organised projects – of ceremonies, re-enactments and displays – all related to heritage. These not only demonstrate the Barossa community's spirit of involvement, but also create and reaffirm local identity in the face of seasonal mass tourism.

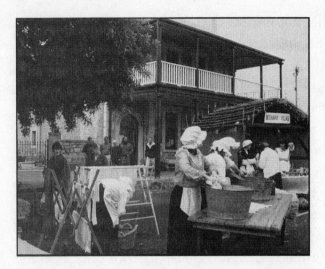

Locals in traditional dress hold various 'pioneer' demonstrations during the Tanunda Town Day. The Museum of Barossa and German Heritage is housed in the Old Telegraph building in the background.

Among all of the revelry and sensory celebration of the vintage, the spiritual aspects of and original reasons for the festivities are not forgotten by the community. A number of special religious services are held including a mass peel of the Barossa's church bells, sounding across the valley; vintage thanks-giving services are held at a number of churches with special 'traditional and contemporary' church services at St John's, Tanunda, and a gospel concert at St Petri, Nuriootpa.

With the glow of autumn colouring the vineyards and street trees of the Barossa's thoroughfares, the harvesting is in full swing, the grapes collected and transported to the wineries where they are assessed and weighed, the crushing begins, and the vintage proceeds to culminate in a festival which celebrates and invigorates traditions transported from the other side of the world. Aside from the abundance of events and attractions offered by the official pro-gramme, it is surely the ready involvement of the region's town, village and farm folk, which continues to ensure that the festival brings locals and visitors together in a harmonious, and sometimes rollicking, celebration of life and the cultural bounty of the Barossa.

Postscript

Caring for the Barossa's Heritage and Landscape

After the discord of the two World Wars and the immediate post-war periods, and following the entry into Australia of further migrants from around the world, enlightened attitudes towards culture, especially the understanding that a diversity of minority cultures enriches mainstream life, led to a re-assessment and appreciation of the Barossa's Germanic heritage. This has, in turn, led to a realisation of the need to nurture and preserve this heritage – as well as an acknowledgment of the ongoing changes which occur as contemporary influences continue to blend with the region's historic fusion of central-European and British traditions.

The following are some of my thoughts and concerns regarding the preservation of this unique place.

Surprisingly, the Barossa's heritage of folk culture, heightened by its concentration in a fairly small region, has only relatively recently been widely

recognised as worthy of being nurtured and preserved. Even the notion of 'cultural landscape' which is replacing to a degree that of 'cultural heritage', is only now becoming understood by a wider public. This is to be encouraged, for one of the ways traditional culture and heritage may be preserved is to make sure as many people as possible are aware of and can sample, the special qualities and differences which make up the character of a place.

In addition, the contemporary traveller is increasingly embarking on a quest for a more authentic cultural experience. And it is the Barossa region's natural environment and its heritage, as well as an absence of mass tourism, that are recognised as among its more significant assets. There is also much current interest in encouraging and promoting cultural tourism by emphasising the heritage of a place, offering travellers with a deeper, more fulfilling travel experience of the 'cultural landscape', through interpretation by various experts – or by books such as this one.

Research has shown that staged entertainment and imported festival events are regarded by visitors as the least authentic or desirable aspect of a trip. There is also the risk that the introduction of exotic activities or festivals which have little relevance to or any links with regional traditions may dilute and diminish the value and identity of the endemic culture. The Barossa's existing and new festivals have, up to now, adhered to this principal. However, in 1997, a musical concert was created as a new tourism event to be held annually in the Barossa. Called 'Barossa Under the Stars', the inaugural concert featured the international popular singer Shirley Bassey. Publicity tied the concert to the region through the combination of its open-air winery venue and picnic setting, and catering by leading Barossa chefs.

Yet, beyond these links, the concert had little else to do with the character or traditions of the region, particularly in terms of the style of music presented. This may appear to be nit-picking, but I present this example to simply illustrate that the balance between an emphasis on what is unique in the region's culture and the tendency to exoticise is something that warrants consideration. It is all very well to bring in artists from outside and create new events for the Barossa, but surely it is best to attempt to tailor these in a way which complements its distinctive regional culture.

The size of a festival is also emerging as a key factor in attracting or

deterring would-be visitors. While it is the quality of intimacy and uniqueness of small-scale festivals that is one of their chief attractions, a number of Barossa festivals have lately been encouraged to grow in size to the point that these qualities are in danger of being extinguished. Already, people in and outside the community are voicing their concerns.

The Barossa's wine industry, much of it owned by external corporations, draws freely from the region's cultural heritage to emphasise the traditional inheritance of its members' wines. This is perfectly reasonable given their economic input into the region. This emphasises the care that must be taken in terms of the authenticity of marketing strategies. For example, in an exhibition display of the history and processes of the region's viticulture and winemaking, set up with considerable expense in Tanunda, the incorrect translation of the Barossa's name as meaning 'hill of roses', has been, once more, repeated. Yet the not-so-romantic though correct meaning 'hill of mud' reveals an important link with its earliest European explorer (see Chapter 1). This may seem like a minor point, but it serves to illustrate how the lack of sensitivity to the notion of cultural tourism can lead to the projection of clichés, rather than a fostering of the true cultural identity of the region.

There is a real risk too, that more recent governmental marketing of the idea of cultural heritage and landscape for tourism will be chiefly motivated by the economic imperative. This raises a number of queries. Will the cultural groups who have inherited and live within the Barossa region benefit from proposed projects or activities, or will tourism organisations be the chief profiteers? Will cultural tourism build on local resources while returning something to the community? Will the community be adequately consulted: indeed, who controls their cultural property? These are questions that surely need to inform any major directives or activities likely to influence the region and its community.

In addition, the commercialisation or 'selling' of our cultural heritage and landscapes must take a sensitive approach if the damaging, sometimes trivialising, effects of tourism are to be resisted. Tourism organisations, both private and governmental, need to retain an awareness of the impact of their activities on the identity of the local community, its cultural heritage and its ongoing community integrity.

In particular, well-meaning groups or individuals, especially those originating from outside of the region, have a tendency to 'take over' and see the Barossa's landscapes, historic churches, community spirit, and its culture, as assets which they may appropriate and exploit at will, or to use as part of a marketing strategy. This does not necessarily always have a positive effect on community respect, identity and feeling: adequate consultation is the key.

Sometimes, it is the community itself that needs to be mindful of decisions which affect its own heritage. Recently, I was most concerned to hear of a plan to either lop the tops off the candle pines which form a stately avenue leading to the heritage-listed Langmeil Lutheran Church, or else progressively replace them with the modern 'golden cultivar'! Langmeil Church is itself of inestimable value, but its cultural quality is especially enhanced by the candle pine avenue planted by a past congregation member, one who had a vision of what would be accomplished. After close to a century of growth and care by many others, these trees today represent heartfelt decisions taken in the past, as well as telling us something of the values of previous generations.

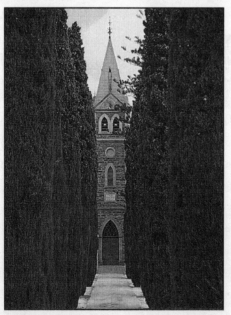

The steeple of Langmeil Lutheran Church framed by its distinctive candle-pine lined path. Its historic cemetery contains many finely carved headstones, as well as the grave and memorial to Pastor August Kavel, leader of the refugee Lutherans. The Church, its cemetery and its candle-pine avenue comprise one of the many cultural icons of the Barossa.

Langmeil Church, its pioneer cemetery and its candle pine avenue, constitute a particular vision as well as creating a special ambience and place, one which cannot be found anywhere else in Australia, or around the world for that

matter. The site's outstanding cultural and historical significance, attracts pilgrims and tourists. Replacing the traditional, mature candle pines with the new, smaller-scale golden cultivar will undoubtedly diminish the cultural significance of this site – even trivialise it! As an important site with strong associations beyond the congregation, any decision to radically alter it should be a matter which involves the wider Barossa community.

The mid-1980s destruction of much of the region's heritage of old shiraz vineyards is still lamented – it could have been averted with due consideration of all factors, cultural and economic.

I present the preceding comments and examples simply to illustrate the degree of awareness and sensitivity which communities and authorities must demonstrate if regional heritage is to be preserved in a dynamic manner.

Cultural tourism aims to provide travellers with an opportunity to experience the essential, true character of a place, to gain access to its stories, to realise the cultural and symbolic meaning of its artefacts, buildings, monuments and other structures, and ultimately, to instil a sense of purpose in their journey. As such, any means by which the Barossa's (and Australia's) cultural heritage and landscape is altered, or commercially exploited, must be balanced with a knowledge of, and respect for, past and contemporary community values, as well as the long-term preservation of the diversity of the region's heritage.

It is with a wish to avert the possibility of a superficial version of the notion of cultural tourism taking hold, that the depth of content and sophistication of the Barossa's heritage and story is presented here, to make available the necessary intellectual and sensory challenge for the visitor. Ultimately, engagement is the key word – engagement in the richness and meaning of stories, and in the accessibility and comprehension of the region's key heritage or other elements.

In this manner we may delve beyond the visual scene, unwrapping the successive layers of past occupancies, to take delight in, and celebrate, the imprint of humanity on the ancient landscape of the Barossa.

Bibliography

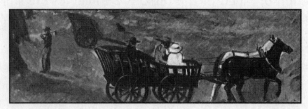

Suggested Further Reading

Aeukens, Annely et al., *Vineyard of the Empire: Early Barossa Vignerons 1842–1938*,
Australian Industrial Publishers (Adelaide), 1988.
A history of the early viticulturalists and winemakers of the Barossa, covering
the period from settlement up to the Second World War. 256 pp. Black-and-
white and some colour photographs, appendices, index.

The Barossa Cookery Book, Soldiers Memorial Hall Committee, 1992 (Third Edition).
Includes 1 000 selected traditional recipes donated by the housewives of the
Barossa. 159 pp.

Barker Sue (ed.), *Explore the Barossa*, State Publishing (Adelaide), 1991.
Useful for the dedicated tourist who is interested in and has the time for walking
and driving tours. Covers most aspects of the Barossa and surrounding regions,
including botany and geology. 160 pp., detailed maps and gazetteer, and
illustrated.

Dunne, Mike, *The Winelover's Companion to the Barossa*, The Dunne Thing, 1993.
Covers all wineries in the Barossa region, including family wineries, with descriptions of their best wine, with location and touring maps. 120 pp., and colour photographs.

Heuzenroeder, Angela, *Barossa Food*, Wakefield Press, 1999.
Combines traditional recipes, history and stories.

Hoskings, W.G., *The Making of the English Landscape*, Penguin Books, 1985.
An account of the historical evolution of the English landscape. A pioneer study illustrated with photographs. 327 pp.

Ioannou, Noris, *The Barossa Folk: Germanic Furniture and Craft Traditions in Australia*, Craftsman House Press (Sydney), 1995.
A cultural history focussing on furniture, but including other Germanic folk arts. All German settlements in Australia are covered, but the Barossa Valley and Adelaide Hills are featured. It includes comparisons with North American Germanic folk arts. 368 pp. Illustrated with 150 colour photographs, 120 black-and-white photographs, maps, bibliography, appendices, index.

Leske, Everard, *For Faith and Freedom: The Story of Lutherans and Lutheranism in Australia 1838–1996*, Openbook Publishers, 1996.
Australian Lutheran history summarised and illustrated with historic black-and-white photographs. 288 pp., index.

Munchenberg, R., Proeve, H.F.W., Ross, D.A., Hausler, A., Saegenschnitter, G.B., Ioannou N., and Teusner, R.E., *The Barossa A Vision Realised: The Nineteenth Century Story*, Barossa Archives and Historical Trust Inc., 1992.
History of migration and settlement of the Barossa Valley covering the nineteenth century. Illustrated with historic black-and-white photographs. 216 pp., index.

Proeve, H.F.W., *A Dwelling Place in Bethany*, Adelaide, 1983 (reprinted 1996).
Covers the migration and founding of the first German settlement in the Barossa, and focuses on the religious community. 88 pp.

Young, Gordon, Harmstorf, Ian and Langmead, D., *The Barossa Survey*, Techsearch, Adelaide, 1977.
Three volumes produced as a report following a survey of the Barossa Valley's heritage by the Centre for Settlement Studies, detailing land settlement, agricultural land use, building techniques and styles.

Index

Page numbers in **bold** refer to illustrations